Last Stand

AMERICA'S VIRGIN LANDS

BARBARA KINGSOLVER

Photographs by ANNIE GRIFFITHS BELT

NATIONAL GEOGRAPHIC

Washington, D. C.

Foreword

NEAR MIDNIGHT, IN THE ENDLESS LIGHT of an Arctic summer, I quietly scaled a ridge in northeastern Alaska. Miles away I could see them — 10,000 pulsing dots moving across the tundra. Caribou. The sight brought me to my knees. How few places are left on this Earth grand enough to support any wild herd? Before the Europeans arrived, North America teemed with herds of bison, elk, antelope, deer. But now even these caribou, at the farthest corner of our continent, are under seige from those who covet the potential petroleum reserves beneath their hooves.

In my 25 years as a photographer, working in every region of the United States, I have often been struck by how little virgin land is left. Some of the purest remnants have been saved by accident: a roadside ditch, a private estate, a cemetery. Now only a small fraction of the vast wildness of our continent remains untouched. As we urge the rest of the world to stop clearing rain forests, to halt poaching, and to save the whales, we would do well to look in our own backyard. If we, who are blessed with an abundance of space, wealth, and education, can't cherish our own last wild places, then who can?

Annie Griffiths Belt

Dedication

For our children Camille, Charlie, our two Lilys,

and our children's children.

We hope for wild places that will forever stir your hearts.

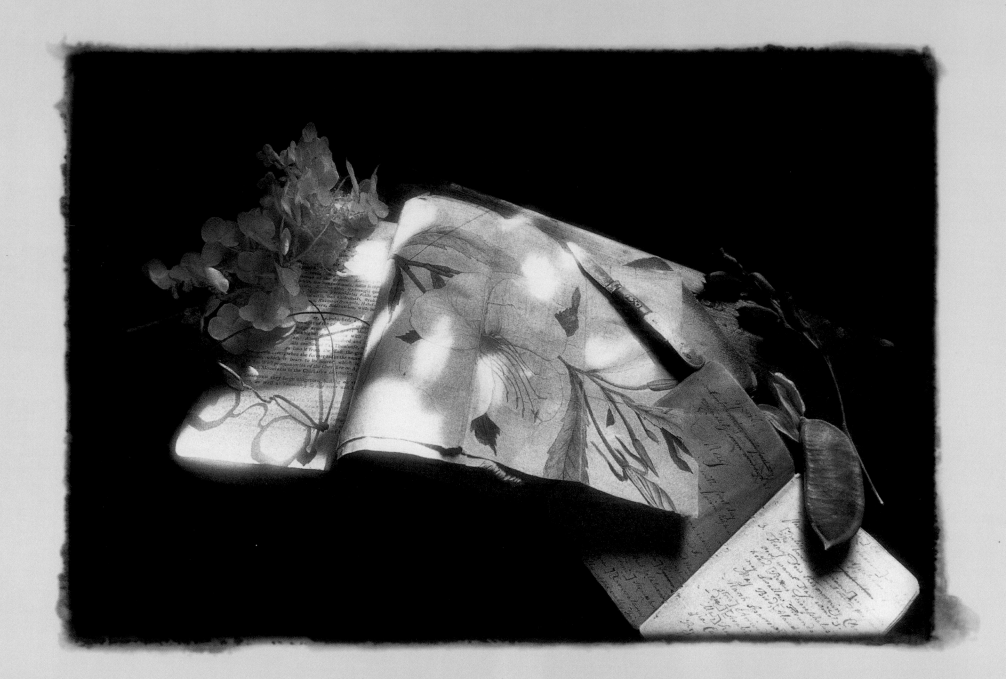

An original copy of William Bartram's TRAVELS *(Overleaf) North Cascades sunset* / NORTHERN WASHINGTON

Contents

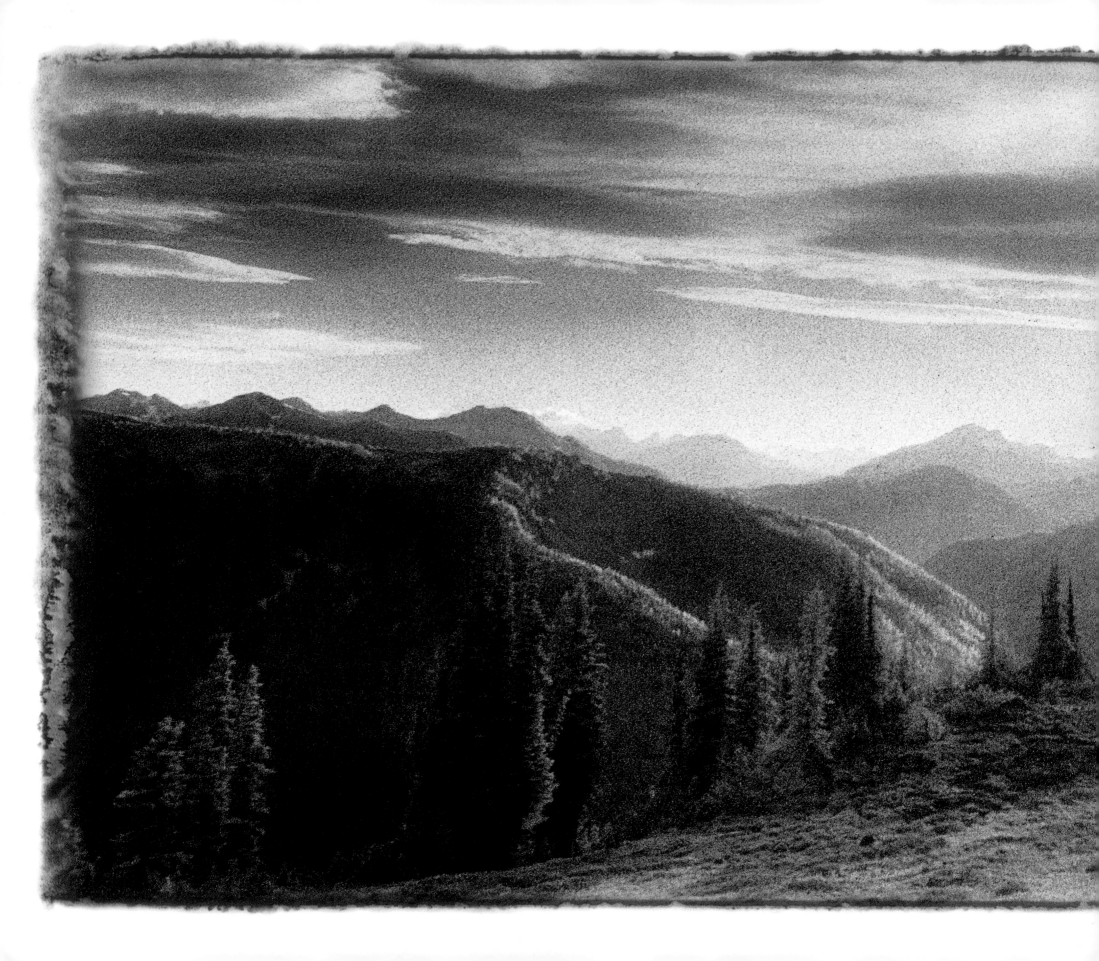

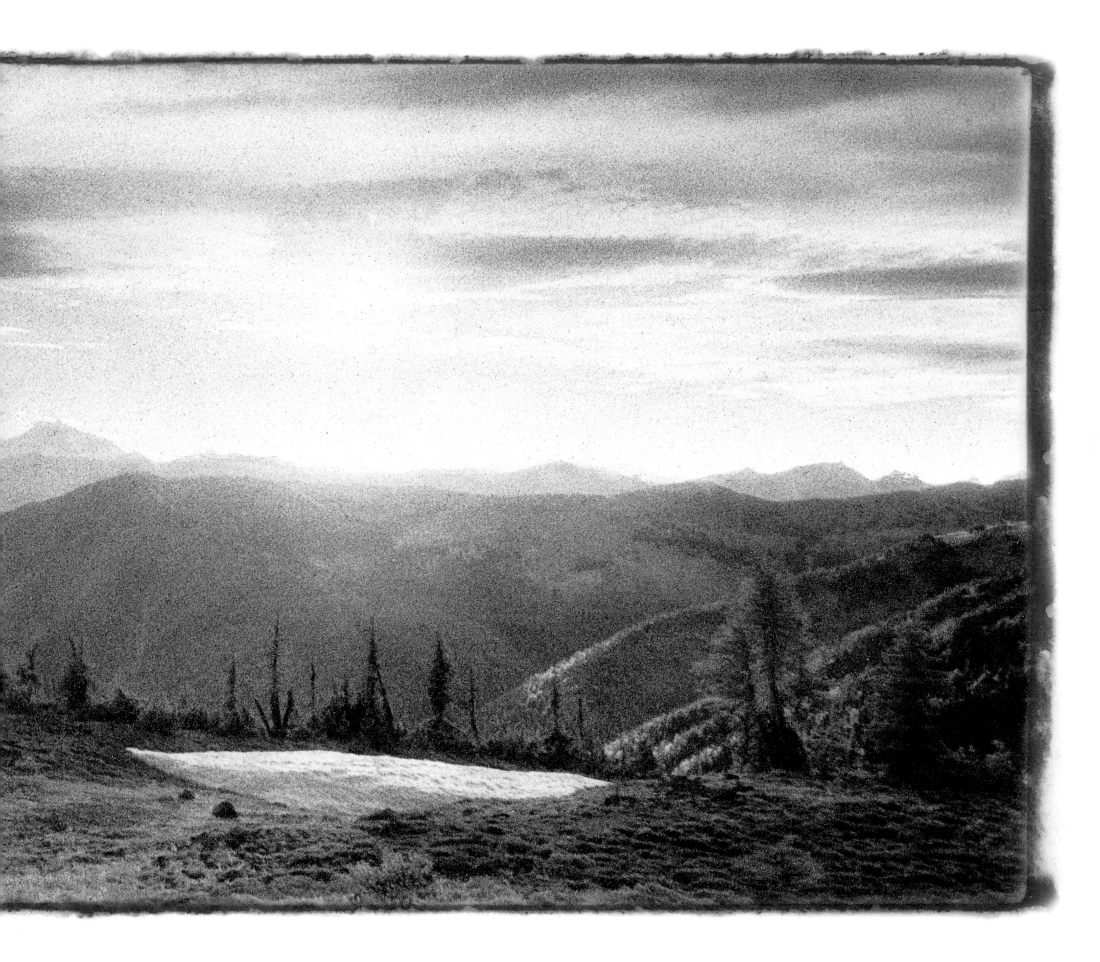

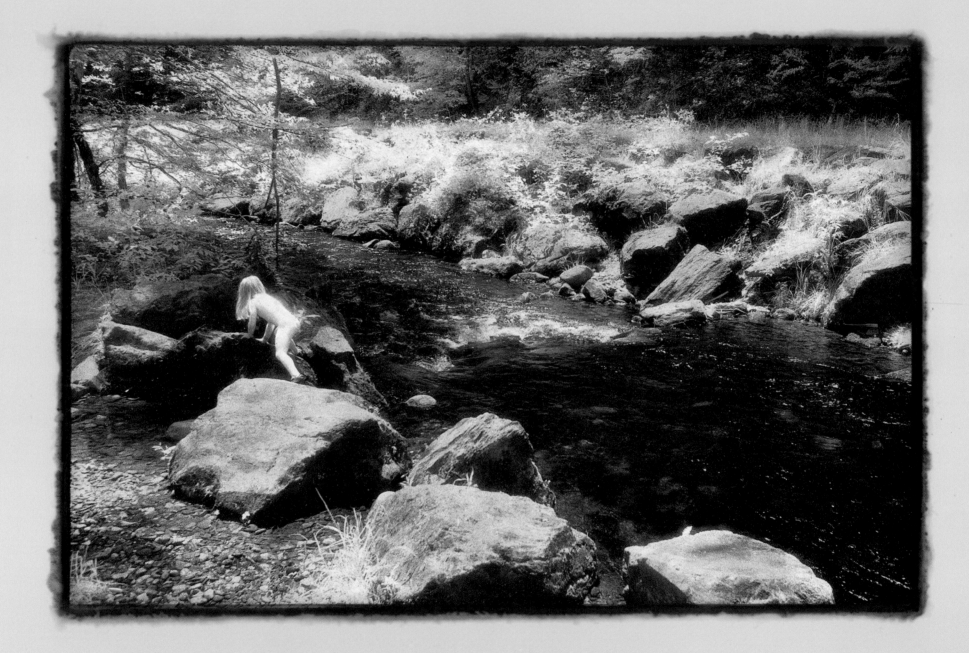

Mountain stream / WESTERN NORTH CAROLINA

How is the American childhood to be measured? So many different kinds of landmarks may have punctuated those years: The baseball games attended with distracted but loving dads; the marble doorways of great museums entered; the sandlots or spelling bees faced and conquered. For some, school report cards marked the high or low waterlines of hope; for others it was the friendships gained and lost on playgrounds.

But there is another category of child, bred in the back fields and uncultivated edges of America, whose years were measured in genuine, living seasons: The first clear day of winter's end when the maple sap runs; the moment of summer when earth and air have conspired to raise the temperature of a pond so it might embrace the joyous goose bumps of a naked child's skin; the last leaves piled high and leaped upon in autumn; then snowfall, hushed and final as the white endpaper of a favorite book.

I am one of those lucky ones, whose best memories all contain birdsong and trees. In the long light of summer, on every consecrated Saturday of spring and fall, and whenever we were blessed with the gift of a "snow day" in winter, my compatriots and I carried out our greatest accomplishments in the company of hickory and maple. Relieved of the instructive intrusion of adult company, we explored and reexplored the rambling patchwork of woodlands that formed irregular connective tissue between the alfalfa fields and cow pastures that stretched in all directions from our homes.

The fields were fair enough. They harbored the occasional find — a nest of baby rabbits tucked into the thatch, or a sneezy bouquet of butterfly weed running renegade through the alfalfa — but these fields that constituted the farmers' only wealth in our neighborhood were viewed by us kids

as the empty spaces between precious wild woodlands. From the farmers' point of view, the woods themselves were wasted land, usually left standing as woodlots because they were too steep or creek-riddled to plow efficiently. But we saw the world otherwise. We waded through alfalfa and skirted around bored cattle to get to the real places: damp groves smelling of humus and earthworm industry, rich in the pecky music of birds seeking forage.

In this cool shade I found my first jack-in-the-pulpit preaching his springtime gospel of life everlasting to a wide-eyed congregation of creek frogs. In these woods I found and consumed my first — and hundredth — wild pawpaw, a fruit that few people have tasted because it can't be transported, only pulled from the branch and licked from the fingers like a handful of rich, banana-scented custard. We found half-buried in the banks of these gullies the bones of dead animals we imagined to be buffalo, or mastodons, though I'm sure now they were only the weathered remains of cattle that had strayed from neighboring pastures years before, to expire from some lackluster cow ailment. But that possibility did not cross our minds at the time. We were too rich in love for life to suffer thoughts of the mundane.

We invented the wildest possible stories about what we found. We tried hard (without ever quite succeeding) to get lost, so we might be sorely missed by our parents and perhaps celebrated with funerals we could go back and spy on, as Tom Sawyer did. We packed sandwiches and extra socks and ran away from home *forever* on the slightest provocation, though our mothers knew to expect us back by dinnertime. We crouched and stalked and were thrilled by the sight of any wild animal we discovered: Occasionally, we'd catch the black-tipped whisper of a fox sliding through

tall weeds; more commonly we'd startle up a groundhog who'd waddle fatly to the next nearest shelter, undulating in her haste. In every case, we ached to possess what we saw, just as Henry Thoreau did when he wrote, "I caught a glimpse of a woodchuck stealing across my path, and felt a strange thrill of savage delight, and was strongly tempted to seize and devour him raw; not that I was hungry then, except for that wildness which he represented."

We had no idea we were living at the edge of an epoch, tasting the wild remnants of a great, newly plowed continent — a species of experience that most of the world's children in this era can find only in storybooks. We knew just enough of our world to eat it alive, swallowing wildness by the mouthful, our hearts trembling with gratitude. We tasted the soft green stems stripped from tall grass stalks, like new asparagus. We picked blackberries that stained our tongues and colored our insides, we imagined, with the juiciness of July's heat. We ate cattail roots and wild onions and once captured a bucketful of the crayfish that scrabbled through the creek. We boiled them over a creek-bank campfire and sucked our puny feast from the cracked pink shells, declaring ourselves the equals of Davy Crockett and Pocahontas. Years earlier, when I was a less competent hunter-gatherer, I remember delicately tasting even moss and mud, so intense was my desire for union with the wildness of the woods.

Most of all I remember lying on my back in summertime, staring skyward through the leaves with my head resting on woody roots that were the bunioned feet of a particular old maple. It would be years before I learned the words xylem and phloem, but I didn't need them yet, for it seemed to me I could feel the earth's amber nurture moving up through me from roots to branches —

the same stuff that would flow downward again in late winter and that we would sometimes steal, drip by drip, into our maple sap bucket. I could taste its sweetness with my fingertips as I lay beneath the tree. Clouds and birds slipped through the blue spaces between leaves as I looked up through them for what seemed to be hours, or magically concentrated years. It felt like flying, or better yet, a breathless suspension in a living world that had bigger things on its mind than gravity.

Even now, in every season, there comes a certain day with a scent on its air or a birdsong needled through it like a silver promise, some germ of evidence for a life beyond my own that calls me out the door. When I can't resist any longer, off I go, heading for someplace where I can participate in a conspiracy of forest or desert, giving thanks that I may still seek out some wild corner that hasn't yet been tamed. I go with a single precious hope between my teeth: That my children, and theirs, may grow up to inherit something of this world I have been lucky enough to love.

In the wild places that call me out, I know I'll recover my wordless childhood trust in the largeness of life and its willingness to take me in — the stuff of my ancient desire to taste moss. That generosity seems to lie in wait in any wild place I may go. It found me in the Arctic, where my own sleepless energy rose to meet the riot of flowering and courtship dances proceeding without cease even at midnight under the midsummer's sun. But it also lies waiting for me a hundred paces from my back door, at the edge of a creek or among the wooden toes of a tree. It will come to me as I sit still watching ravens, my favorite bird, the only animals I know that will routinely go out of their way for the heck of it, looking for fun. I've seen ravens perform barrel rolls in the air or dive suddenly toward the ground, purely for thrills. It's easy to let an hour slip by while watching a small congregation of

them on the ground, fussing, and laughing, displaying different gaits in a hilarious competition to amuse one another — one trotting with a leg forward like a child imitating a horse, another hopping two-legged and flat-footed, exactly as I have seen a rooster progress across the yard right after becoming deprived of its head. But these big black corvids retain all their faculties and rule any roost they choose.

In times like this it comes to me, the folly of what we're doing on the face of this world: behaving as if it were ours, utterly. And I wonder at the arrogance of the agenda we've inherited from our forebears. What would a raven think of our notion that he is only here to serve our needs for food or a feathered cloak or, at best, our hunger for beauty? What would a raven care, really, if we were all to remove ourselves tomorrow to some other planet? Most likely, he'd be relieved. He does not need us, except insofar as he needs us to refrain from destroying every forest, tundra, or canyon in which he might make a home. He needs us to stop behaving as if that program of steady destruction were our only and ultimate aim. Perhaps he hopes we will soon think of some other plan.

When my European ancestors first stepped on the great patchwork quilt of interconnected wild habitats that we now call the United States, it seemed to them endless. It fairly roared at them with infinitude. What they made for themselves — and us — on this land during the next two centuries took an enormity of courage and industry and a firm belief in something they understood to be God's mandate and guarantee: the promise that the living land was nothing more or less than raw material for human increase. They'd arrived here with no spiritual capacity to see nature as anything else. A different way of thinking — the belief in the sovereignty of other creatures with their own

spirits and plans, quite separate from ours — was familiar to the people who had come into North America millennia earlier. But for the pragmatic Europeans who succeeded and largely displaced them, this kind of thinking stood in contradiction to their religious beliefs and firmly outside the well-fenced boundaries of their imaginations.

That is, it was so for all but a few. Surprising as it seems, every era of our history has brought forth at least a few Americans who could see far beyond their time on the matter of wilderness conservation. These people were not eccentrics or heretics, they were simply gifted with a longer vision. As early as the 1760s, when we were still a colonial outpost, the devout Quaker and dutiful son William Bartram dipped his canoe paddle into the uncharted swamplands of southern Georgia and Florida, which most people of his time viewed as a mosquito-infested curse. But Bartram spent years observing the wild profusion of species in those swamps, and the peaceful people who coexisted with them, and he came back with descriptions of this new Eden that would hold poets and scientists spellbound for decades to come.

In the middle of the next century, as our nation became more settled, Henry David Thoreau walked away from what most of his peers thought to be the necessary comforts, as happily as a raven diving off a cliff. He went to the northeastern woods to live deliberately and simply, to learn appreciation for the wildness that burgeoned around him, and to find a better way to think about being human. A few decades later, toward the end of the 19th century, John Muir explored the opposite edge of the continent — the only part of it that was still wild enough to suit him — and foresaw the need to call together kindred souls who would work to save what remained of our wilderness.

Aldo Leopold picked up the thread of that hope in his early 20th-century lifetime of writing, teaching, and understanding his prairie-and-woodland home. In lyrical language informed by the nascent science of ecology, he gave the world a new way of thinking about the interface between time, sunlight, tree rings, and feathered wings. That story continued through the latter half of the century when a grizzled writer named Edward Abbey (who could, fairly enough, be called eccentric and heretic, as well as prophet and visionary) planted his feet on the gorgeous, ravaged southwestern desert and burned her face into the nation's heart and conscience with his prose.

Countless other Americans have shared a passion for our wild landscape and a commitment to its preservation, and many of them have altered history. Rachel Carson's tireless work, in particular, salvaged a vast legacy that was nearly lost to us in a close shave with poisoning the world irretrievably. Half a century after Carson's death, we're still unraveling that complex story and are more stunned each year by the scope of the disaster she helped avert.

But the wide-ranging nature writings of just these five men — William Bartram, Henry David Thoreau, John Muir, Aldo Leopold, and Edward Abbey — stitched together, make for a fascinating alternate draft of our past two centuries on this continent. In their version of the story it's possible to sense the presence of a natural world that proceeds by its own rules, for its own reasons, apart from any measure of utility to human need. It's also a heartbreaking story of what could have been — the green water palaces and redwood cathedrals, passenger pigeons and nations of whales we still might know, if people then had been more ready to listen. These five naturalists intimately studied the wild places they knew and argued eloquently for their preservation. They were lone voices in the

wilderness. The lands they loved have continued to diminish in size and vigor throughout the decades in which they lived.

Today, precious little of our continent remains as it was in Bartram's time, unaltered by development. What does remain is not all of a piece but piecemeal, scattered like buckshot across our map in specks and ragged fragments, very much like those woodlots of my childhood that fell between the useful fields. The wildlands that remain to us are surrounded in some quarters by officially protective fences, and in others by shopping malls or subdivisions. Our parklands deserve our devotion as, increasingly, even these remnants are threatened. But a great deal of America's remaining virgin land lies outside their protection, in bits and pieces that have managed by unofficial means to persist unscathed through a century and a half of Manifest Destiny. Some escaped destruction purely by accident, not because they were striking or grand but because they were over-looked: Their ownership was uncertain, or they were just too bony and recalcitrant to pave over or plow under. As it turns out, they were history's small acts of grace, now left to us as refuges of wilderness where once plentiful creatures now survive in quiet scarcity. Here, in these lost corners, are the reserves of species abundance and strength for a continent that once roared with wild grandeur; they are its swan song. This book is about them.

We chose to organize the book not by geographic regions, designated as such categories are by the lines we draw for political and economic reasons, but rather by habitat type. Biologically speaking, the Mojave Desert of California has more in common with a desert in Arizona — or for that matter in Asia — than it shares with the rain forests or coastal wetlands that also happen

to be part of the huge area we call by the name California. Habitat zones reach across distances great and small to create with all other ecotypes of their kind a powerful biotic resonance. In presenting that resonance in these pages, we hope to suggest natural truths about how these habitats interconnect, placeless and timeless by our own measures of those concepts. We may look at a map of our land-mass and see something that began in the year 1776. But from a forest's point of view, it began as the glaciers of the last ice age receded, and the story goes like this: There was a long morning of silence, interrupted suddenly by a crash. Our own energetic beginnings here have brought down an end. Our continent is making its last stand.

These wild remains will continue as they are, or they will fall. Their fate is not sealed, just because we know enough now to recognize their irreplaceable value as refuges for endangered species — far from it. We're still in the throes of a heated debate over whether or not any species but our own possesses the inherent right to live and carry on.

The debate gets noisy at times, but we humans — as is natural for any species — like to listen mostly to the sound of ourselves talking. The other side of the story is quieter: a tale of whispering marsh grasses, ground doves, bristlecone pines. That story ends with a question mark — and unfortunately, perhaps, for the doves and pines, it's only ours to answer. Our task is to convince ourselves that wildness deserves to persist, not because of what it can give us but simply because of what it is. Because it was here first. Because life, by definition, is its own reason for being, and the only justification it needs. Because we ourselves arose ultimately from the rich mud-scented cells of the fecund earth and now must fight our adolescent urge to destroy the evidence.

One chapter of Edward Abbey's masterwork, *Desert Solitaire,* describes his poignant raft trip through Glen Canyon, Arizona, as one of the last people to navigate that exquisite red rock sister to the Grand Canyon before a dam buried it forever under mud. He walked up one narrow side canyon after another, contemplating sights that would never again come before human eyes. "Alone in the silence," he wrote in his journal, "I understand for a moment the dread which many feel in the presence of primeval desert, the unconscious fear which compels them to tame, alter or destroy what they cannot understand, to reduce the wild and prehuman to human dimensions. Anything rather than confront directly the antehuman, the *other world* which frightens not through danger or hostility but in something far worse — its implacable indifference."

It's true, it almost seems to rebuff us, this mountain-and-cavern magnificence we call nature. The raven at his games gives me a cool black glance and wishes I would go away. The dove building her nest outside the upper corner of my study window will never read the books I write at the edge of her domestic scene. We'd like to be loved in return, maybe — but that is to fall short of knowing our place. By the rule of biological law, the living world possesses us, not the other way around. It will embrace us in its water and nutrient economy to give us food and oxygen enough to reproduce ourselves, the only mothering life really requires, but for more than that — for the stories of creation and eternal life that give us cause for awe and self-explanation — it will give us just what we're willing to work to find. Otherwise, it could live without us.

And we could live without wildness; that's also true. We could get along, at least for awhile, with far fewer species in the world than we have now: Three grains, some legumes and a tuber, plus

three animals, provide the great majority of our food — and would feed us indefinitely if we could suspend our interest in flavors. The cotton plant and sheep give us our clothes, and there are petroleum alternatives. Medicines, more each year, are derived from newly discovered plants, fungi, even bacteria — but maybe we have enough medicines already. The microbes and pollinators that support our food system are also great in number, and their contributions to our survival are only beginning to be understood, but perhaps as we lose these we will engineer our way around them.

What's the point of so many species? Who needs caribou? Who cares that herds of them once darkened the tundra like a storm cloud across the firmament, that they fed on exorbitant lichens, that their pelts had hollow hair shafts that provided a uniquely warm blanket for those who needed to use them — beginning with the caribou themselves. We could do without this world of ours, overstuffed as it is with beetles and brambles, nightingales and nightjars, a million and one uniquely adapted species and the terrain that sustains their livelihoods and miraculous reproductions. We could set our souls in steel and cement and try to forget what Thoreau meant by "lives of quiet desperation." We could construct for ourselves a soilless home where food would come from a hydroponic universe of measured, sterile nutrients, where clothes never get dirty, where children's adventures and glimpses of fox dwell only in books, and where the taste of moss and mud are a distant history, or an inexplicable dream.

We will do it, if we can't find in ourselves the grace to do otherwise. I only hope I will never know what kind of life that would be.

Wetlands

(Overleaf) *Morning fog on Yellowstone River* / NORTHERN WYOMING **23**

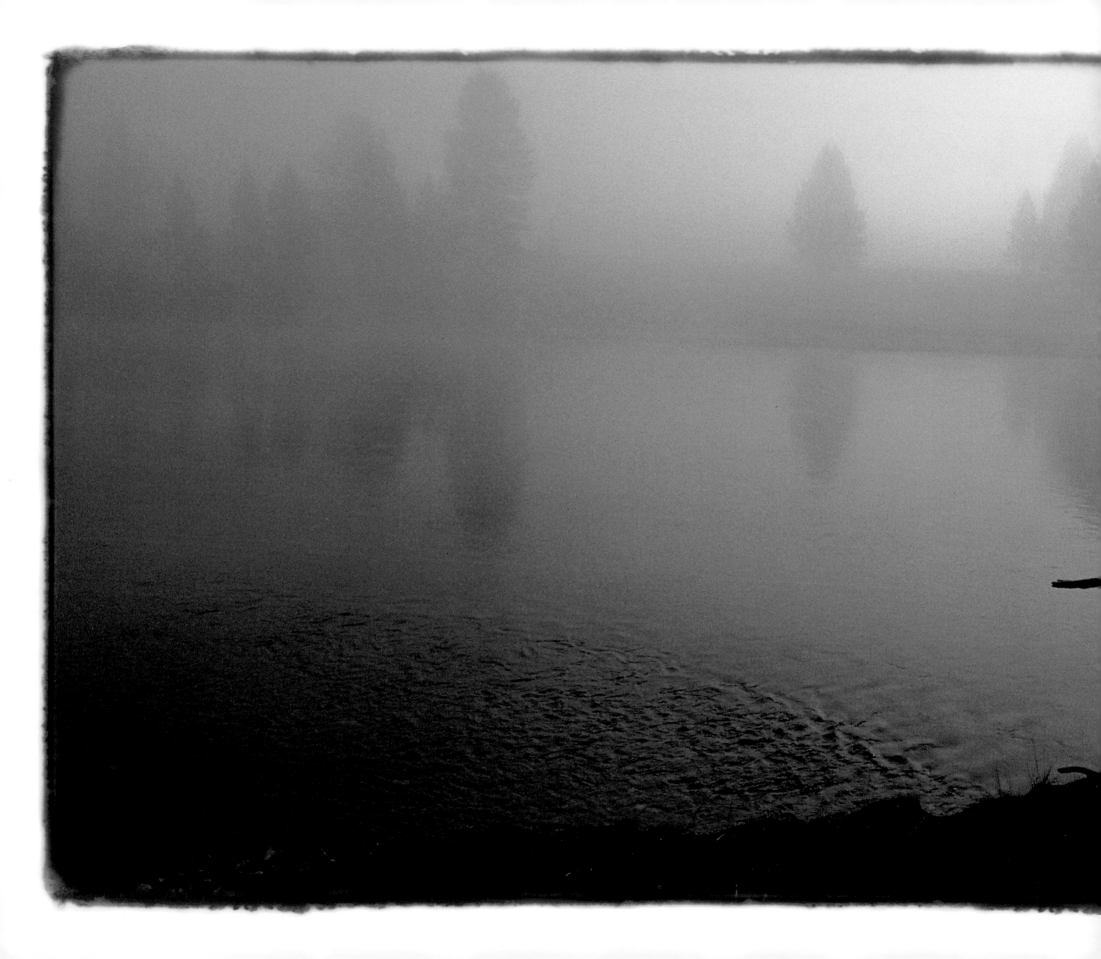

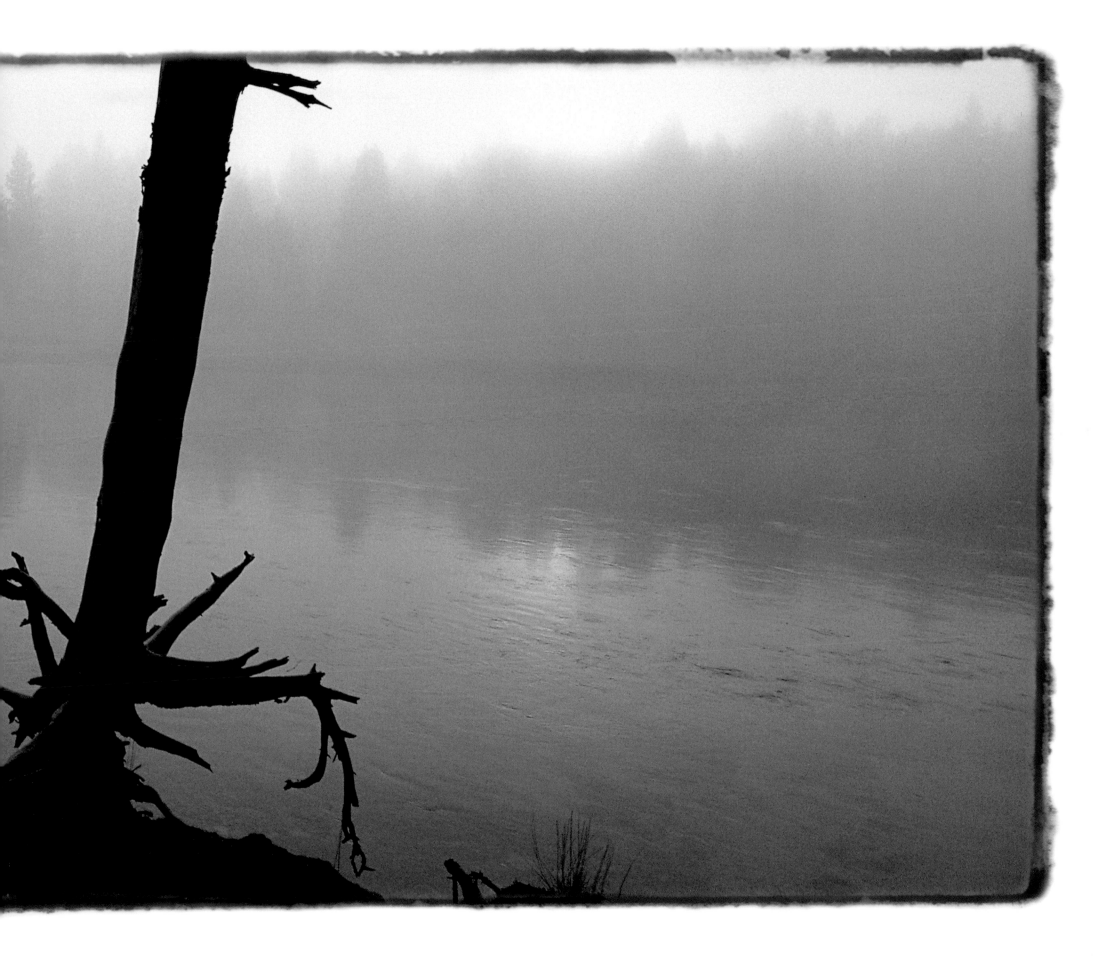

The alligators were in such incredible numbers....it would have been easy to have walked across on their heads....

WILLIAM BARTRAM

Alligators and wood stork / CENTRAL FLORIDA

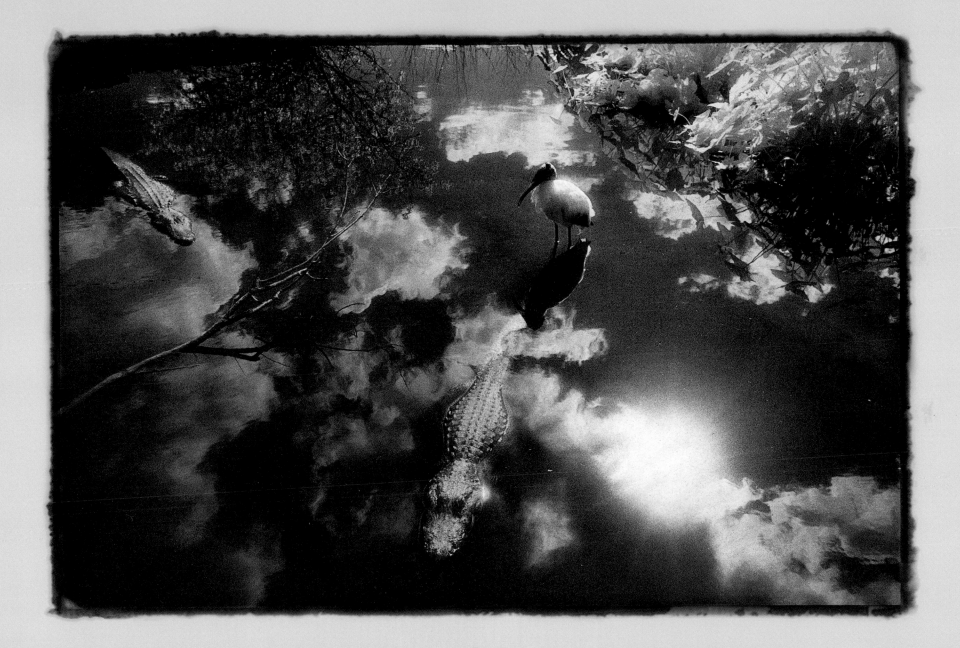

Water is the blood of a land. It courses through the internal seams and passageways of a continent, cleansing and carrying nutrients to all its farthest reaches, from the mountaintops to the deltas. Water defines the boundaries of life on Earth in every range — in bogs and forests and even, especially, in deserts.

Still waters may run shallow or deep, but they hold the roots of floating marsh plants in undulating, upside-down forests that create the complex filtering system of a swamp. A river contains the chemical vocabularies that drive the intricate plot — as heartrending as any novel — that is the life story of a salmon. Water is ancient and endless: The immortality of molecules, the originality of a tadpole, a history of the world in the eye of an alligator. Beneath all else, water is the thing we cannot live without.

And yet, from a biotic point of view, the history of our own enterprise on this continent is the tale of a relentless bloodletting. Southern marshes were drained to make new croplands. The seasonal rise and fall of a slow, riparian pulse was stanched with dams. The opening of the American West was a story of water claimed, then conquered, as the needs of ranching and agriculture called for aquifers to be tapped and rivers to be channeled for irrigation. Subsequent desires for power and more arable land set dams across virtually every western river, putting strangleholds on the vital ebb and flow of aquatic communities. As we've turned our continent's veins to the work of transportation, power, and the removal of waste, we have gradually forgotten that water once had a life of its own.

In some deep lagoons and watery preserves, it still does. Here memory returns in the blink of a half-submerged eye, as egg masses stir and reptilian limbs slowly recapitulate the story of life on Earth. Beneath the sway of duckweed and water umbel, the endangered Huachuca leopard frog calls from underwater. Zooplankton swim toward the mouths of their predators, beginning a chain of provenance

that ends in the farthest reaches of land and sky. The unique plant communities of wetlands provide spawning and nursery habitat for aquatic life, cover for nesting waterbirds, forage for life-forms without number. Marshes transform the elements necessary to life, dissolving nutrients from decayed organic matter, infusing the land's bloodstream with new vitality. They retain and remove pesticides and other toxins from the nutrient cycle, maintaining water quality downstream, their retention of carbon reducing global warming. The capacity of wetlands to store surface water is key to flood control and moderates seasonal stream flow between rainy and dry spells. Where nature is inconstant, wetlands provide stability.

For all these reasons and more, the green world of a wetland contains a natural wealth whose dividends are countless. A biologist or a fisherman — not to mention a duck or salamander — may look upon a wetland and see a biotic gold mine. But historically, Americans have looked upon wetlands as little more than impediments to progress. At the time European settlement began in the early 1600s, the land that would become the conterminous United States contained about 221 million acres of wetlands. In the view of nearly all who saw them, this amounted to 221 million acres of accursed mire, good for nothing but the breeding of diseases and the entrapment of wagon wheels.

Government projects for draining swampland began in the southern Colonies in the mid-1700s, gained momentum through the next century with the westward expansion into the Ohio and Mississippi River Valleys, and proceeded rapidly northward into the Great Lakes region with advances in technology that facilitated wetlands conversion. The drying trend then expanded westward with agriculture along every major river system. The desiccation of our continent persisted well into the 20th century, as the government provided free engineering services to any farmers wishing to drain their wetlands. This movement reached its technical and ideological pinnacle in the hundreds of miles of drainage canals

cut through the Florida Everglades, in a massive undertaking aimed at transforming one of the true wonders of the natural world into a sugarcane monoculture.

And so it came to pass that America's wetlands — the spongy green organs that maintain and purify the blood of our land — were excised from the body of North America, one by one. Less than half their original area still remains. It's difficult for human enterprise to stand back from its urgent agenda and see how the economy of the moment undercuts the economy of eternity, as we eviscerate our golden goose of a continent. As recently as 30 years ago, tile and open-ditch drainage were still called "conservation" under the Agriculture Conservation Program.

As America moved forward with this herculean effort to bleed itself dry, so did a small but growing counterendeavor. In 1934, in contradiction to the overwhelming attitudes of the time, Congress passed the Migratory Bird Hunting Stamp Act — our first important piece of legislation for acquiring and restoring America's wetlands. Gaining ground in American universities at that time was the new science of ecology, which would grow over the next decades into a powerful branch of biology devoted to understanding the myriad interdependencies of species within and between living systems. Scientists in this pursuit would soon offer up evidence of the crucial importance of wetlands.

But centuries before mathematical modeling began to reveal the miracles of nutrient cycles, a few people took a reverence for wetlands on faith. One of the first was William Bartram, a Philadelphia Quaker who continued to believe in the divinity of all creation even after he was stunned by lightning, attacked by alligators, and driven nearly mad by mosquitoes in the course of his travels. His love affair with wetlands began in 1765 when he accompanied his father — the renowned plant collector John Bartram — on the first botanical survey of Florida after Britain's acquisition of that exotic territory.

It became William's most passionate quest to explore the southern frontier, from Charleston, South Carolina, through Creek, Choctaw, and Cherokee lands into the most secret sloughs of the Seminole.

His life's work is recounted in *Travels,* published in 1791 — long before Darwin began work on his *Origin of Species* — but driven by a similar need to catalogue and comprehend the vast animate diversity he'd found in the swamplands of the New World. Bartram's *Travels* provided imagery for the epic poems of Samuel Taylor Coleridge and served John James Audubon as a guidebook when he entered the territory half a century later. It remains a permanent record of the mystery of these lands in their virgin prime, before they began to be drained, even before they became what we call the United States. The first white man to see and describe beauty in this swamp world was befriended by its native peoples and graced by the good luck to survive its many challenges. He lived 46 more years beyond the end of his long expedition, time he used for writing and carefully recording natural phenomena around him: plant life, weather, the seasonal migrations of birds.

"This world," he wrote, "as a glorious apartment of the boundless palace of the sovereign Creator, is furnished with an infinite variety of animated scenes, inexpressibly beautiful and pleasing, equally free to the inspection and enjoyment of all his creatures." He died with no inkling of the drainage canals that would someday slice through that sovereign palace.

His legacy survives in the plants he named and places he described, most of which are now gone, though generations of scientists and poets have followed him in believing the deep black water of a swamp holds the mysteries of creation. We are left with the conflict that surely must have risen in Bartram's heart when he had to beat an onslaught of alligators away from his boat with a canoe paddle: Such a host of strange and hostile-seeming elements can add up, somehow, to a thing we can't live without.

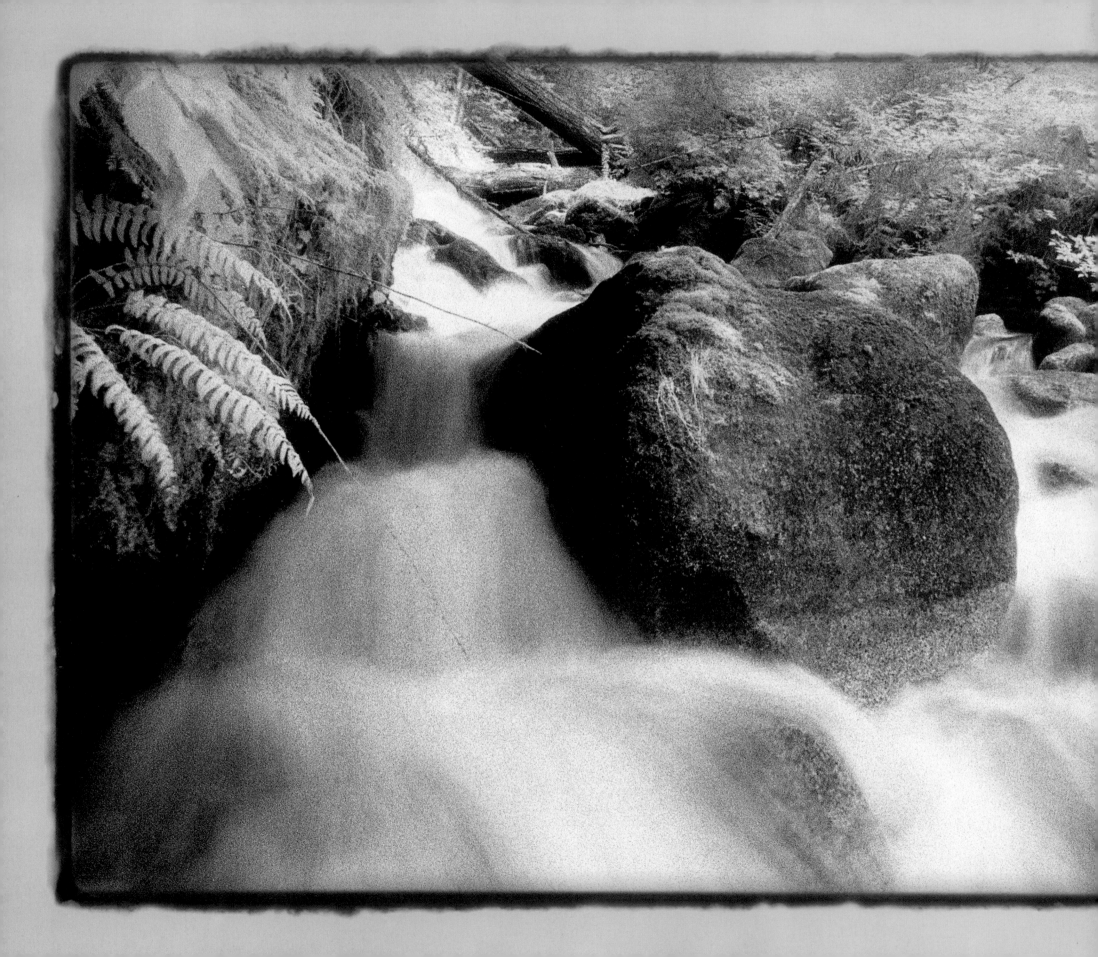

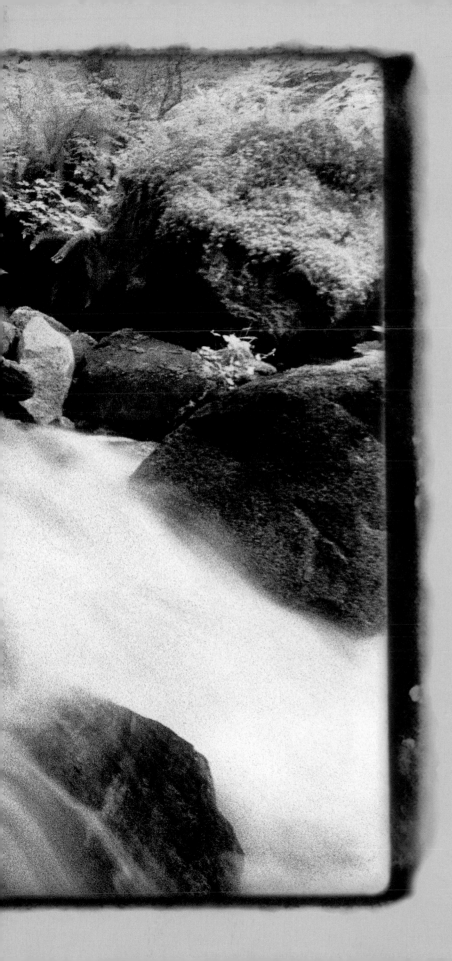

That we were poor made no difference in that beautiful place. The flowers bloomed as thickly for us as for others....

<div align="right">

Dorothy Allison

</div>

Summer stream / NORTHERN WASHINGTON

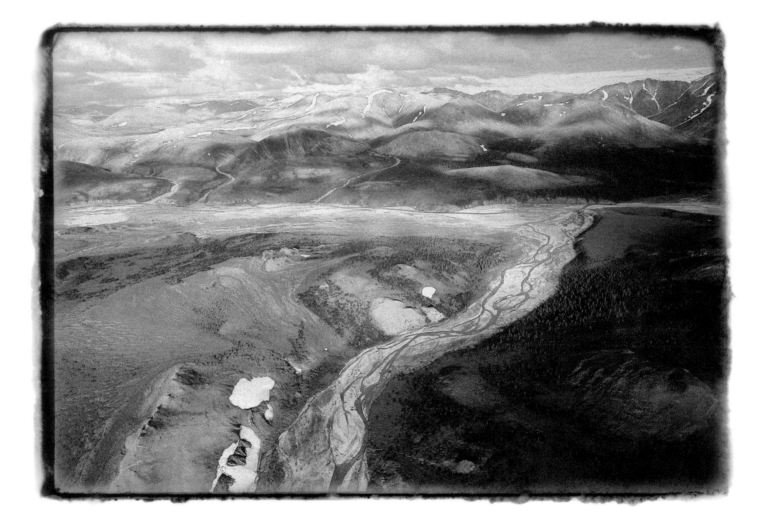

Brooks Range / NORTHWESTERN ALASKA

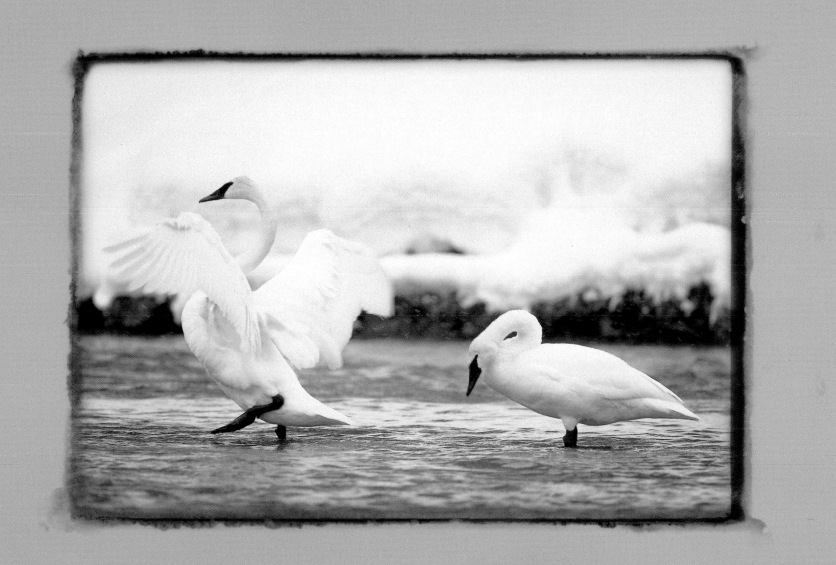

Trumpeter swans / NORTHERN WYOMING

Migratory butterflies / CENTRAL ARIZONA

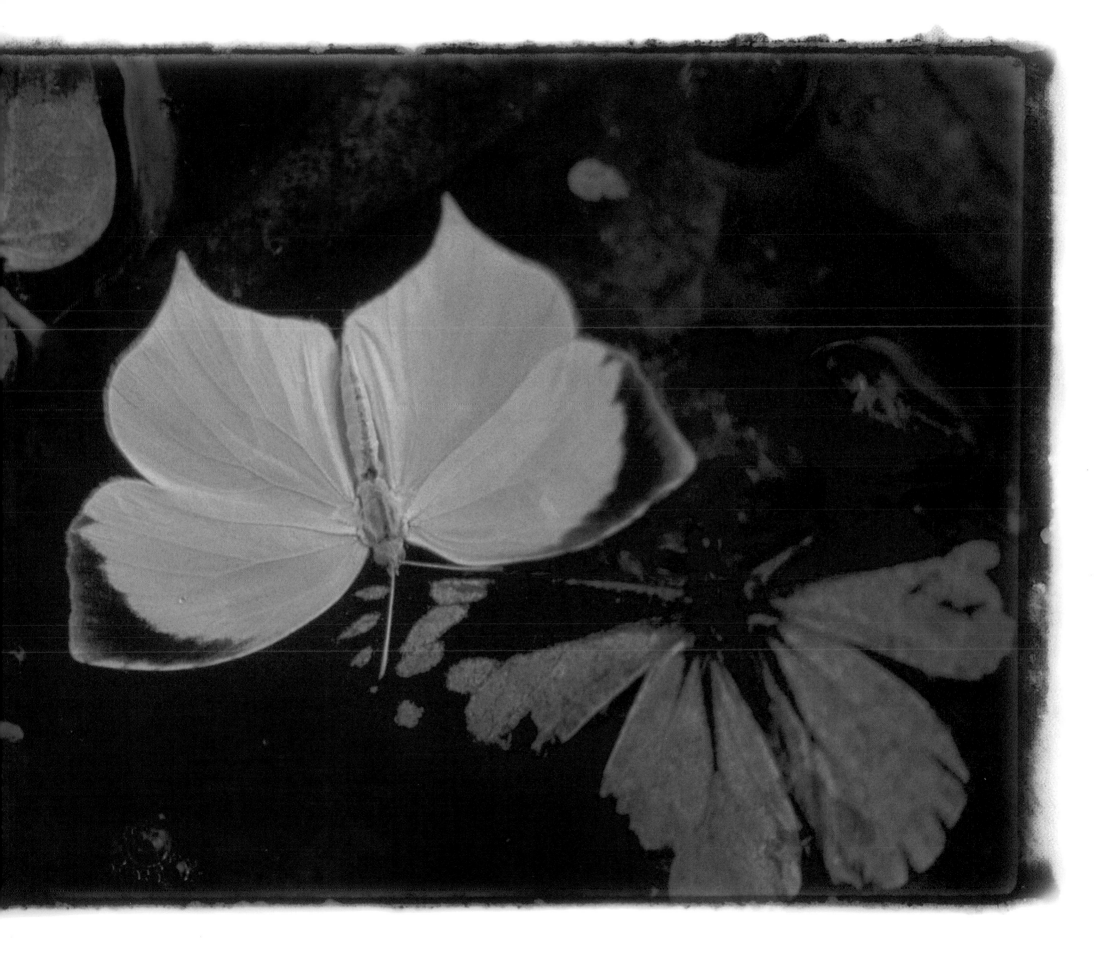

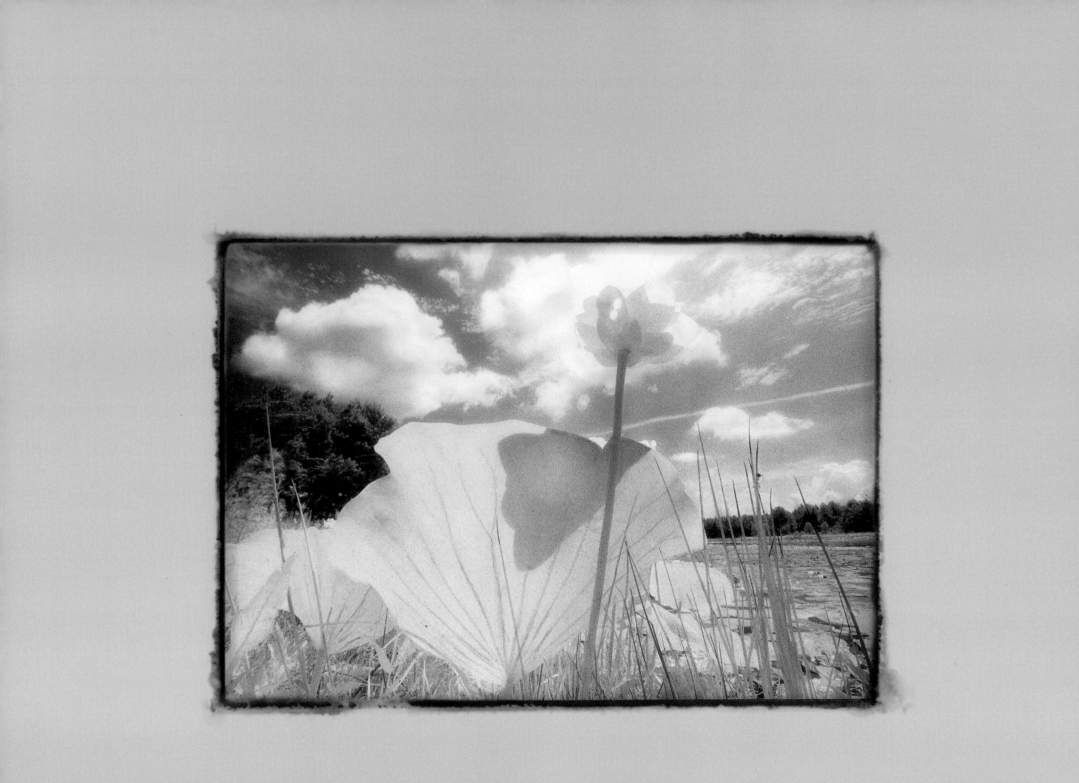

Flowering lotus / EASTERN GEORGIA

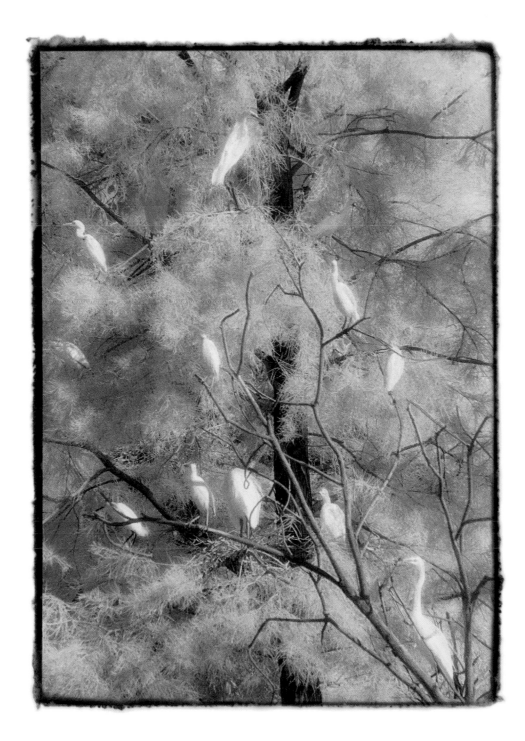

Egret rookery / CENTRAL FLORIDA

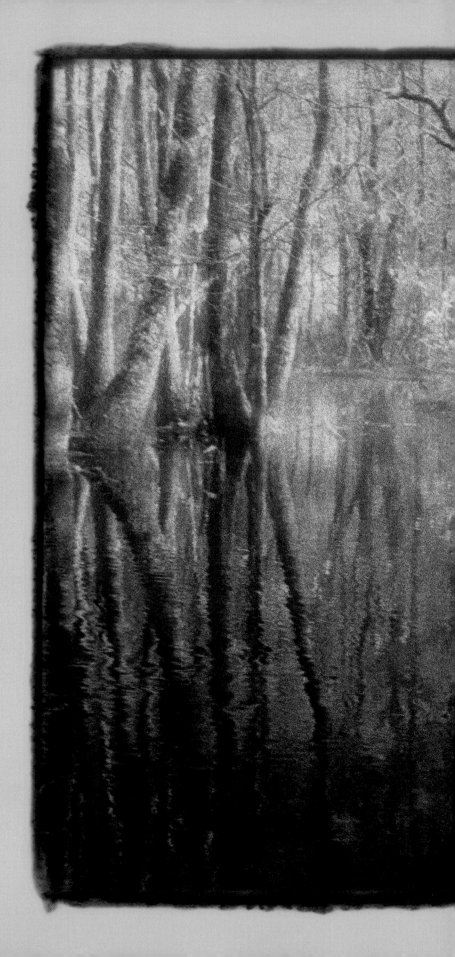

...Perfectly black, soapy, rich earth... this is the heart or strength of these swamps.

WILLIAM BARTRAM

Cypress swamp / NORTHERN FLORIDA

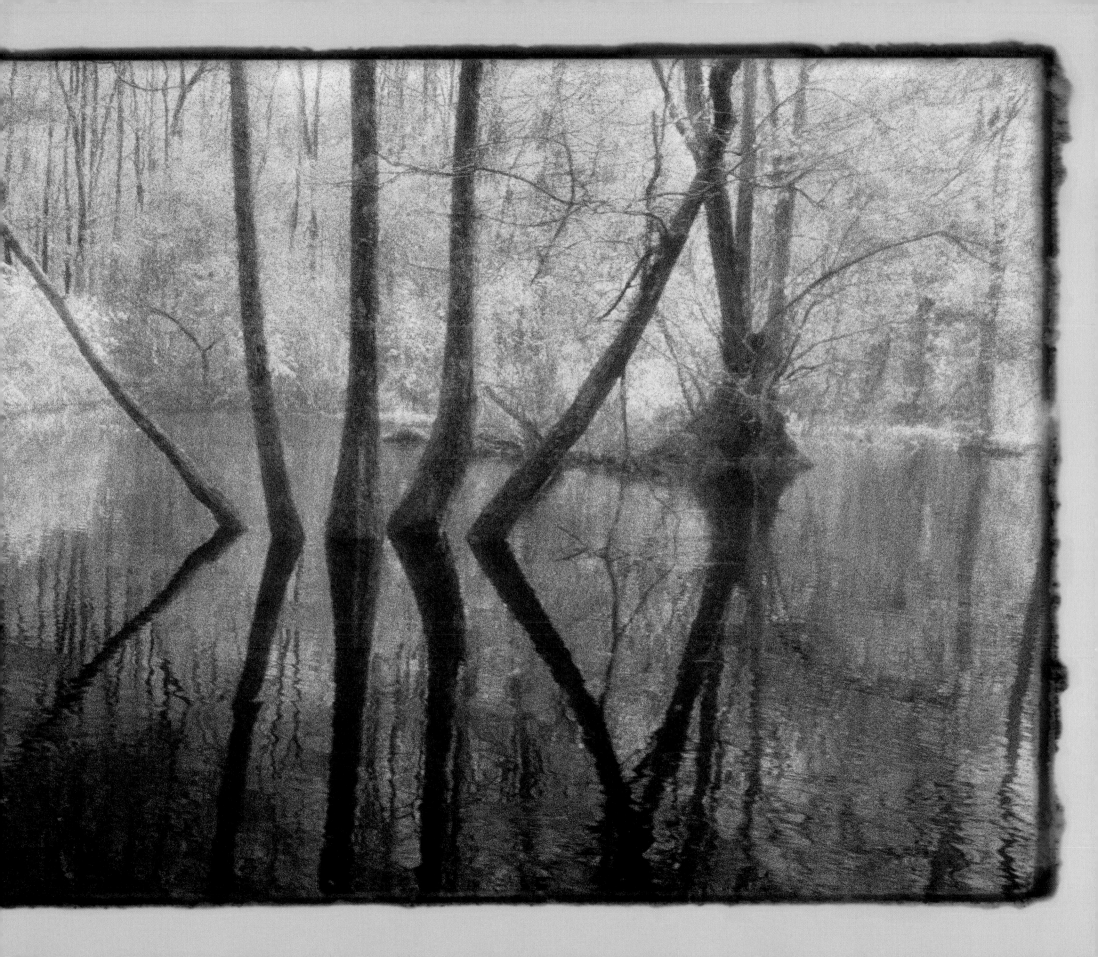

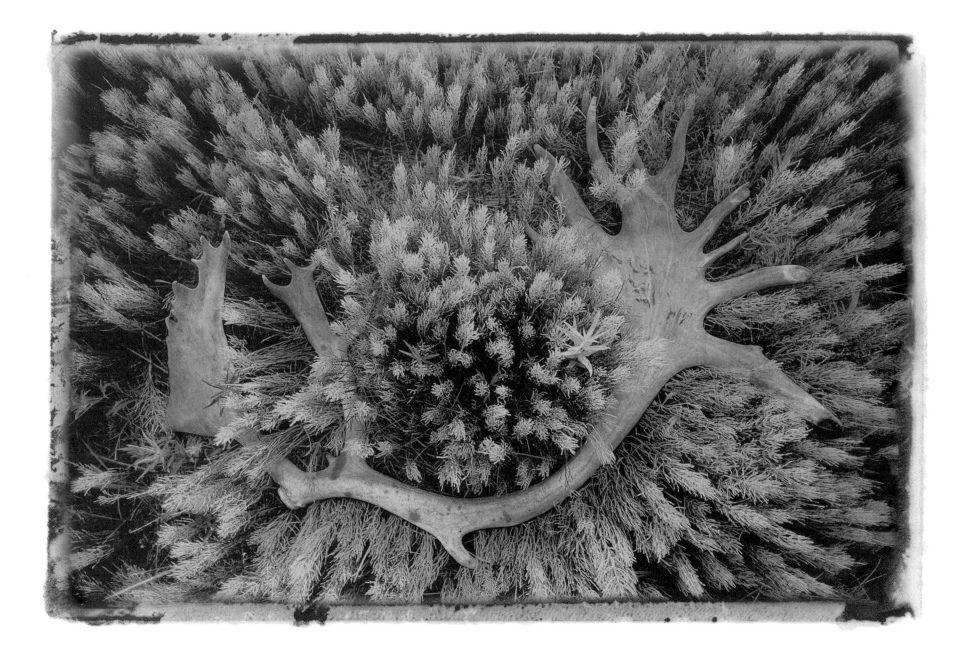

Caribou antler / NORTHWESTERN ALASKA

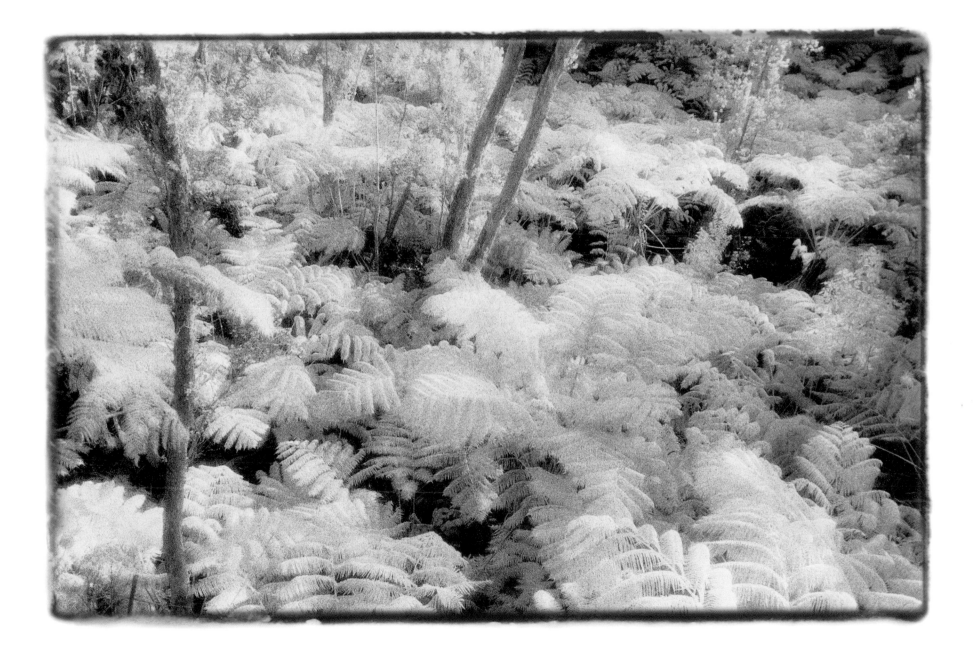

Giant tree ferns / BIG ISLAND, HAWAII

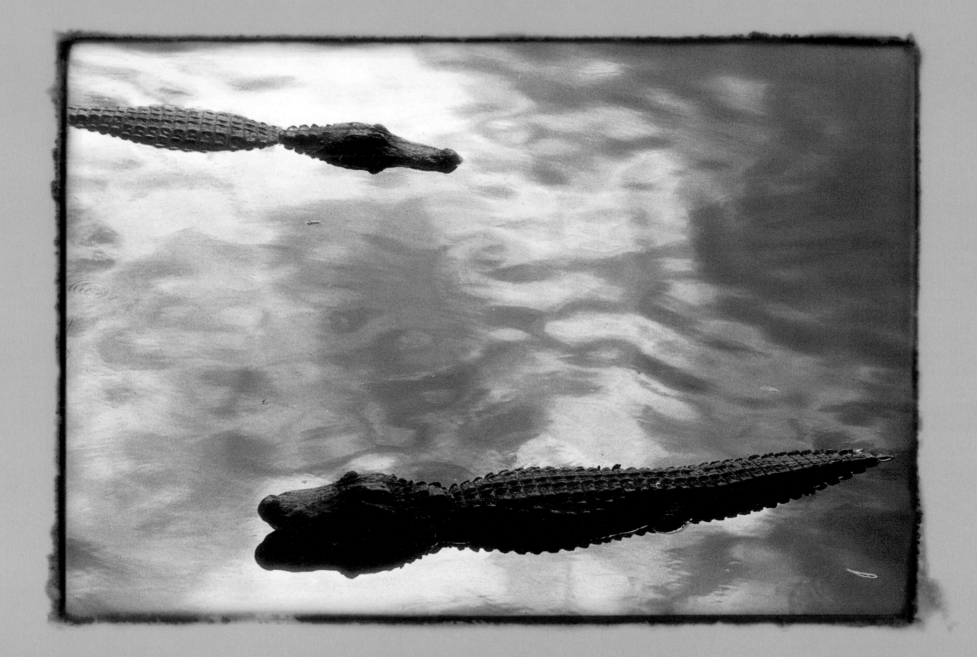

And I find myself being mentored by the land once again.....Even in winter, these wetlands nourish me.

TERRY TEMPEST WILLIAMS

Alligators / CENTRAL FLORIDA *(Overleaf) Boundary waters* / MINNESOTA / ONTARIO

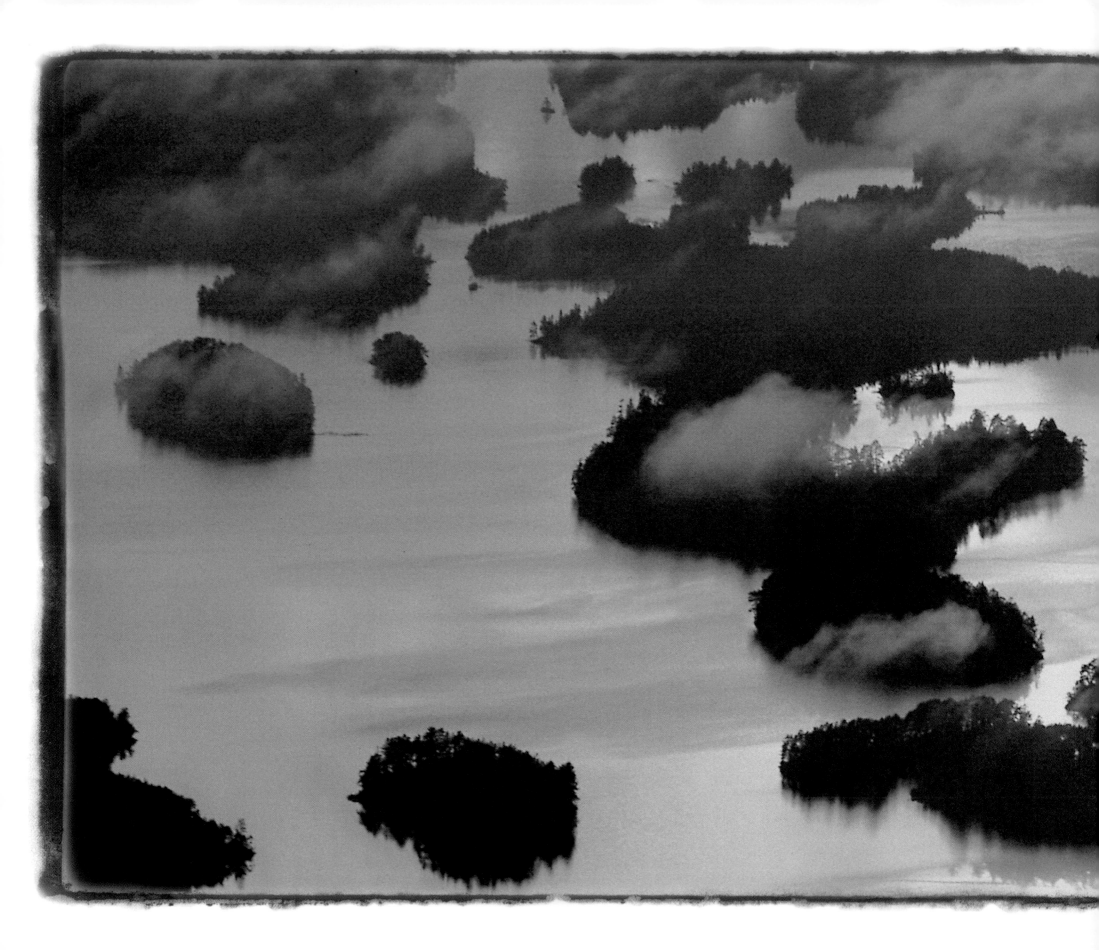

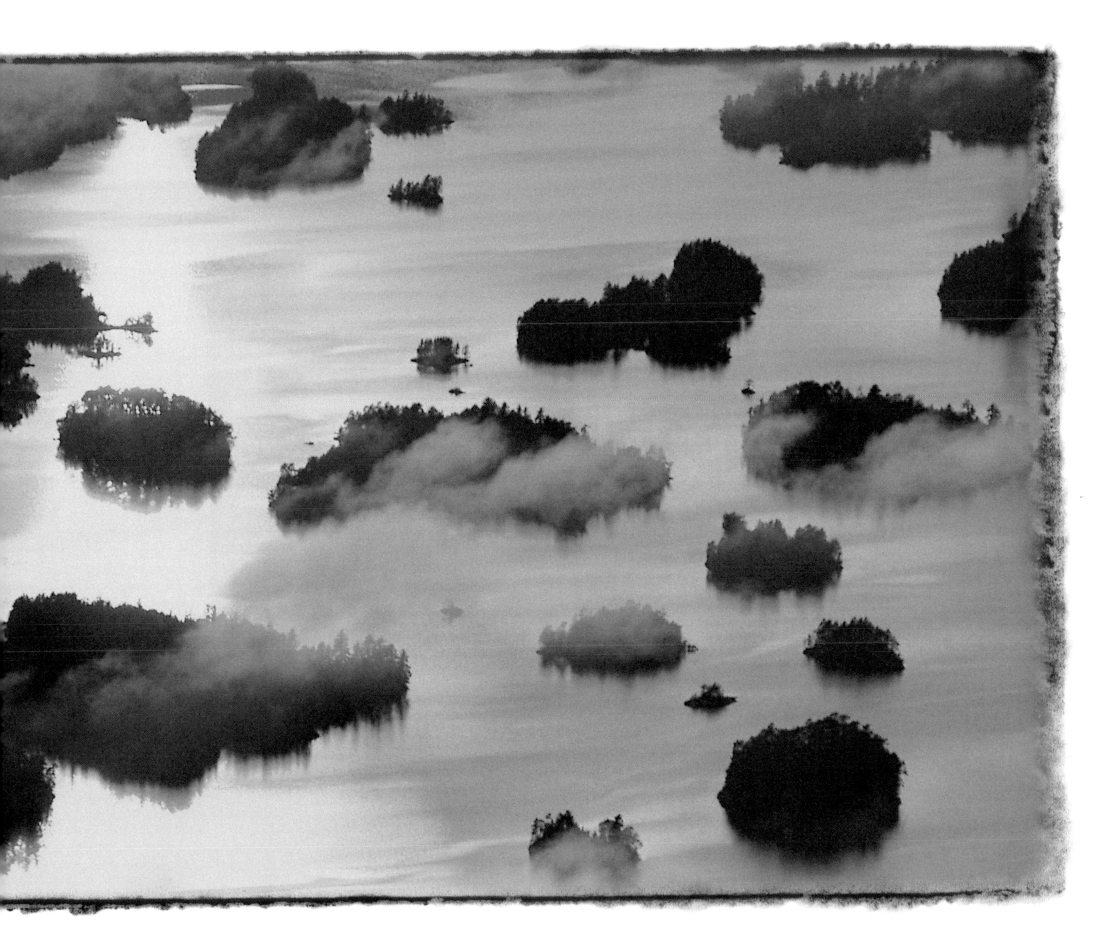

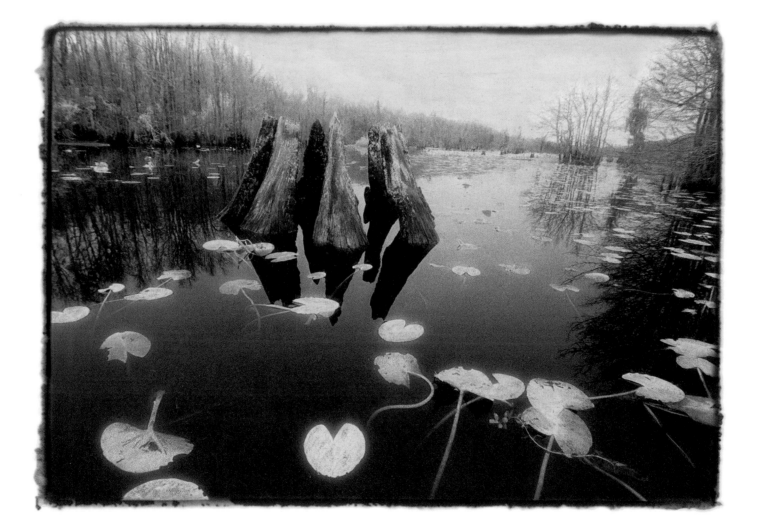

Lily pads / NORTHERN FLORIDA

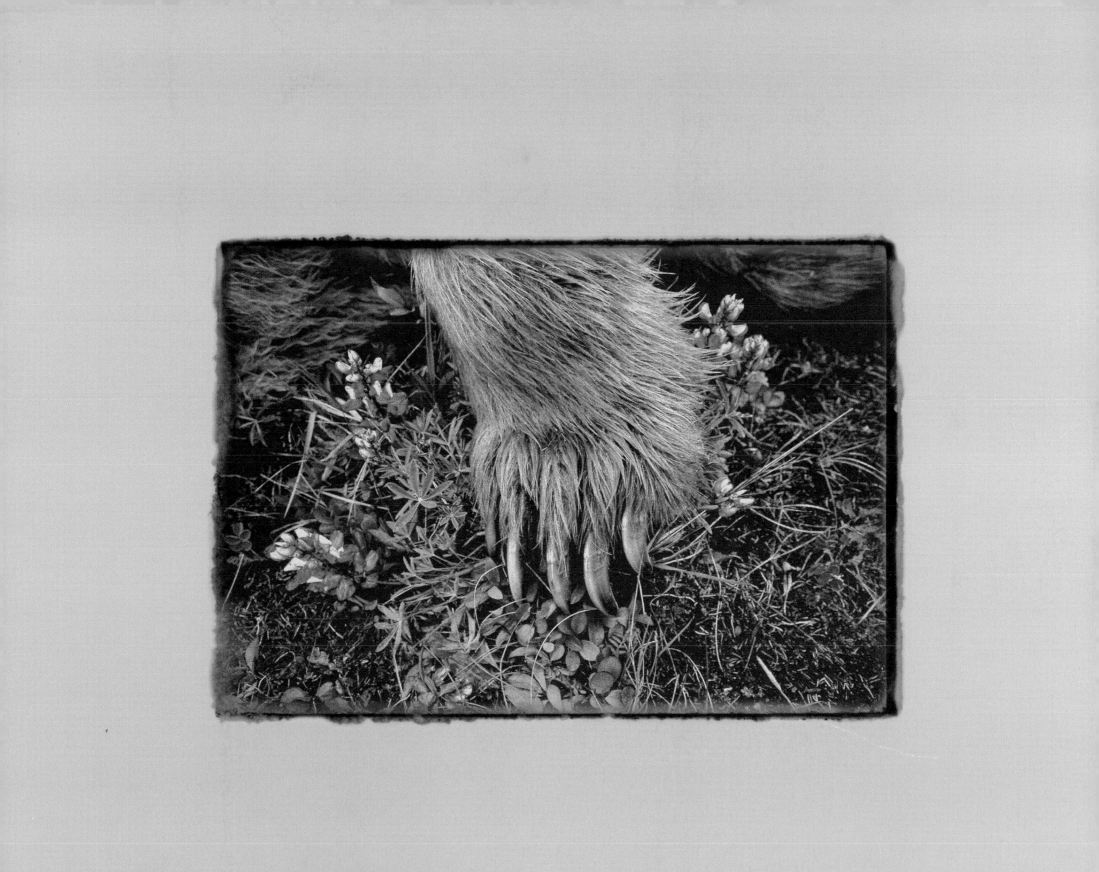

Grizzly paw / ALASKA

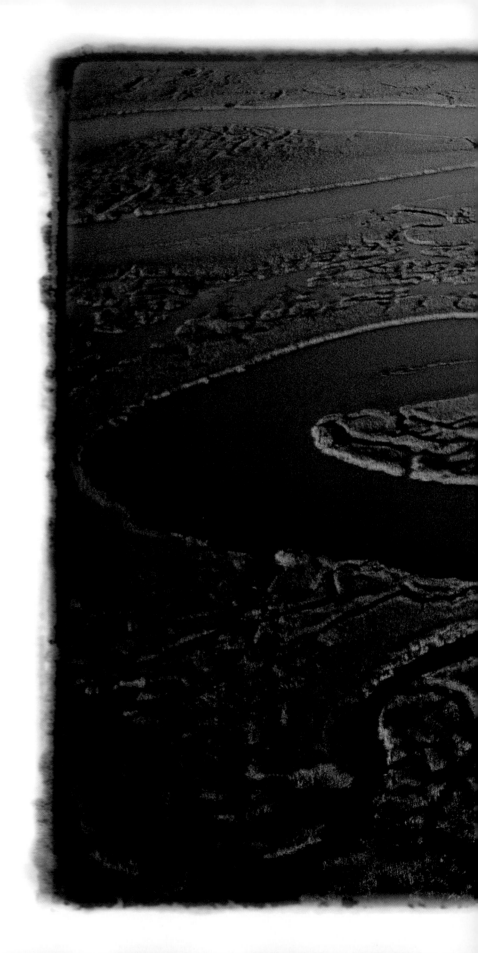

Salt marsh / SOUTH CAROLINA

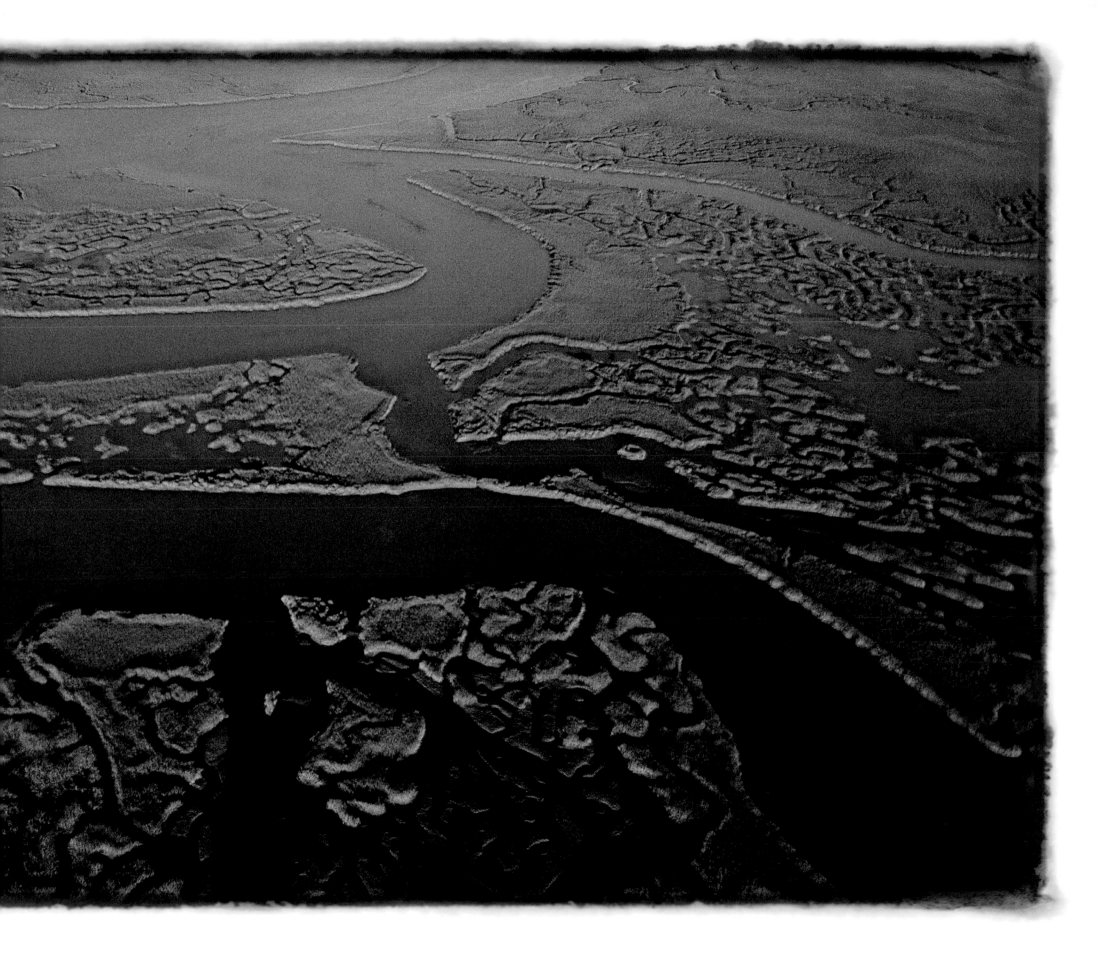

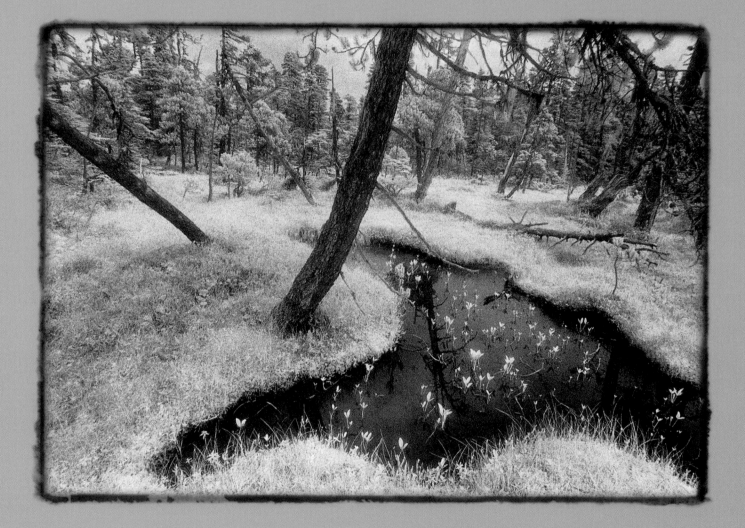

Muskeg / SOUTHEASTERN ALASKA

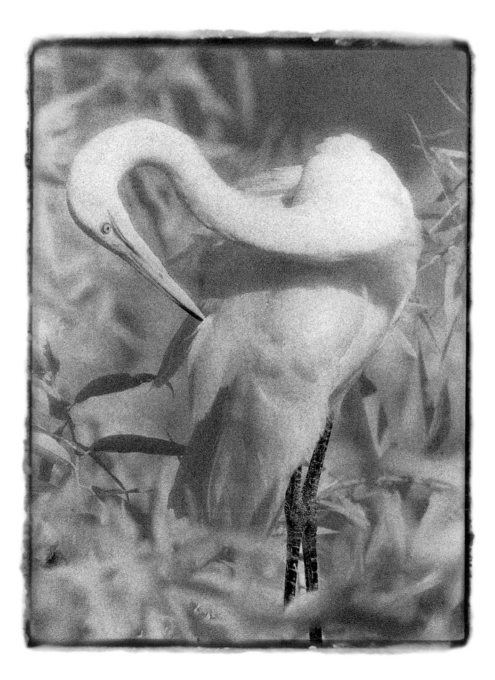

Great egret / CENTRAL FLORIDA

These swamps are daily clearing and improving into large fruit-ful rice plantations....

WILLIAM BARTRAM

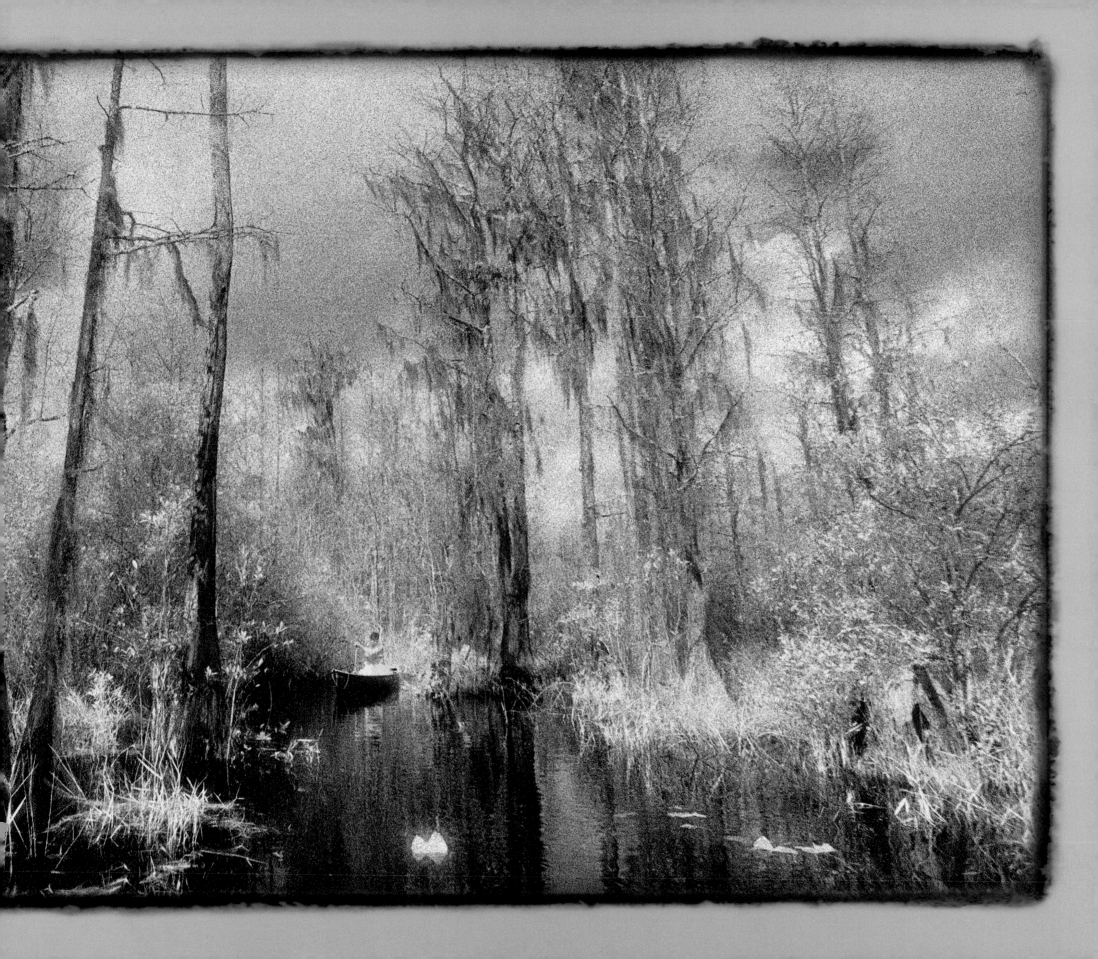

Woodlands

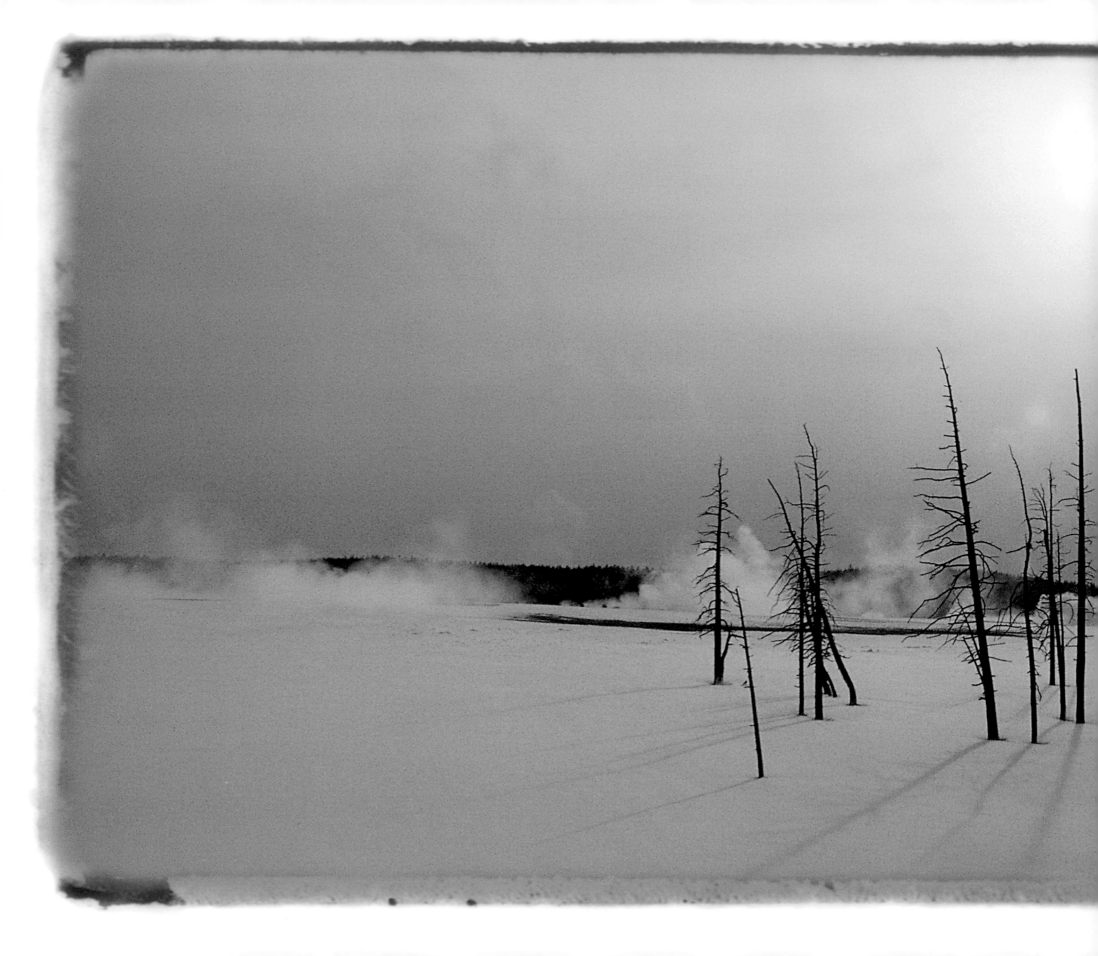

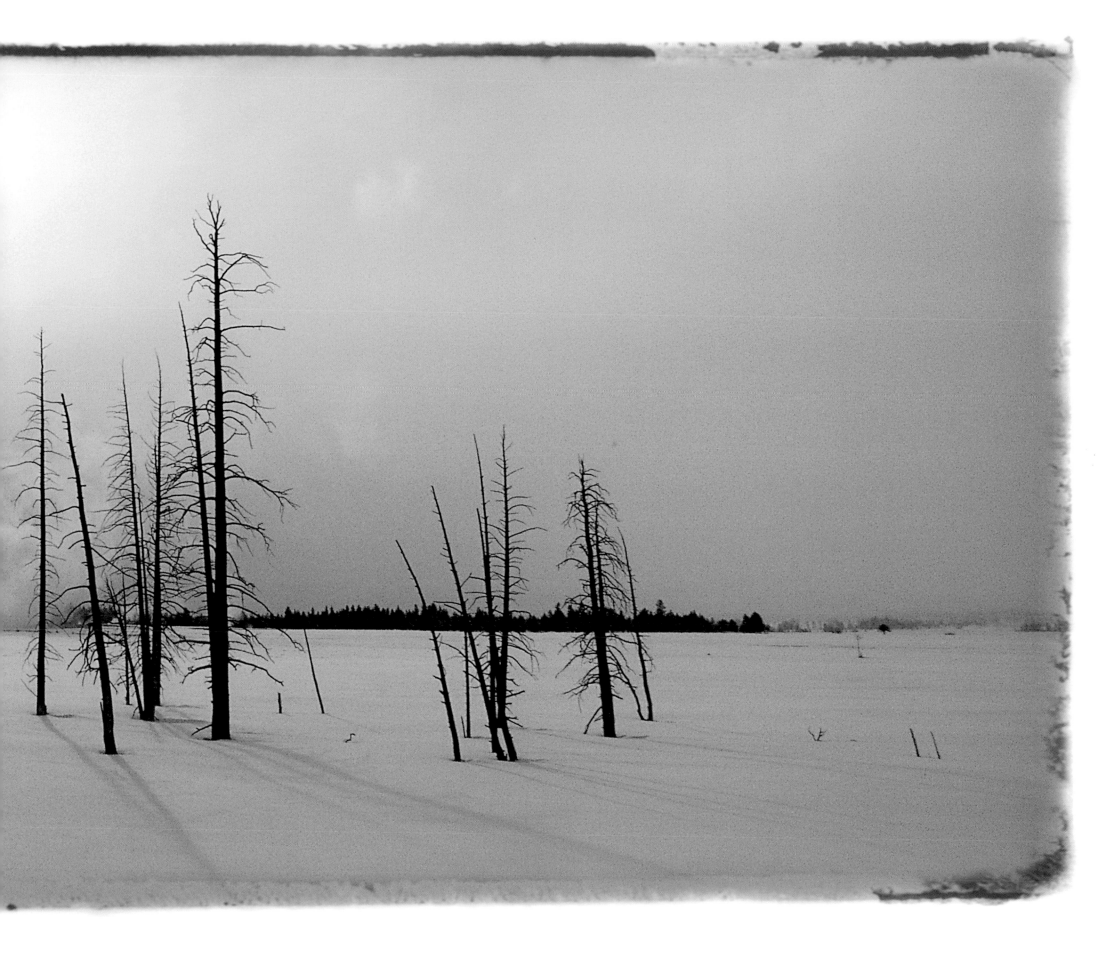

Shall I not have intelligence with the earth?
Am I not partly leaves and vegetable mould myself?

HENRY DAVID THOREAU

Wind-warped live oaks / GEORGIA BARRIER ISLAND

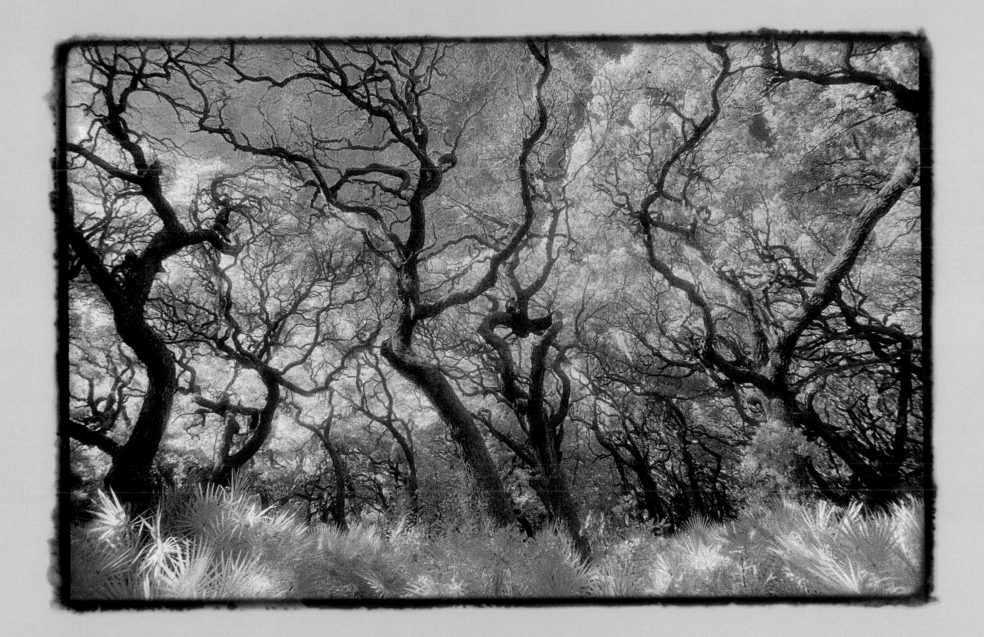

If the presence of humanity poses a question, a tree might be its answer. It offers silence to our noise, longevity to our hurried days, inspiration to our expiration. A tree stands as a lung in reverse: Its uplifted trunk, branches, and leaves form an architectural opposite to the downward reaching trachea and alveoli rooted in our own chests. For our every movement we consume oxygen and exhale carbon dioxide; the rustling green lung of leaves quietly repeals that biochemical motion. And so we go on about our business, without a single thought to the possibility of using up our whole stake in the atmosphere. For every second of humanity's raucous history, every breath any of us has ever taken was absorbed and answered silently by leaves.

In forests, an alternate universe to our own proceeds according to its own quiet plan, in which thousands of species are born and sheltered, where a thrush song blends with filtered sunlight and the flowering of spring ephemerals, where leaf mold becomes new dirt and a million microscopic rootlets reach down into its darkness to recover all the treasure buried there. Knuckled roots clench the soil to hold a hillside to its substrate, keeping streams and rivers clear, keeping a stony planet covered with the tenuous celebration we call life. Roots and leaves drink deeply of all that would be lost to us and give us back what we need.

This is not a thing to cut down lightly. And yet, somehow, we do. In yesterday's newspapers and spent milk cartons we toss away the broken hearts of trees every day. In our country we use a hundred billion board feet of lumber annually, with some of it cut from the wild stands in our own national forests. Though we account for only 5 percent of the world's population, Americans use more than a quarter of all the wood that is commercially harvested worldwide. And nearly a fifth of all the lumber delivered to our construction sites will end as scraps in a landfill.

Our love for trees has taken a strange form. Most of us would marvel at the beauty of a wood-paneled library cut from virgin wood, without seeing it as we might view that same room decorated with the glass-eyed taxidermy trophies of endangered rhinos and elephants killed by a sport hunter. But our virgin forests are now just as endangered as elephants and rhinos. Of the original forests that once covered the 48 conterminous states, only 3 to 4 percent still stand. A few more of these old giants are harvested each day, mostly in the Pacific Northwest. And just like the elephants, our virgin woodlands, once they are gone, can't come back.

We take them down with a pure inability to believe, as our ancestors failed to believe before us, that we could ever reach the end of our forested frontier. The deeply ringed cores of trees give the impression of such permanence that we somehow can't accept the truth of their demise. Possibly in our hearts we are also envious that a tree could see the turn of several centuries while we never will. For whatever reasons, we seem to think we need them dead more than alive, and we take them.

When Henry David Thoreau went to the woods to live at Walden Pond in March 1845, his first deliberate act was to fell a few young white pines for their tall, straight trunks so that he could build his little house. (If we all had to hew our own rafters, studs, and floorboards from raw pine trunks with an axe blade, we would surely send less lumber to the landfills!) The pitch of these pines covered his hands as he worked, and he sat among their freshly stripped boughs to eat his lunch, ingesting their fragrance with his bread. "Before I had done," he declared, "I was more the friend than the foe of the pine tree, though I had cut down some of them, having become better acquainted with it."

For the next years he lived among those trees, faithful to his duty, as he called it, as "self-appointed inspector of snow storms and rain storms." Most Americans know that Thoreau lived in the woods and

wrote about it, but fewer understand that *Walden* is not so much a book about nature as it is a book about the place of human life within a larger natural one, and a philosophical handbook for respectfully coexisting with trees while we burn them for fuel and hew them for rafters. With his own blend of transcendentalist thinking and old-fashioned Yankee Puritanism, he understood what the rest of his nation has taken many more years to learn: that we may live better and longer when we learn how to need much less than we thought.

Beyond Thoreau's famous wariness of all enterprises requiring new clothes, he discerned a need for calling a truce in humanity's nonstop campaign to consume resources and feed unending hungers. The illusion about so-called modern improvements, he warned, is that "there is not always a positive advance. Our inventions are wont to be pretty toys, which distract our attention from serious things. They are but improved means to an unimproved end….We are in great haste to construct a magnetic telegraph from Maine to Texas; but Maine and Texas, it may be, have nothing important to communicate."

His words were prescient. Maine and Texas still don't seem to have a lot to say to one another, but if they ever do think of it, they'll be able to say it with e-mail or cell phones or even flowers, shipped that very day from Holland. Henry would just shake his head. And he would weep, I'm afraid, for what has become of our woodlands in the meantime. Even in our national forests, where the necessity of turning a profit is not supposed to hold sway, over half the land area is open for business in the form of logging, mining, and oil drilling. Only 18 percent of it has been designated as wilderness.

As for the remaining third, the jury is still out. In 1999, after a long and thoughtful study, the National Forest Service declared this public forest land would be preserved for roadlessness and posterity. A record-breaking flood of public support applauded this decision. But even so, at this writing,

the Roadless Area Conservation Rule is being dismantled by the current administration. An unreliable economy, a change in the wind — for any number of reasons a tree may fall.

The decision is ours, and we will make it as we always do, by asking again and again the same question: How much of the world's life do we need to take to feel sure of our own? At what point do we draw a line and declare, "Now, enough." For generations we've believed in the simple formula that says we must choose between our own survival and the survival of wilder natures. We believed in that equation with our hearts and our bottom dollar, and, while we weren't looking, we outgrew the pioneer economy of endless resources that had made it possible. Yet even now, as we stare in awe at the last that stands before us, we still mostly accept the sad verdict that cutting down a forest means jobs, while leaving it standing does not. We haven't yet garnered the resourcefulness that will surely stun us, when it arrives, with the revelation that countless jobs are to be had elsewhere: In the construction of new means for capturing energy from the wind and sun; in the multitude of new things we might build from those we have used once and thrown away; in the possibility of lives built not on what we think we need but on the bedrock of what we already have. Somewhere between our deepest gasp and the exhalations of leaves, we may realize perfection is here already, our most urgent question answered.

It was not material wealth or conquest that gave Thoreau his immortality, but a life paced with the seasons of a woodland. His permanent possession was the precious present moment — a gift most of us only find in rare moments away from the noisy demands of our days. He warned that we cannot kill time without injuring eternity. "In any weather, at any hour of the day or night," he wrote, "I have been anxious to improve the nick of time, and notch it on my stick too; to stand on the meeting of two eternities, the past and future, which is precisely the present moment; to toe that line."

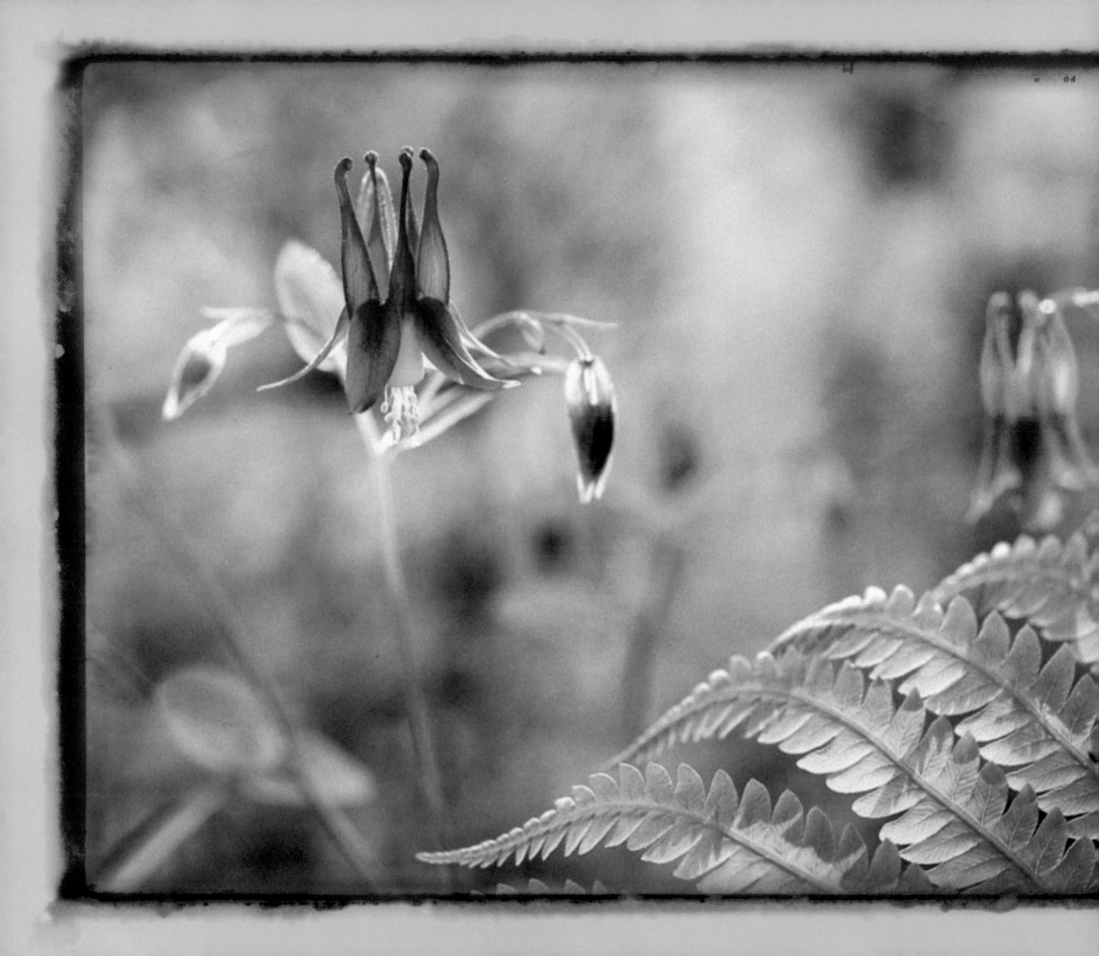

What is a weed? A plant whose virtues have not yet been discovered.

RALPH WALDO EMERSON

Crimson columbine / NORTHEASTERN MINNESOTA

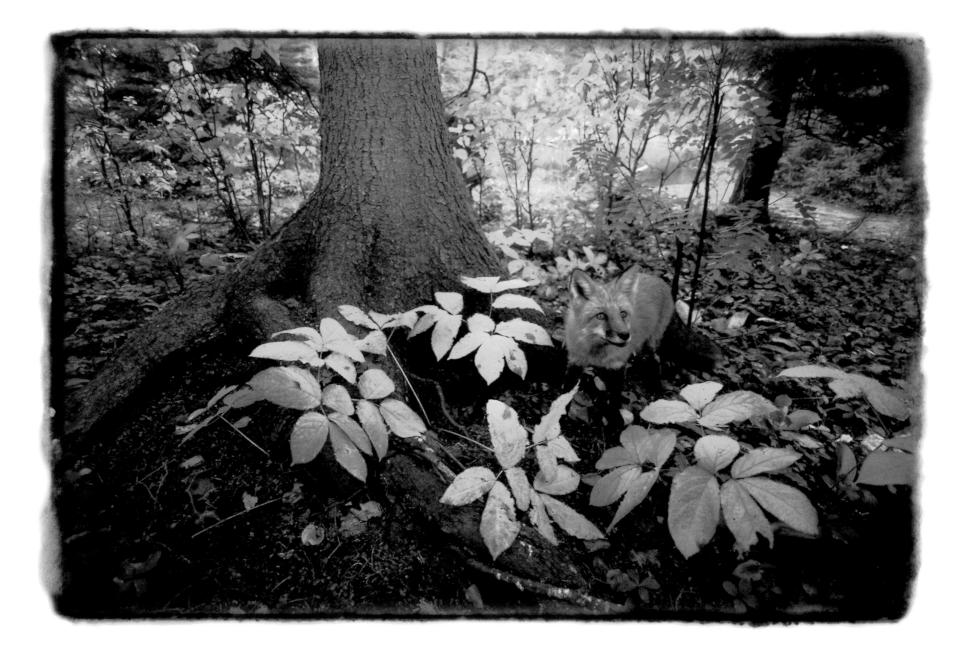

Red fox / NORTHERN MICHIGAN

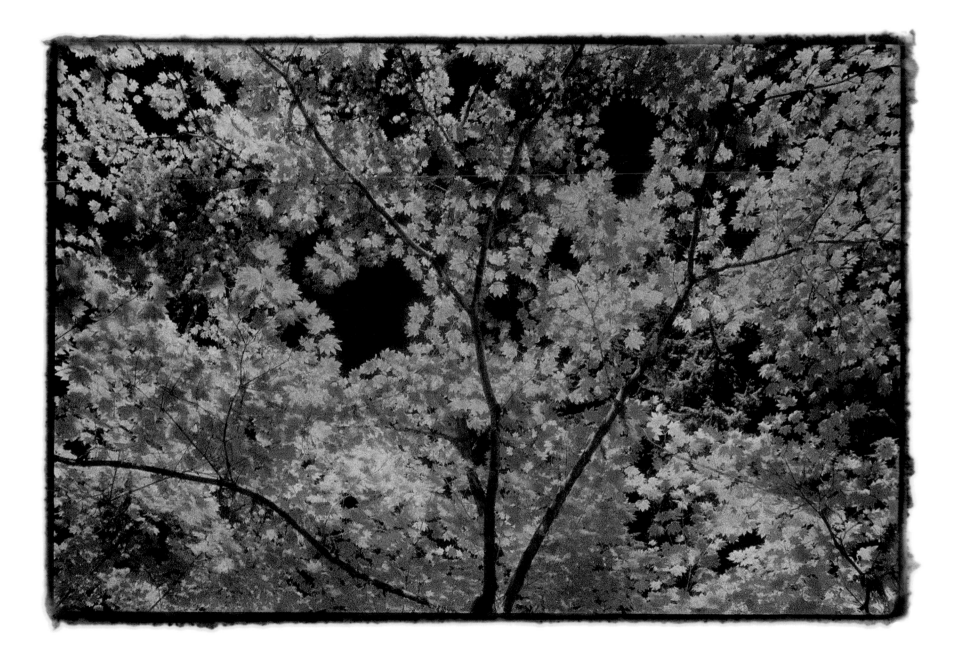

North Cascades forest / NORTHERN WASHINGTON

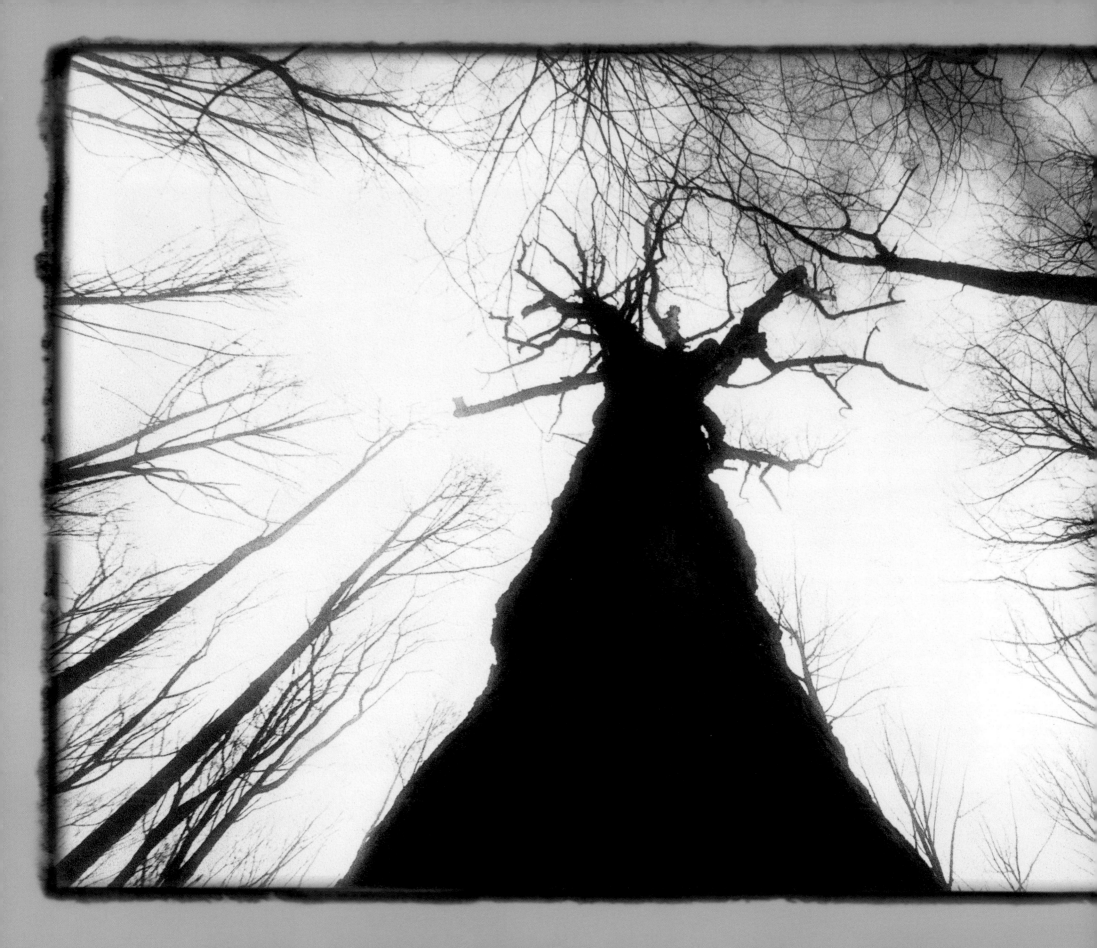

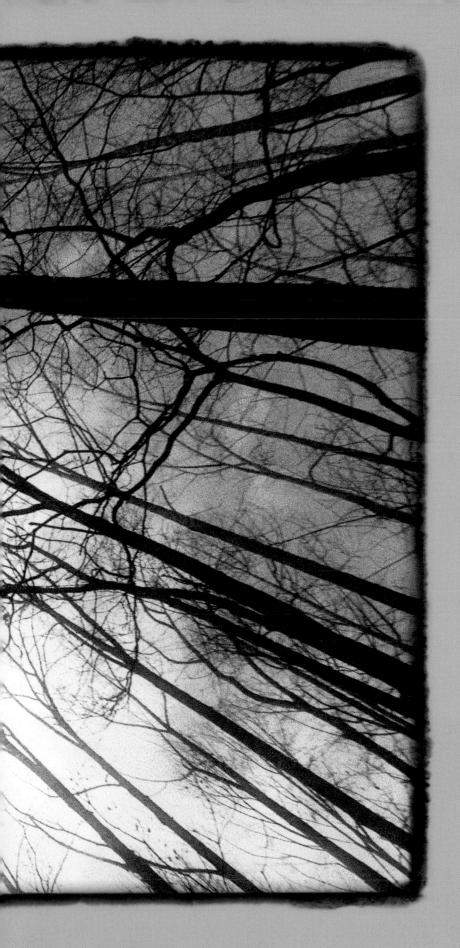

Thank God, they cannot cut down the clouds.

HENRY DAVID THOREAU

300-year-old oak / WESTERN NORTH CAROLINA

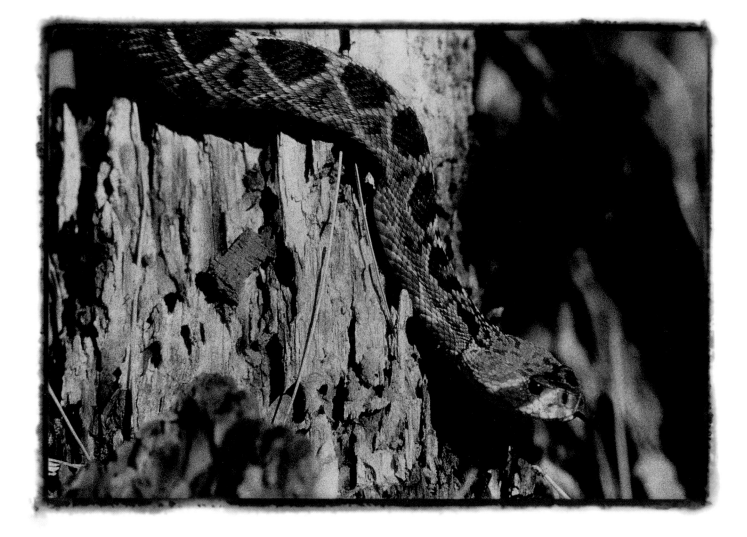

Eastern diamondback rattlesnake / EASTERN GEORGIA

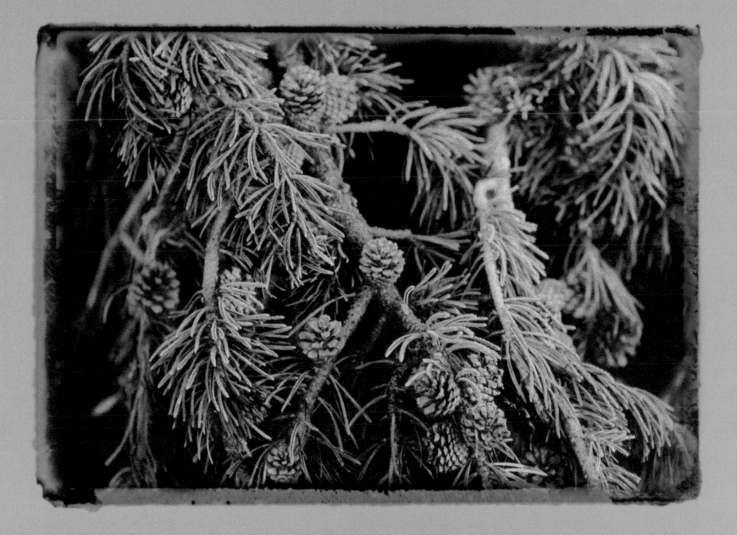

Frosted pine branches / NORTHERN WYOMING *(Overleaf) Appalachian morning* / EASTERN KENTUCKY

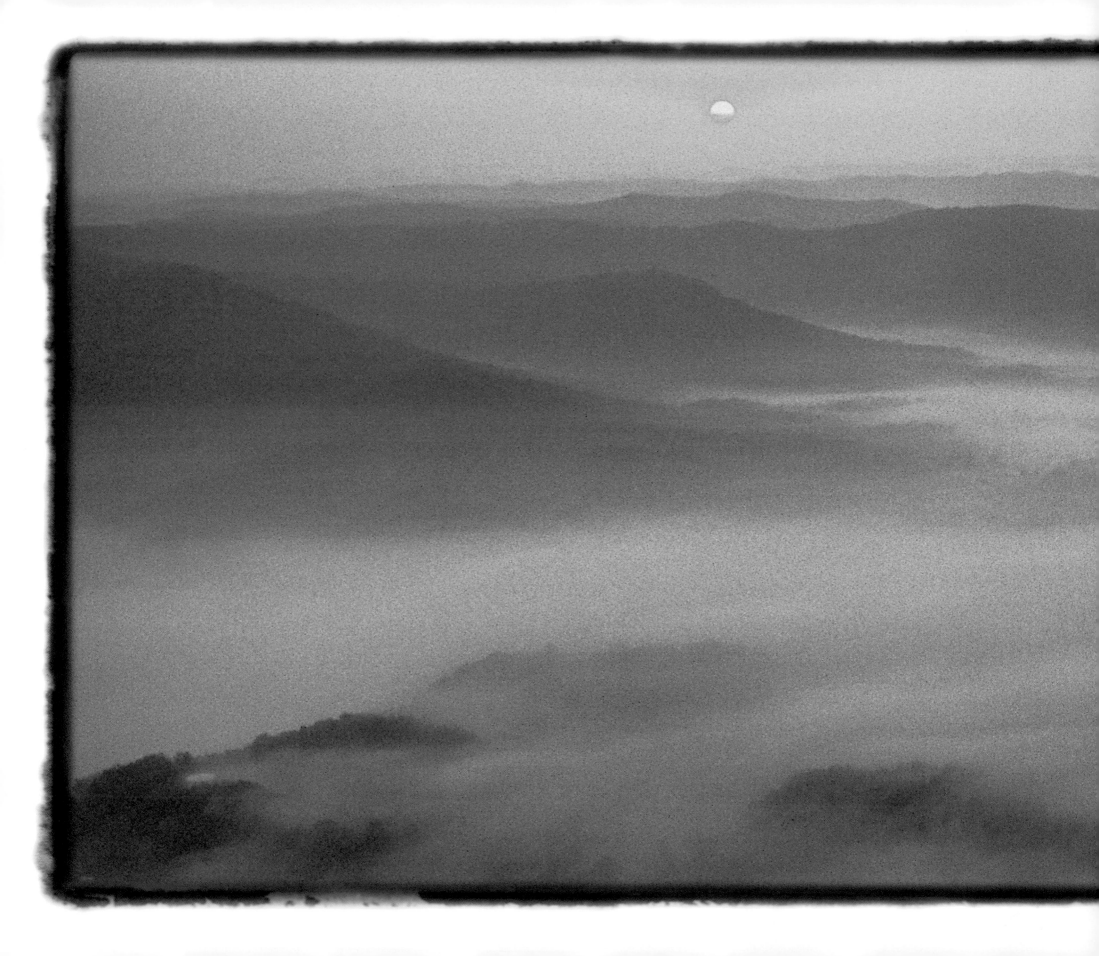

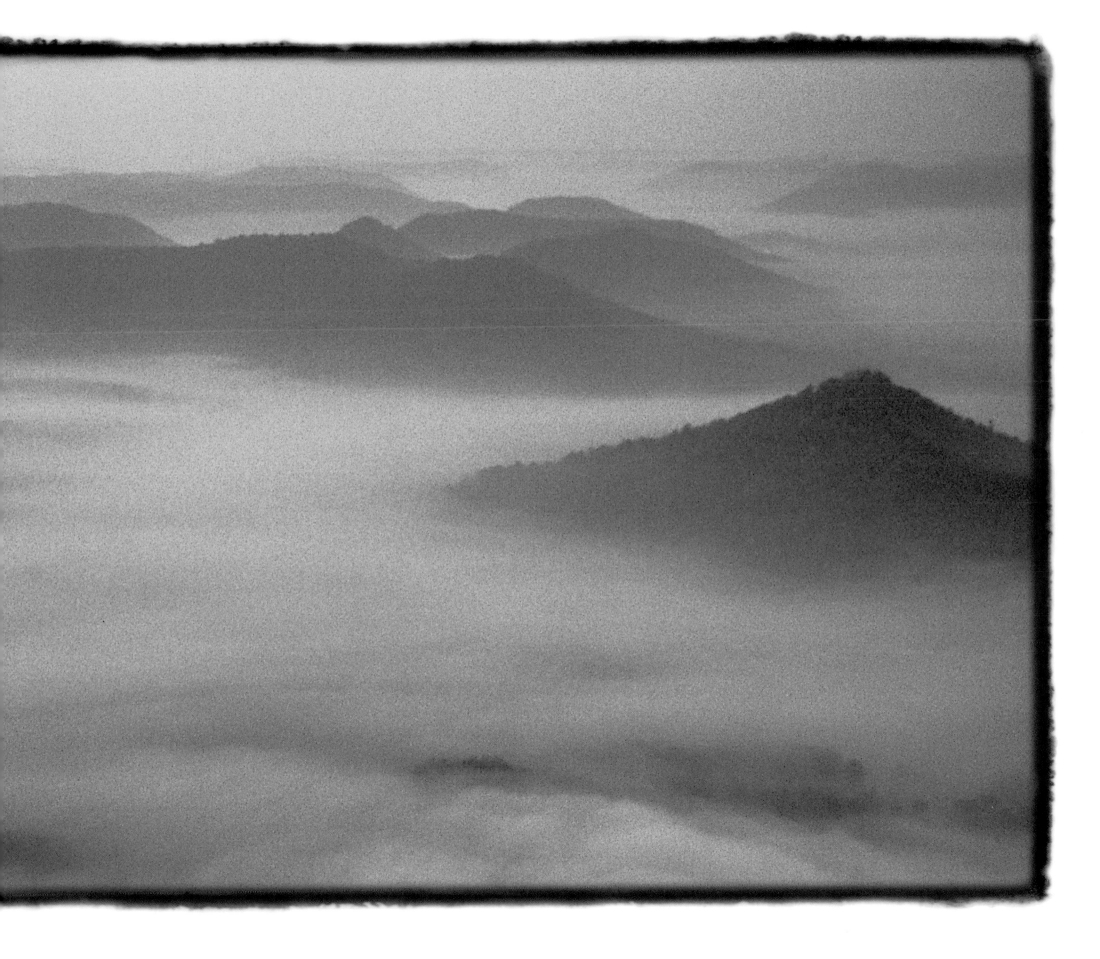

What would human life be without forests, those natural cities?

HENRY DAVID THOREAU

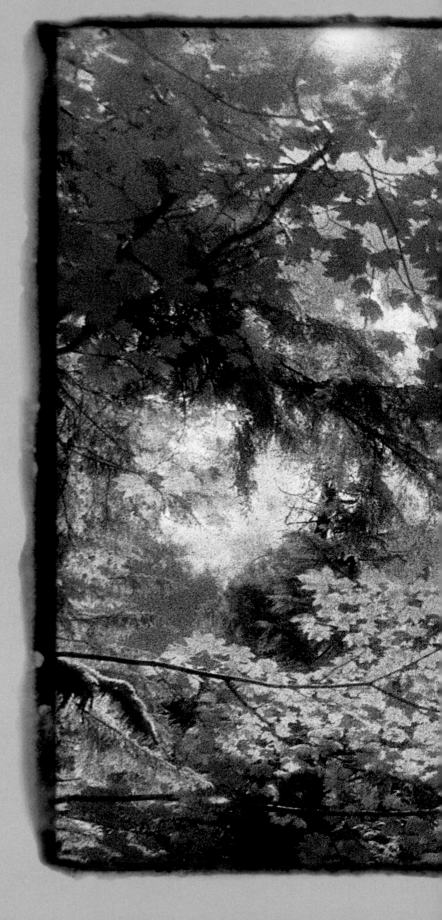

North Cascades / NORTHERN WASHINGTON

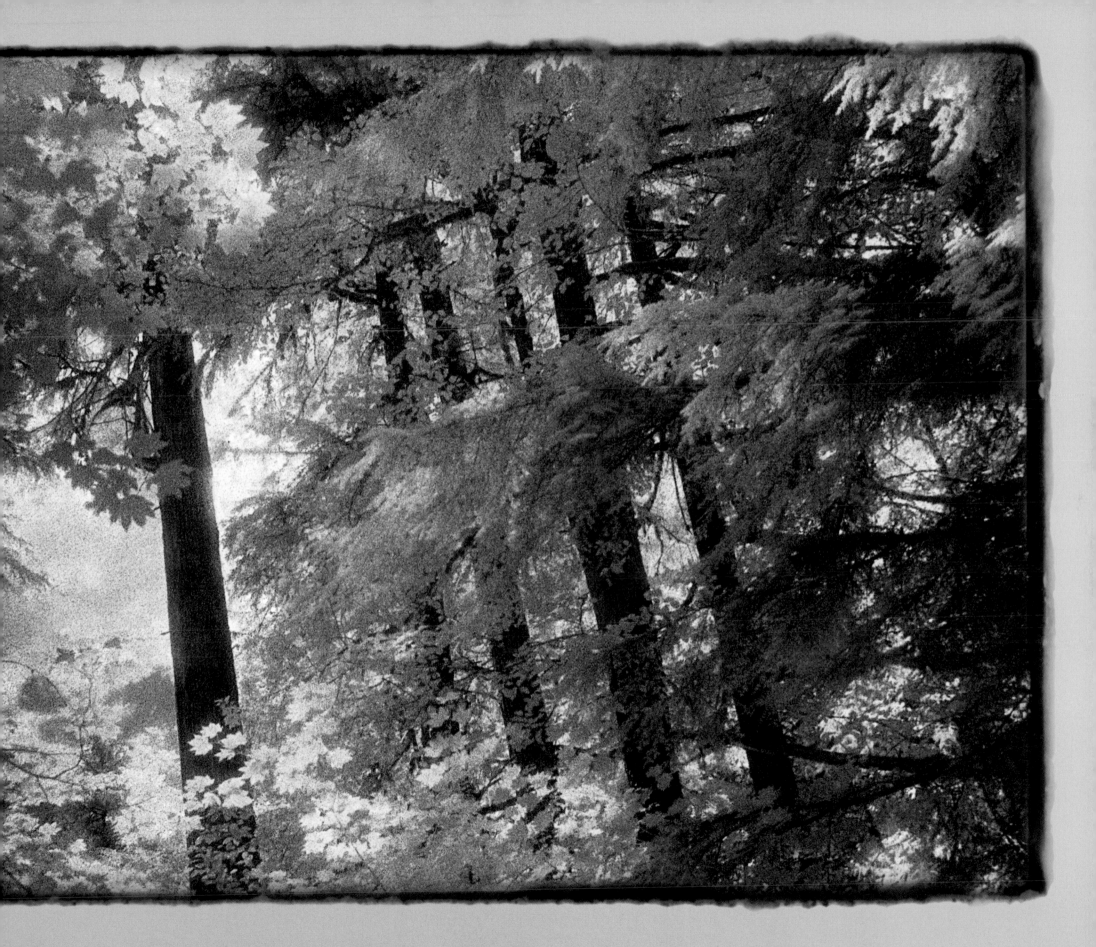

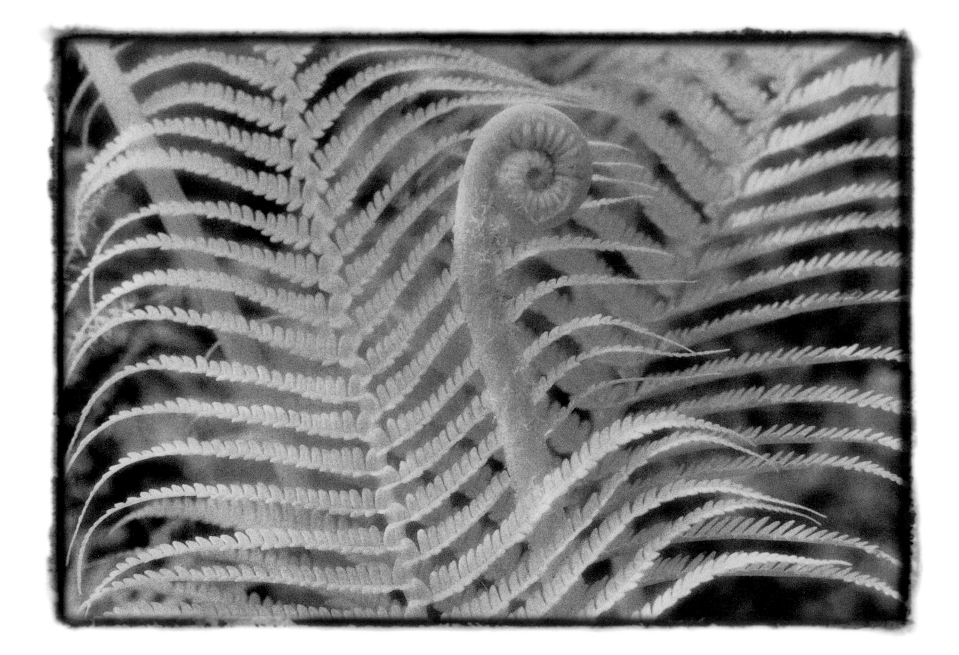

Fiddlehead of fern / BIG ISLAND, HAWAII

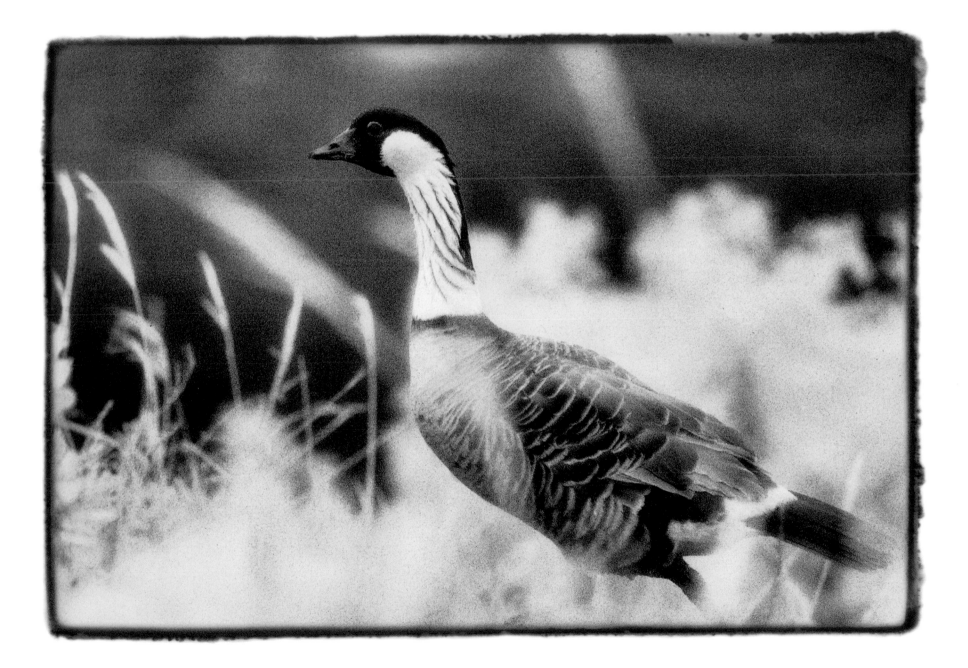

Nene / KAUAI, HAWAII

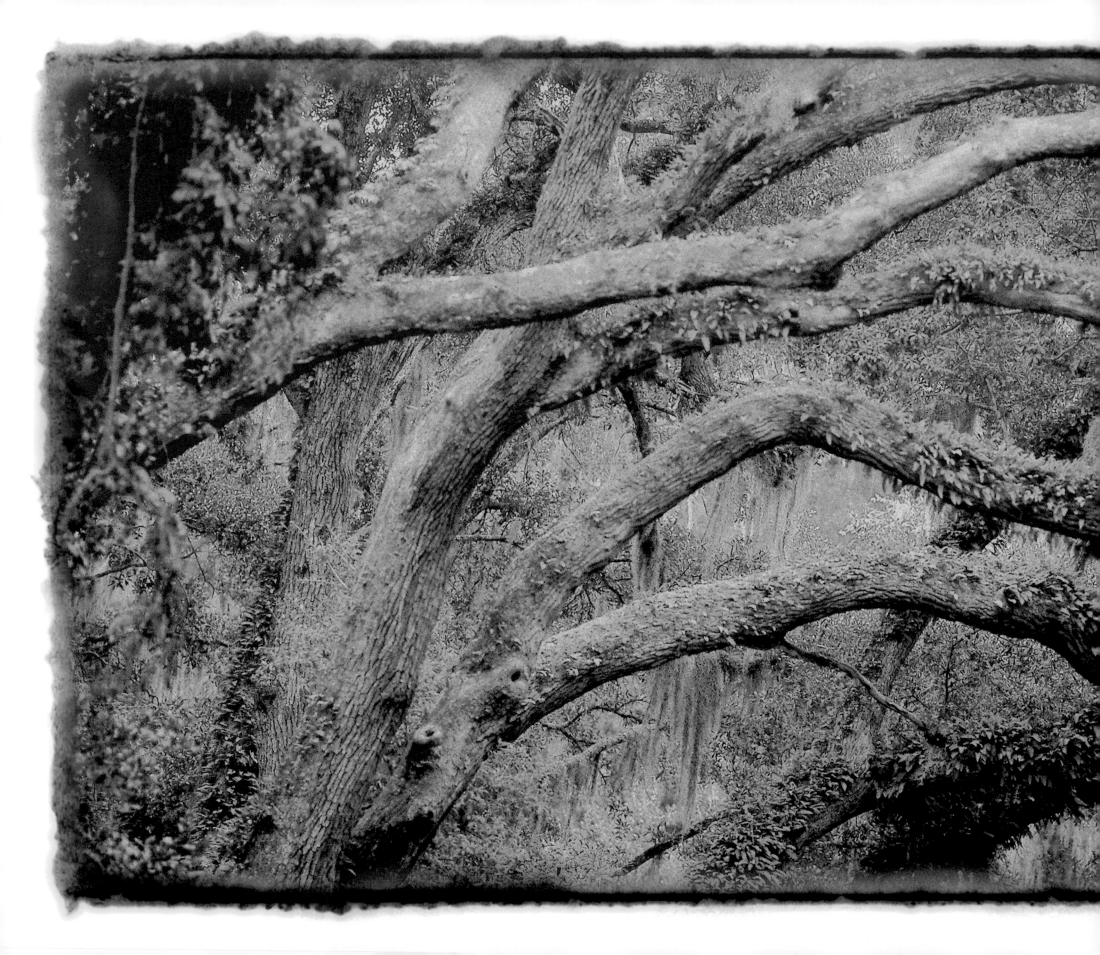

Live oaks / EASTERN SOUTH CAROLINA

To encounter a truly wild animal on its own ground
is to know the defeat of thought....

<div align="right">BARRY LOPEZ</div>

White-tailed deer / NORTHERN WISCONSIN

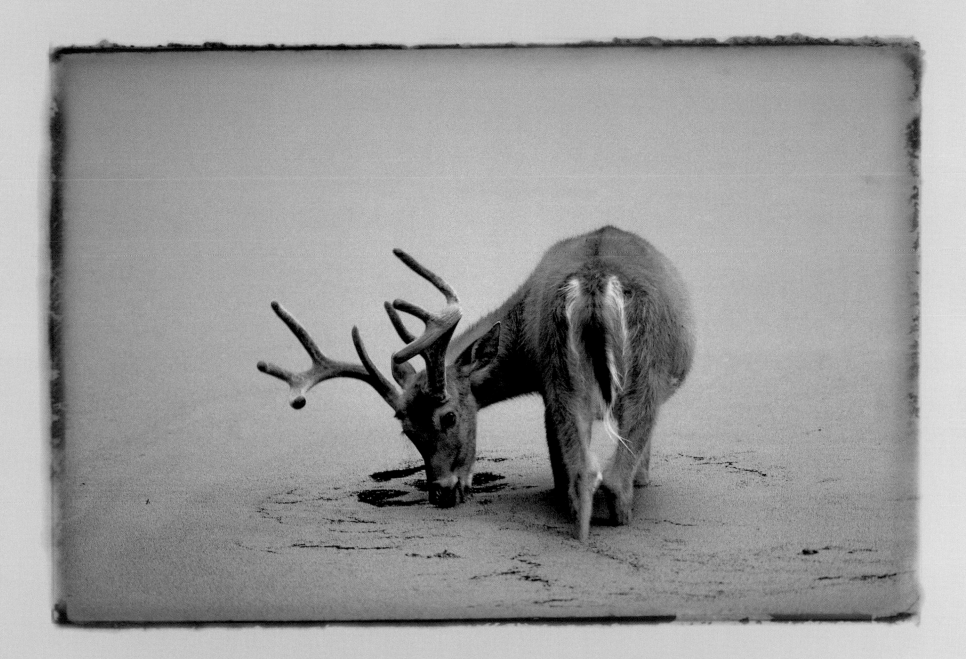

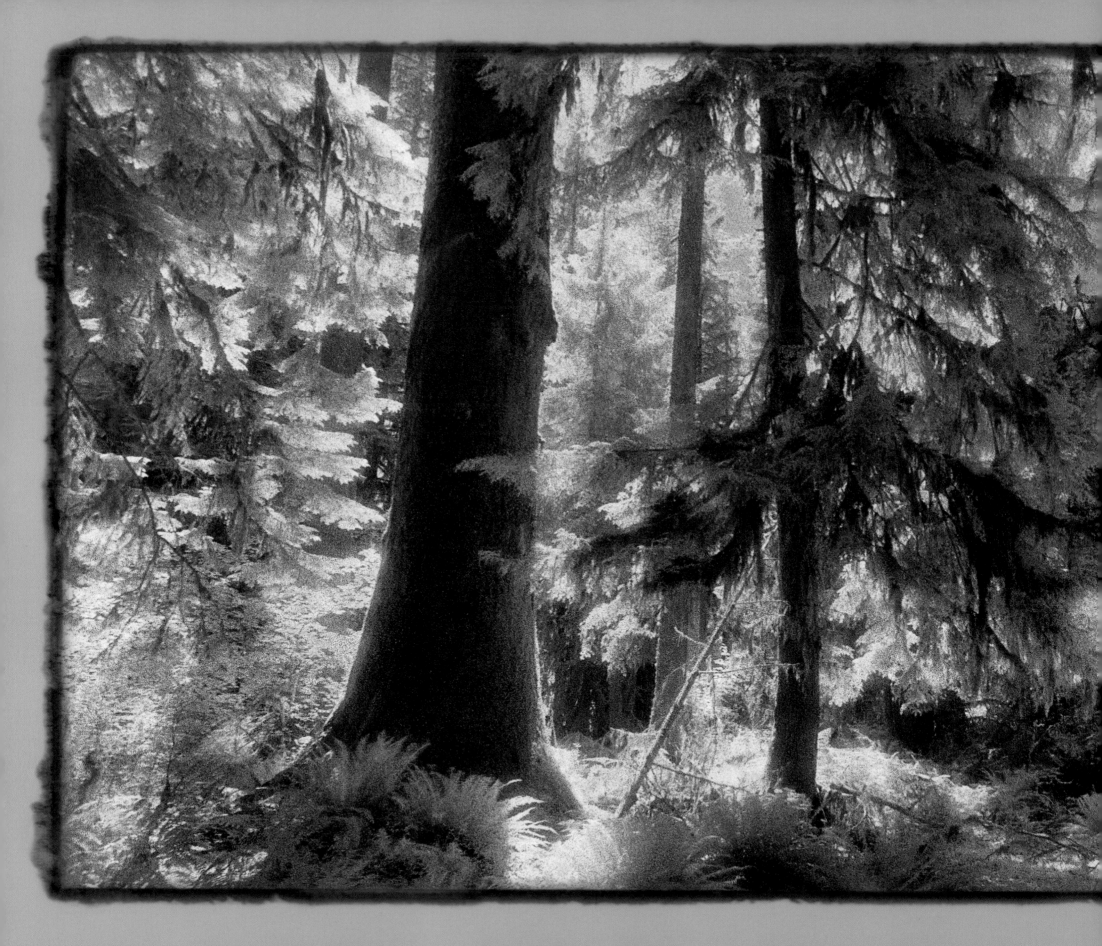

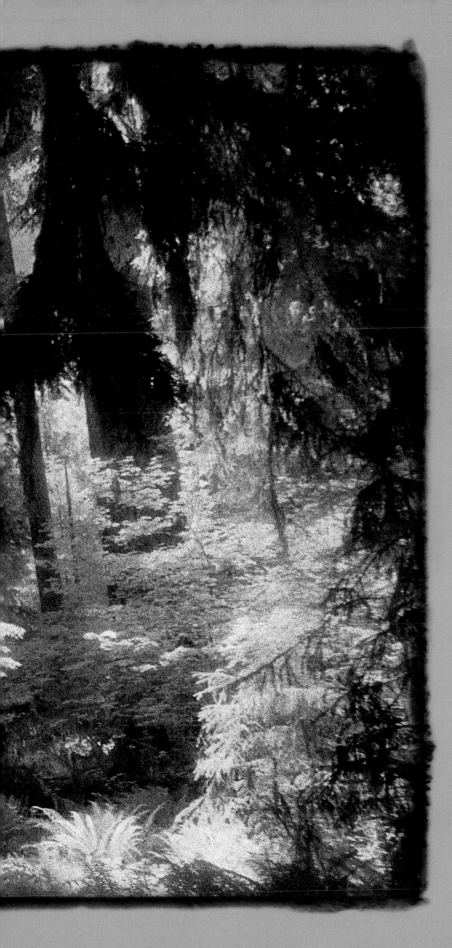

Rain forest / COASTAL WASHINGTON

Coasts

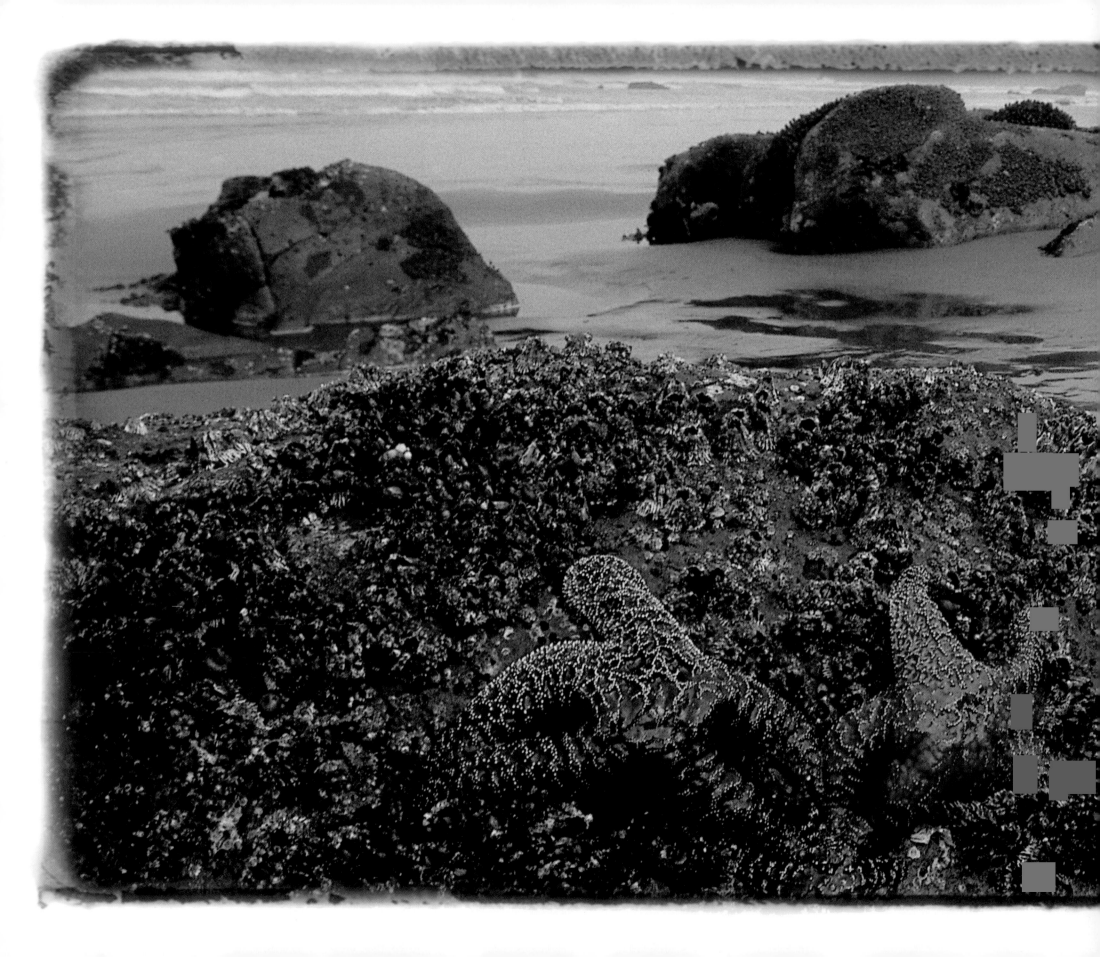

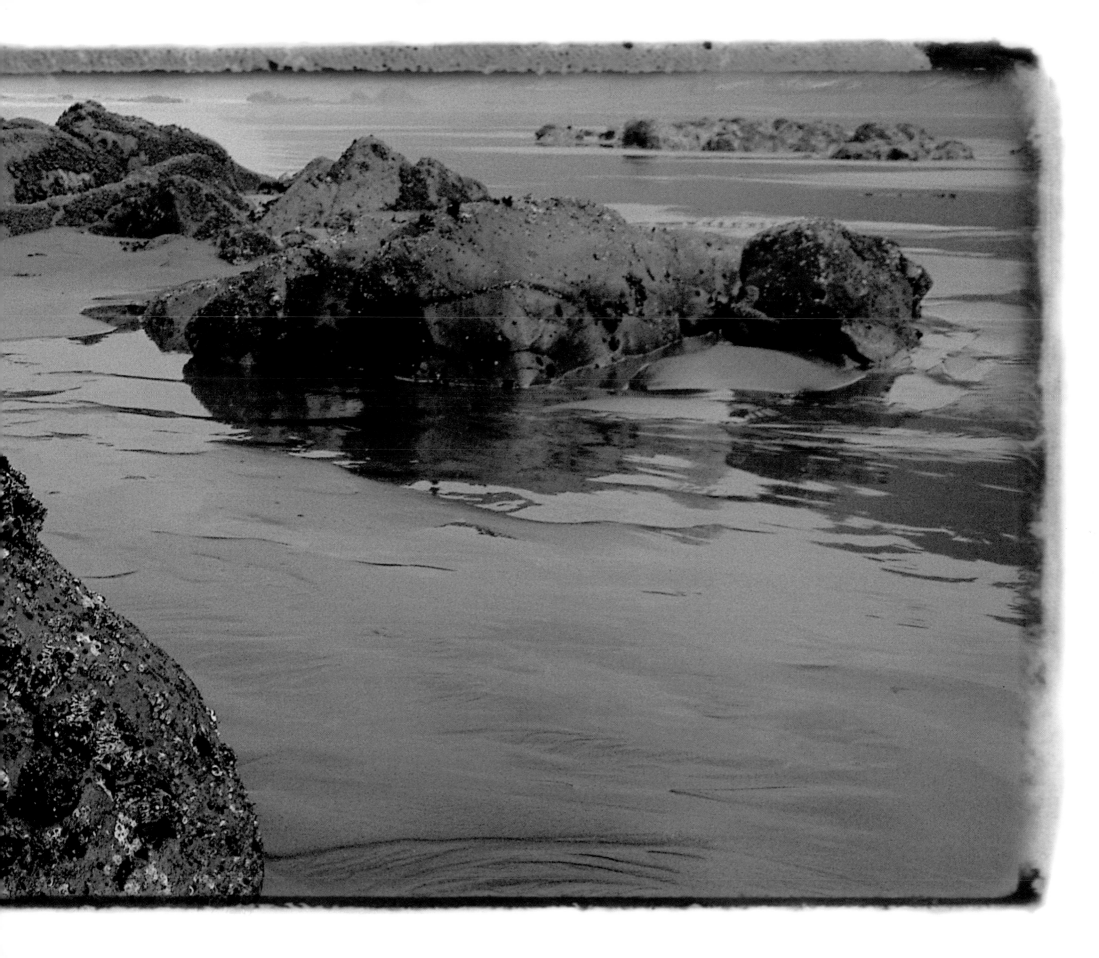

Drifting… through light and dark, calm and storm,
I have come to so glorious an ocean.

JOHN MUIR

Olympic Peninsula / WASHINGTON

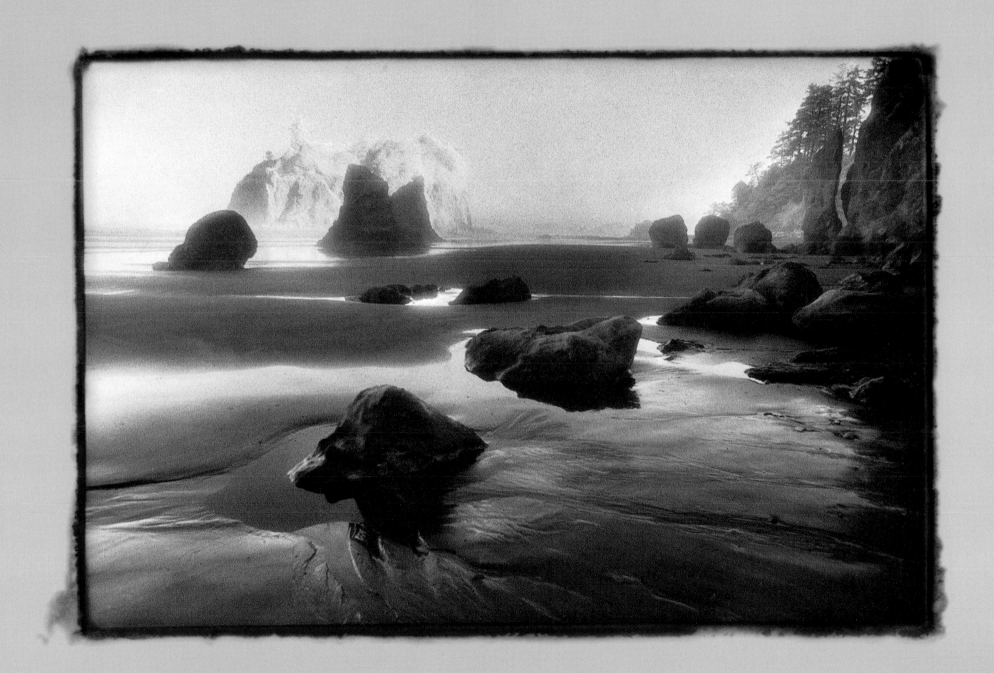

Nothing else calls out to the human psyche the way the ocean does: For as long as we've had the gumption to lash together reeds or oak planks, it has invited us to enter and explore its hidden mysteries. It inspires us with what John Muir called its "grand, savage harmony." To sleep near the shore is to reenter infancy through the rhythm of a vast, planetary heartbeat. A walk along its tide line is a chance to receive endless gifts, glistening with the strange edges of life and decomposition, and to find passage into one new world after another. North America's coasts are long tapestries of varied habitat: Green marshes, windswept beaches flanked by dunes of sea oats, rocky shores dappled with bright tide pools, the shifting mudscapes of river deltas, crescents of barrier islands and shelves of old coral reefs, shellfish beds and acres of underwater sea grass where mollusks graze like elaborately armored cattle.

In the lagoons where rivers meet the sea, the mingling of freshwater and saltwater performs alchemies of nutrient-enriched productivity. This special estuary habitat produces more food per acre than the richest farms in Iowa: 75 percent of the fish we harvest commercially depend on estuarine and coastal habitat for some part of their survival. Cockles and mussels cling to life at the edge of the intertidal zone, crabs scuttle across it, and newly hatched sea turtles make their moonlit maiden trek down and away from the beach to which they will only return to lay their own eggs — if that strip of sand still exists — many years hence. People and pelicans, sandpipers and salmon all navigate the teeming coastal highways in their foraging and migrations, while the ocean's damp breath moves inland to nurture coastal rain forests.

Life clings eagerly to the seashores: plant life, animal life, human life. More than 110 million Americans now live along the coastal edges of our continent and have brought along all the by-products of our habitation. Our dams and dredging, our removal of the land's natural cover to build homes of our

own, our ultimate need to concentrate our wastes and toxins and send them out to sea — these facts of our living have adversely affected the coastal watersheds. The toll, in fact, is enormous: Around the San Francisco Bay, 95 percent of the original wetlands have been destroyed, and only 300 of the Central Valley's original 6,000 miles of streams are still sufficiently intact to support spawning salmon. Puget Sound has lost three-quarters of its salt marshes, and on the opposite side of the continent the estuary-rich coast of North Carolina has now lost more of its wetlands than any other state. On the Gulf of Mexico, Galveston Bay has lost 85 percent of its sea grass meadows. Chesapeake Bay has lost even more — a fact that became direly obvious in the 30 years between 1959 and 1989, when the annual oyster harvest fell from twenty-five million pounds to one million.

It has occurred to me lately, whenever I have the chance to dine on wild-caught Alaska salmon or Puget Sound oysters, that I'm participating in the end of an era for my species. When my children are my age and hear us elderly folk insisting that once upon a time we routinely ate wild game hunted from the sea — shrimp, sea bass, tuna so plentiful we bought it in cans and smeared it on sandwiches — they'll find that story as quaint or dreadful as I've found tales I've read about the people who once shot passenger pigeons and prairie chickens for their daily fare. For a few more years we still may take for granted the capacity of the Earth's one last uncharted wilderness to feed us. But before that bounty dwindles, we stand to lose countless faces of beauty and biodiversity in the lands where ocean habitat comes into contact with our landbound lives. We are in danger of loving our wild coasts to death.

"Everybody needs beauty as well as bread," wrote the great naturalist John Muir, "places to play in and pray in, where Nature may heal and cheer and give strength to body and soul." He believed in the sacred duty of protecting those places, so their magnificence would outlast his own generation.

Few people have devoted their lives to that duty more earnestly than John Muir did, or conquered greater personal barriers to do it. Muir immigrated to the United States from Scotland and spent his boyhood laboring on the family farm in Wisconsin, under the stern eye of a father who disapproved of restless imaginings and who cited biblical passages against the devices John invented to help relieve the hardships of farm life. Young John Muir's story was a common one for his place and time, but he was made of uncommon material. He came to formal education relatively late in life and was largely self-taught in the ways of the natural world, but passion led him continually to the wild, then wildest, regions that America still had to offer in the late 19th century. The care with which he dedicated himself to observing these places rendered him eventually one of the greatest geologists and botanists of his time, and an astute observer of coastal ecology.

John Muir is probably best remembered for his writings about the West Coast, from the redwoods he loved to Glacier Bay, Alaska, which he explored and described, opening a new world of icy and oceanic wilderness to the American imagination. A redwood grove and a glacier, among other things, bear his name. In 1892 he helped found the Sierra Club and served as its first president, for the initial purpose of combating the logging and ranching interests that then threatened to decimate Yosemite National Park. "Hoping that we will be able to do something for wildness and make the mountains glad," Muir wrote. The Sierra Club attracted 250 people to its first general meeting in San Francisco; a month later twice that many came, pledging to enjoy and protect the remaining wild regions of the Pacific coast.

When John Muir died on Christmas Eve, 1914, the *Los Angeles Times* wrote, "Up through the far-flung reaches of the Yosemite, the Sequoias, the Muir Woods and all the mountain wilds of the West

will ring the mournful echo of that message, for the birds and the beasts and all living things have lost a friend. America has lost perhaps its greatest naturalist, the world one of its most remarkable nature poets…." But America hasn't lost his legacy. The club he started one century plus a decade ago now has 700,000 members who share Muir's devotion and have extended the initial promise of protecting the wilds of California to embrace every bit of American wilderness that still stands. The Sierra Club and other environmental groups across the country continue to awaken us to the value of our remaining virgin lands, so that we might work harder to preserve them.

The need has never been more urgent. The coastal temperate rain forest, in which John Muir once could have walked from California to Alaska without ever having to shade his eyes from the sun, has been mined deeply for lumber. Clearcuts lie across it like wounds, and the soil and streams of the Pacific Northwest have been so disrupted that the last wild fisheries in the continental U.S. are now threatened. We've harvested our magnificent abundance to the point that it cannot regenerate itself. As Muir said of the fishermen who ignored the glory of Yosemite while tramping across it to get a hook into its trout, it must seem that we are "sillier than the silly fish themselves."

As a young man, John Muir was nearly blinded by an industrial accident. Standing by a window, holding a hand over his injured eye, he said quietly, "Closed forever on all God's beauty." But he recovered his sight, then packed a knapsack and set out for the Gulf Coast, turning his vision for the rest of his days toward the beauty he nearly lost. "This affliction has driven me to the sweet fields," he said. "God has to nearly kill us sometimes, to teach us lessons."

More than a century later, as the nets we cast into coastal waters begin to come up empty, it must be time for more of us to believe in some version of that truth.

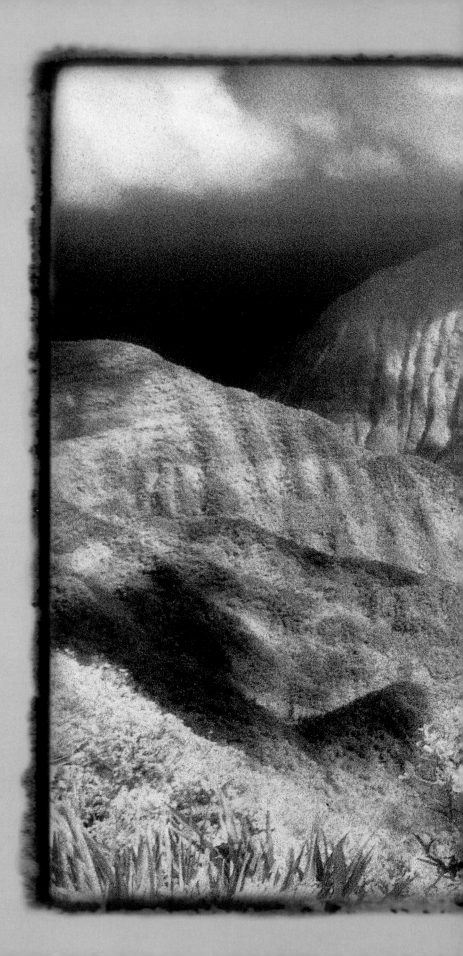

As soon as we take one thing
by itself, we find it hitched
to everything in the universe.

JOHN MUIR

Sea cliffs / MOLOKAI, HAWAII

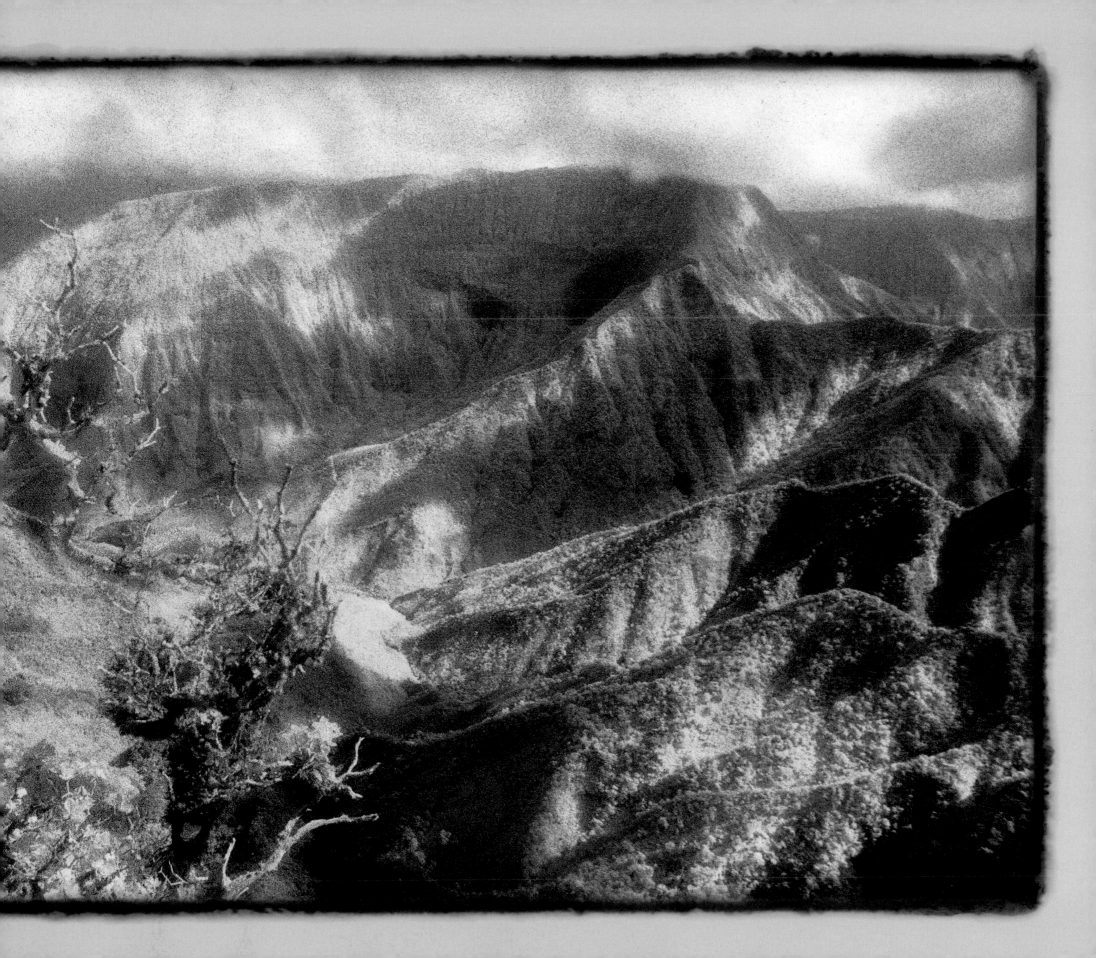

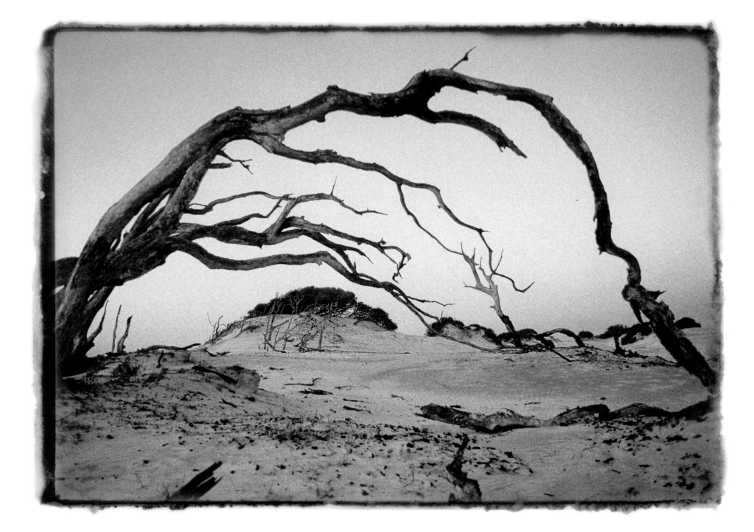

Drifting sand dunes / GEORGIA BARRIER ISLAND

Aerial of a barrier island / GULF OF MEXICO

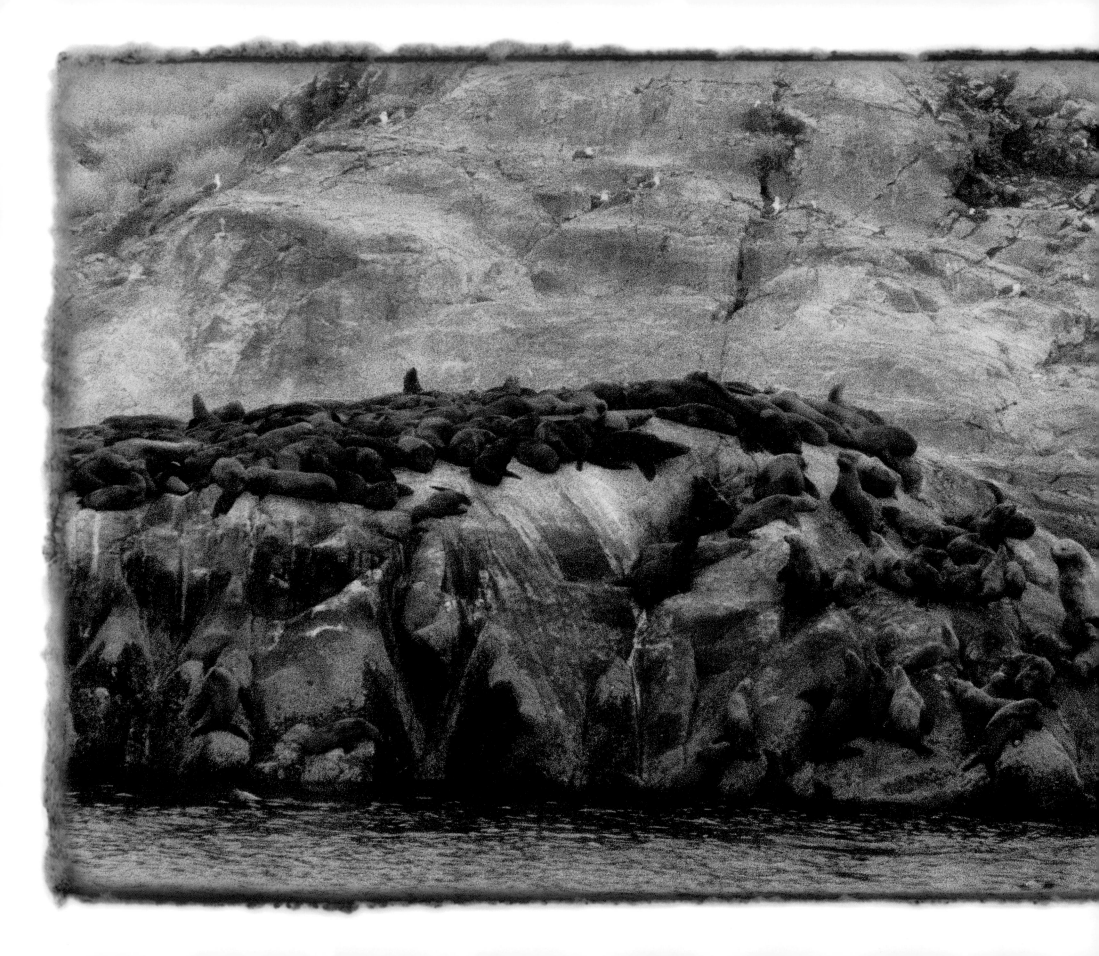

Seal colony ⁄ COASTAL ALASKA

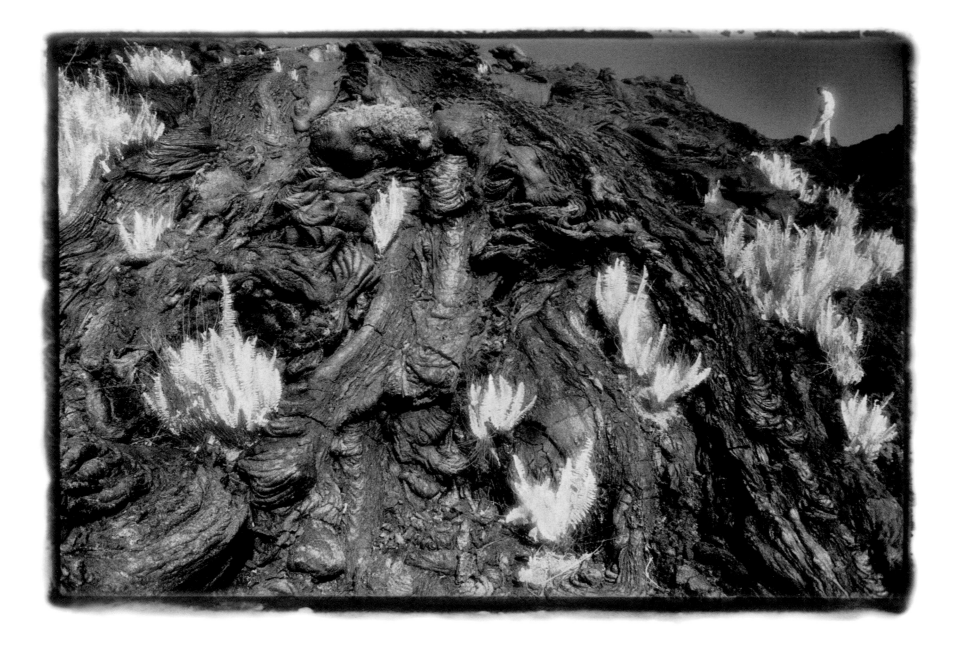

New growth on lava beds / BIG ISLAND, HAWAII

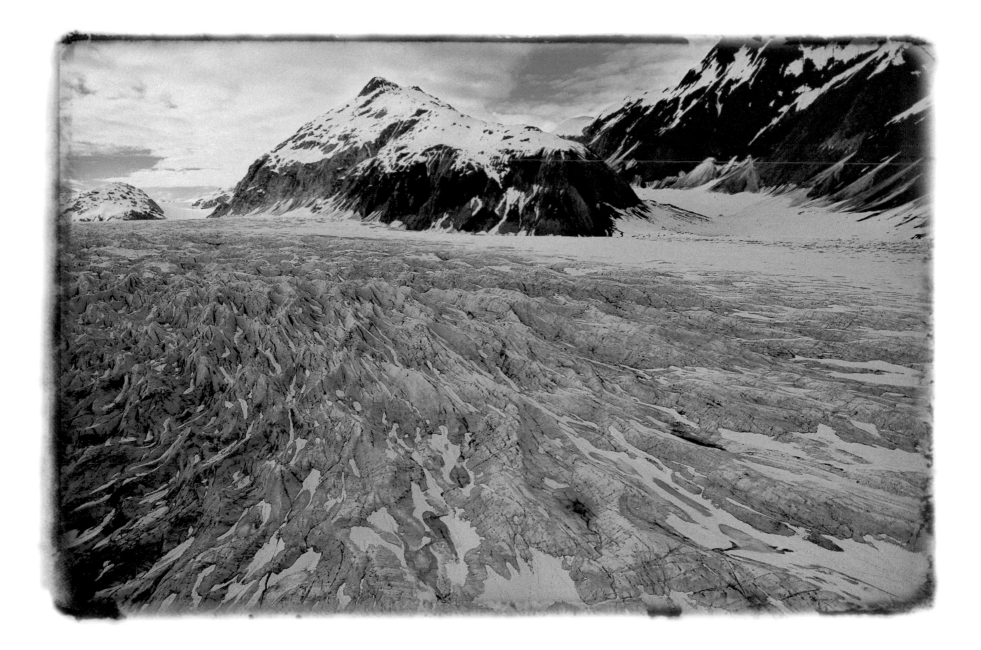

Coastal glacier / SOUTHERN ALASKA *(Overleaf) Olympic Peninsula* / WASHINGTON

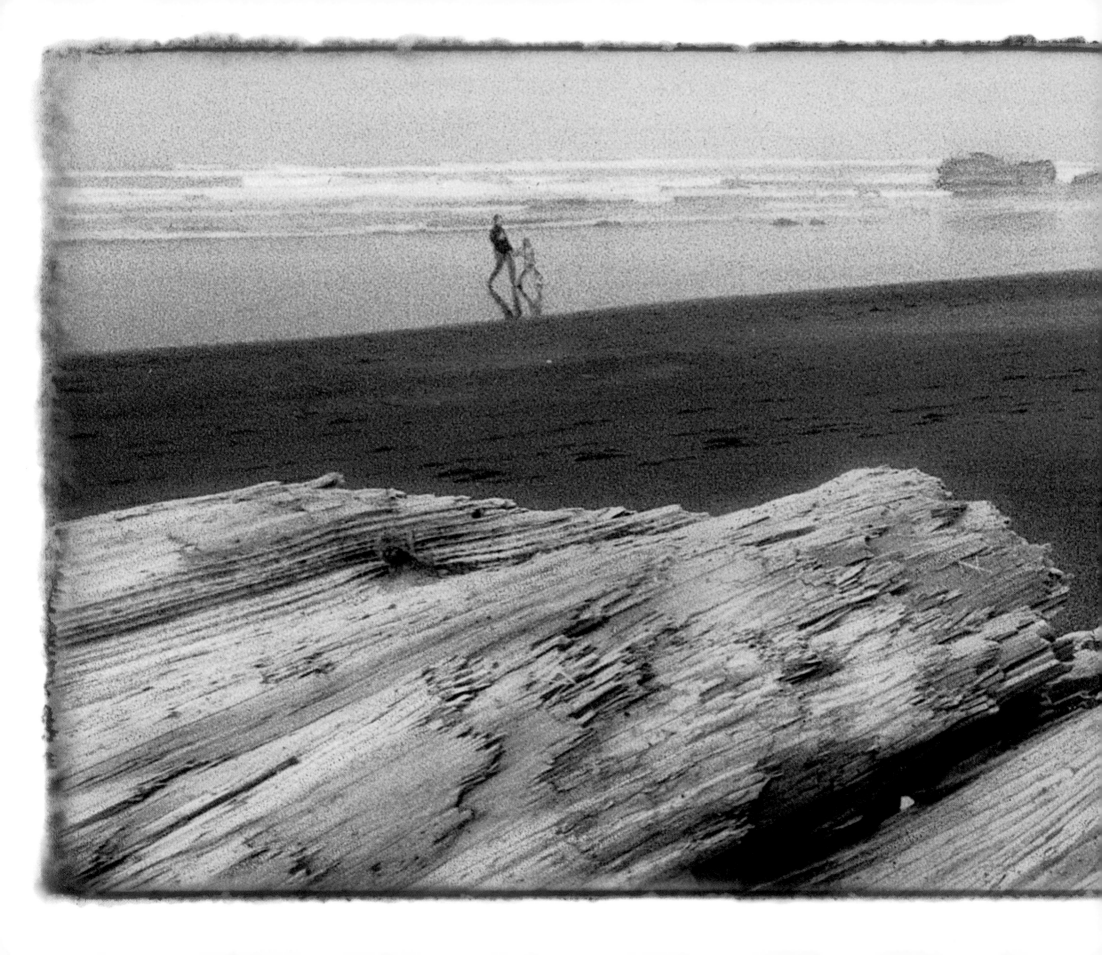

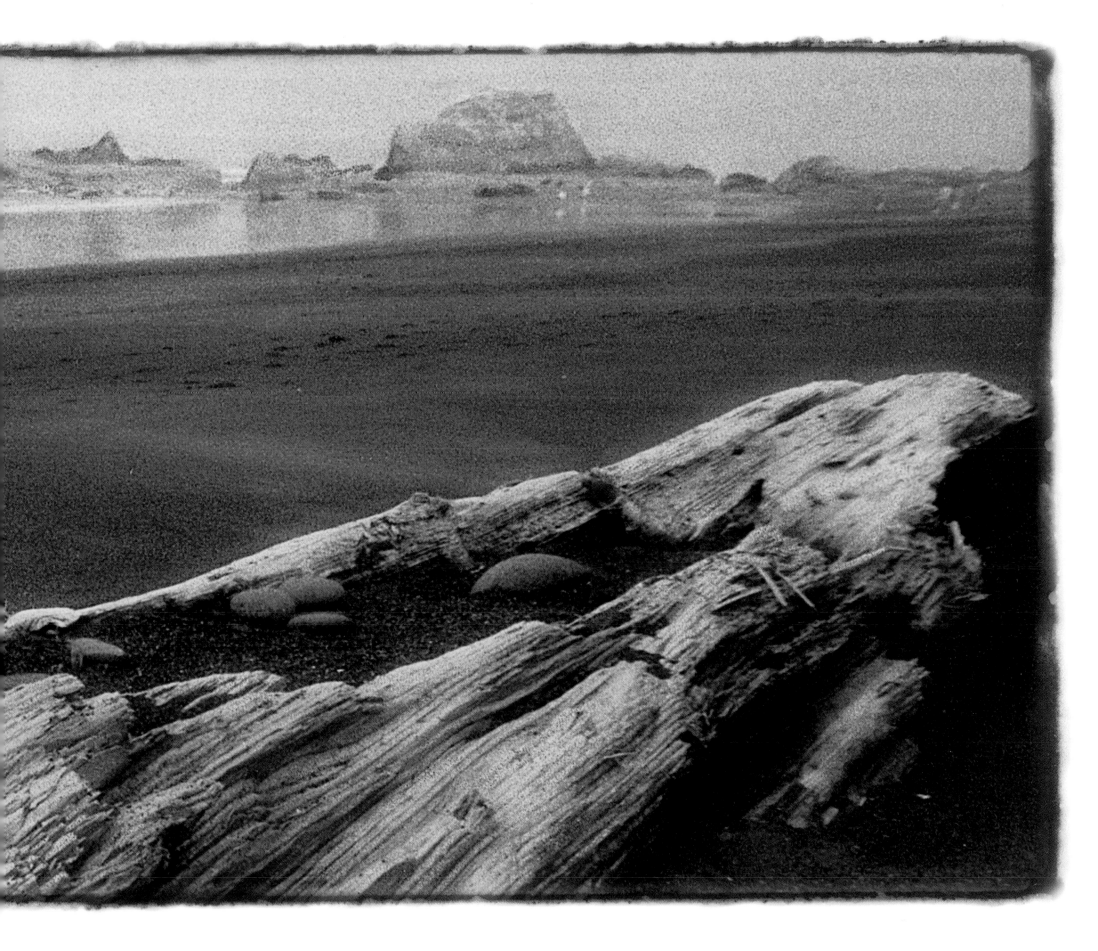

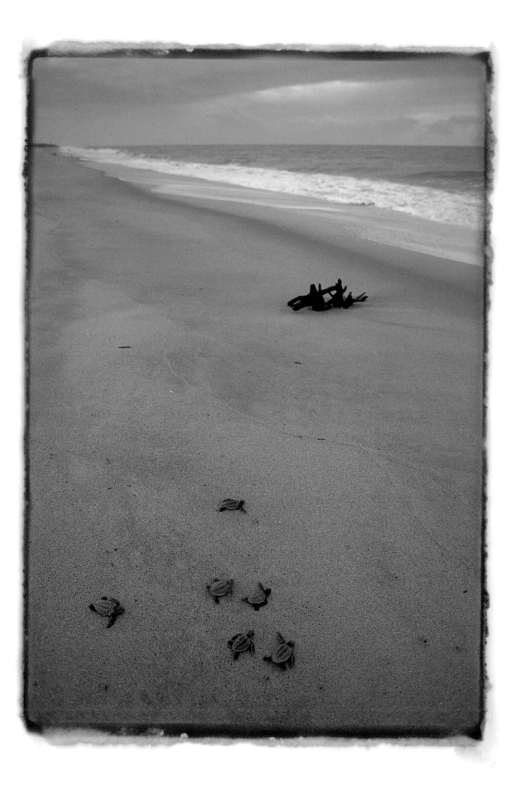

Loggerhead hatchlings / SOUTH CAROLINA BARRIER ISLAND

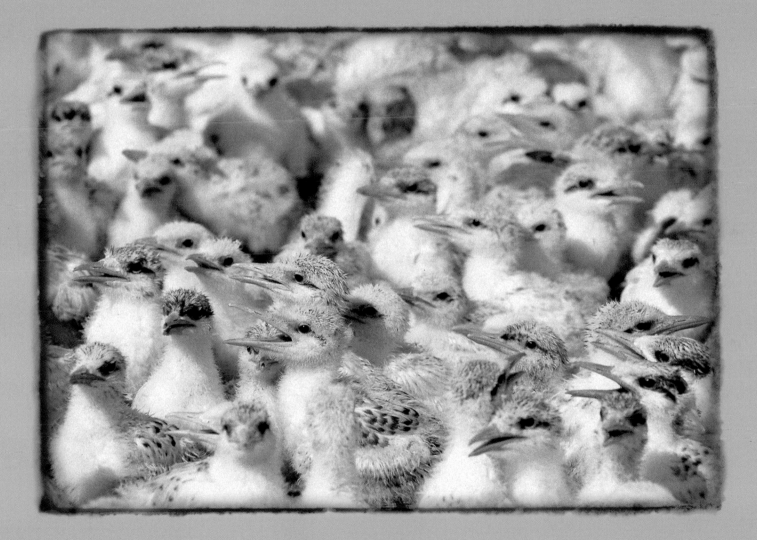

Tern chicks / COASTAL VIRGINIA

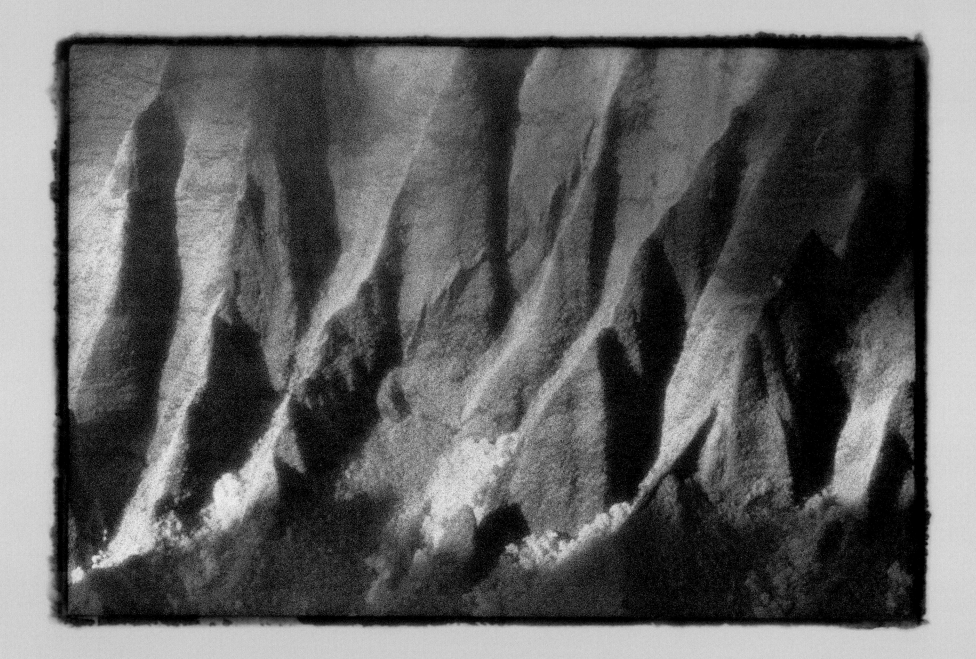

The land is like poetry: it is inexplicably coherent....

Barry Lopez

Na Pali Coast / KAUAI, HAWAII

Shell on driftwood / COASTAL SOUTH CAROLINA

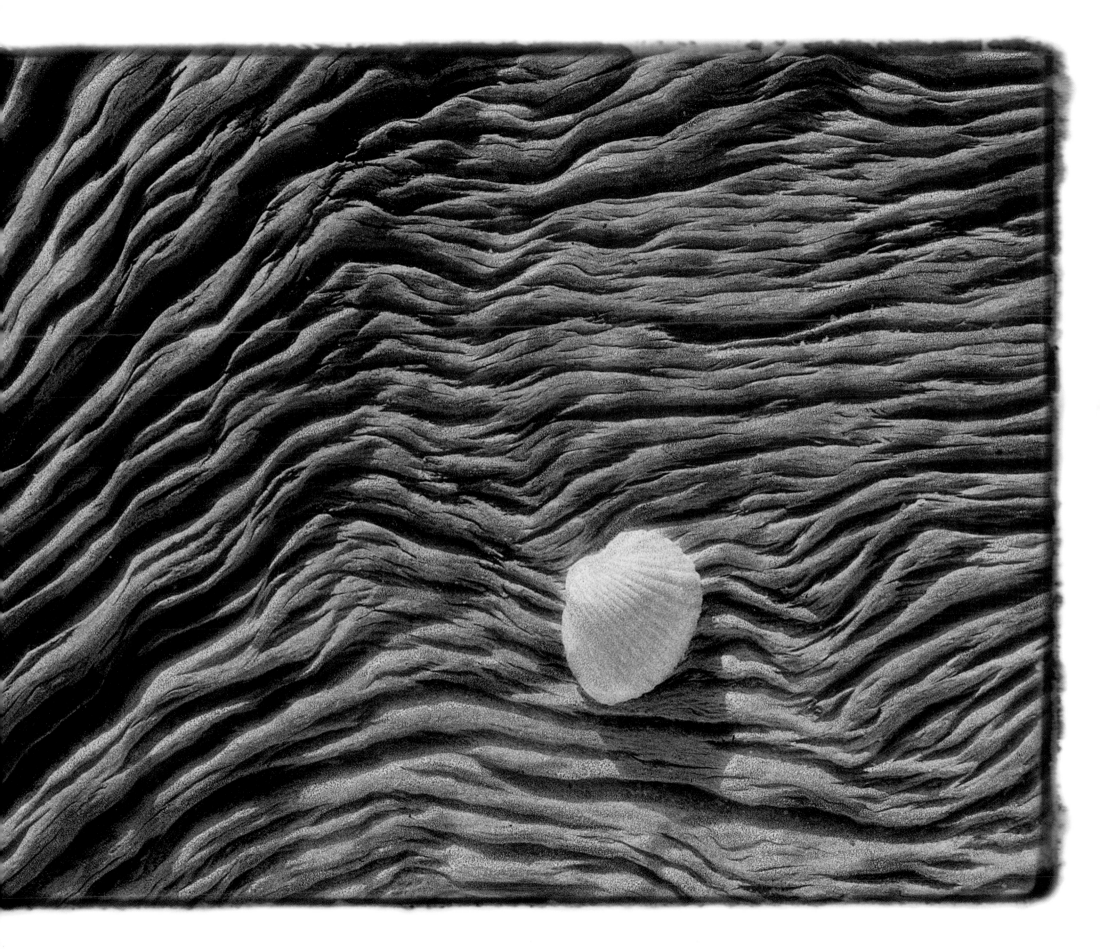

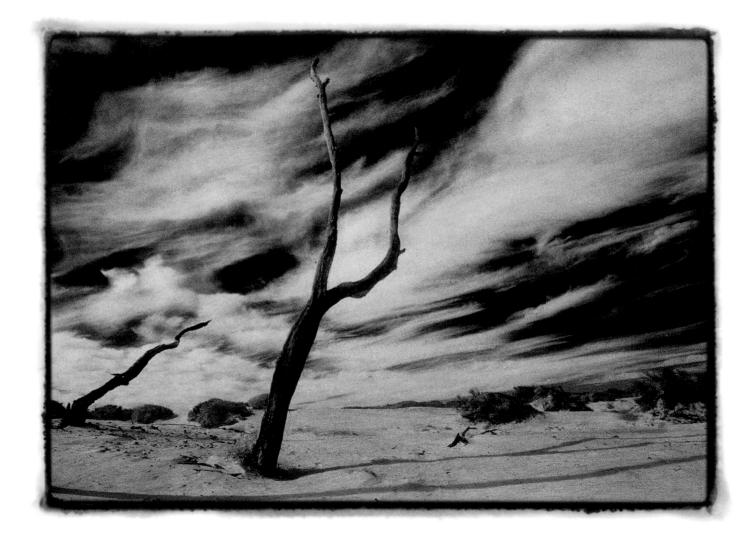

Forest buried by dunes / COASTAL GEORGIA

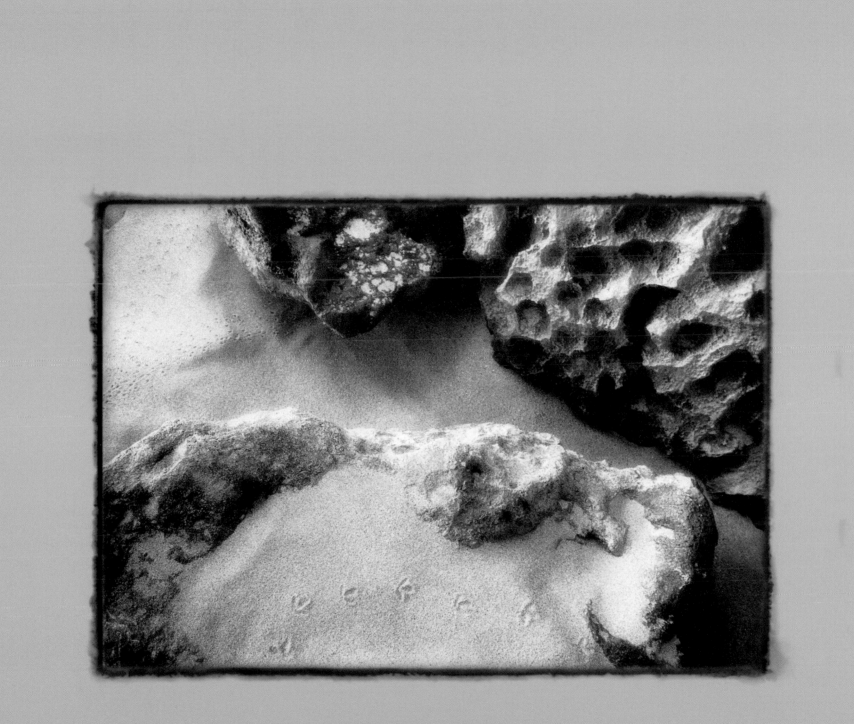

Beach detail / MOLOKAI, HAWAII

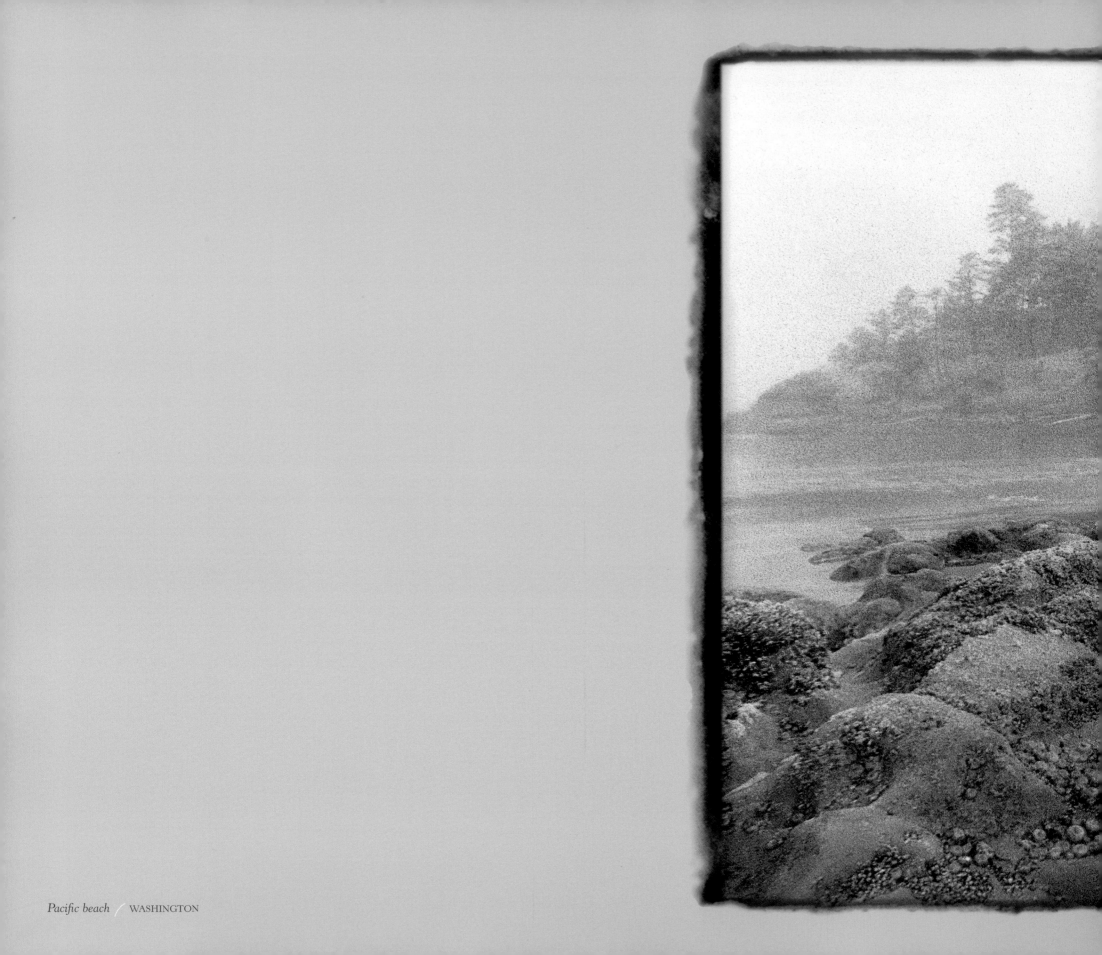

Pacific beach / WASHINGTON

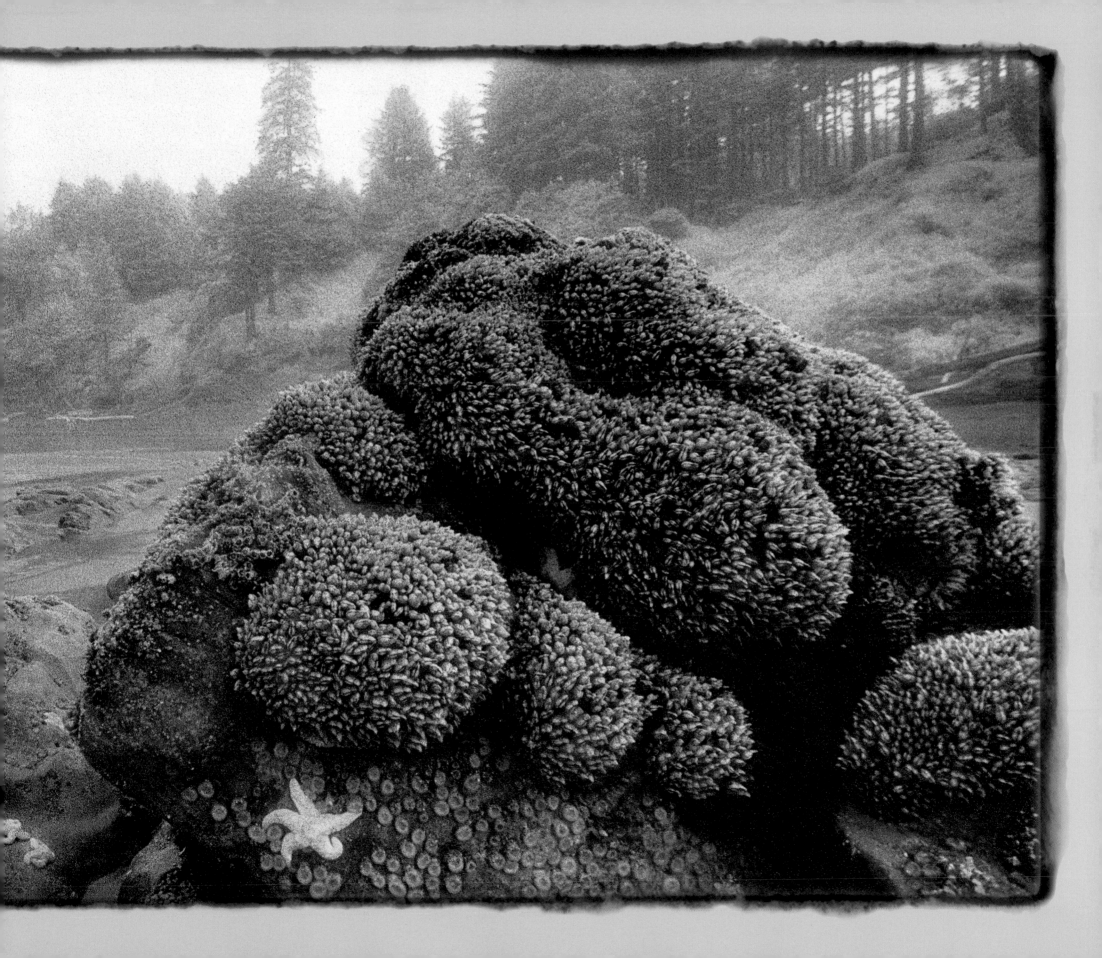

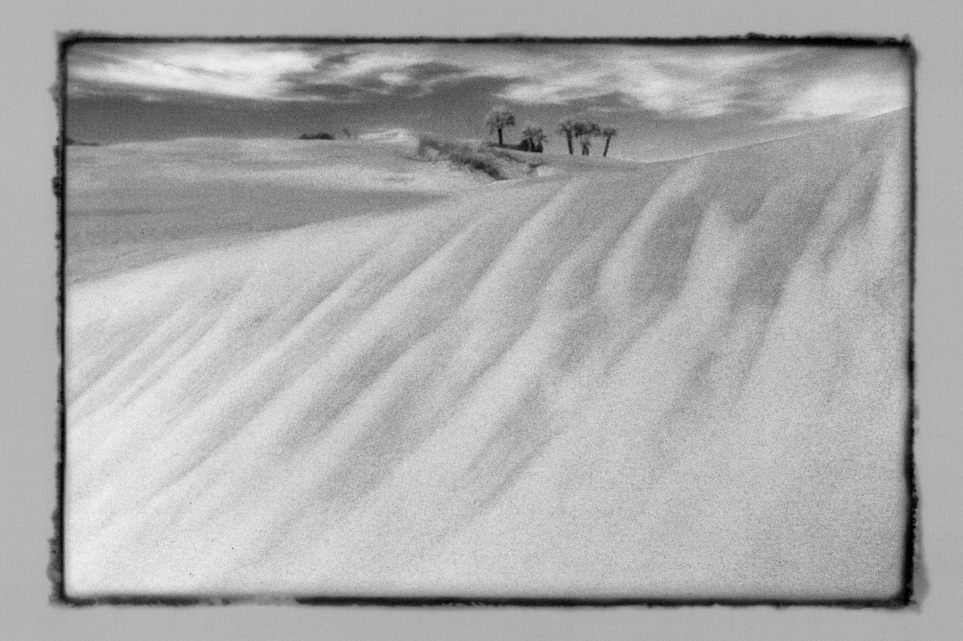

The health of the eye demands a horizon.
We are never tired — so long as we see far enough.

RALPH WALDO EMERSON

Dunes / GEORGIA BARRIER ISLAND

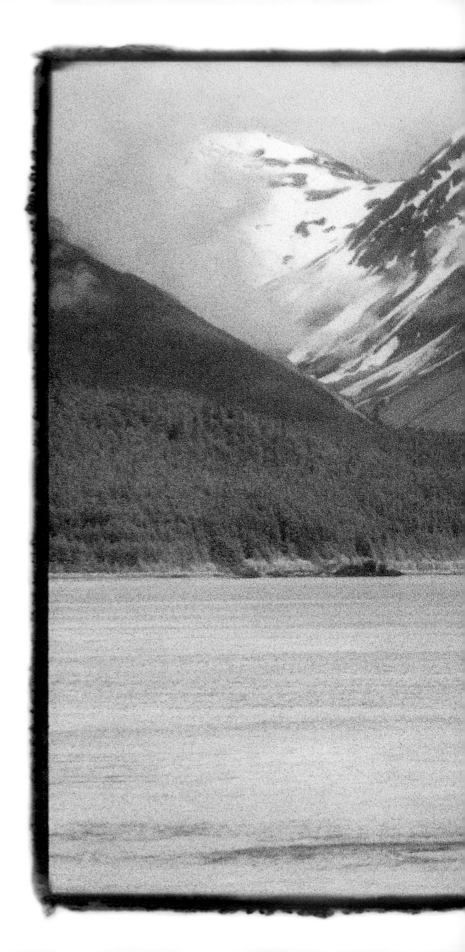

Humpback whale / COASTAL ALASKA

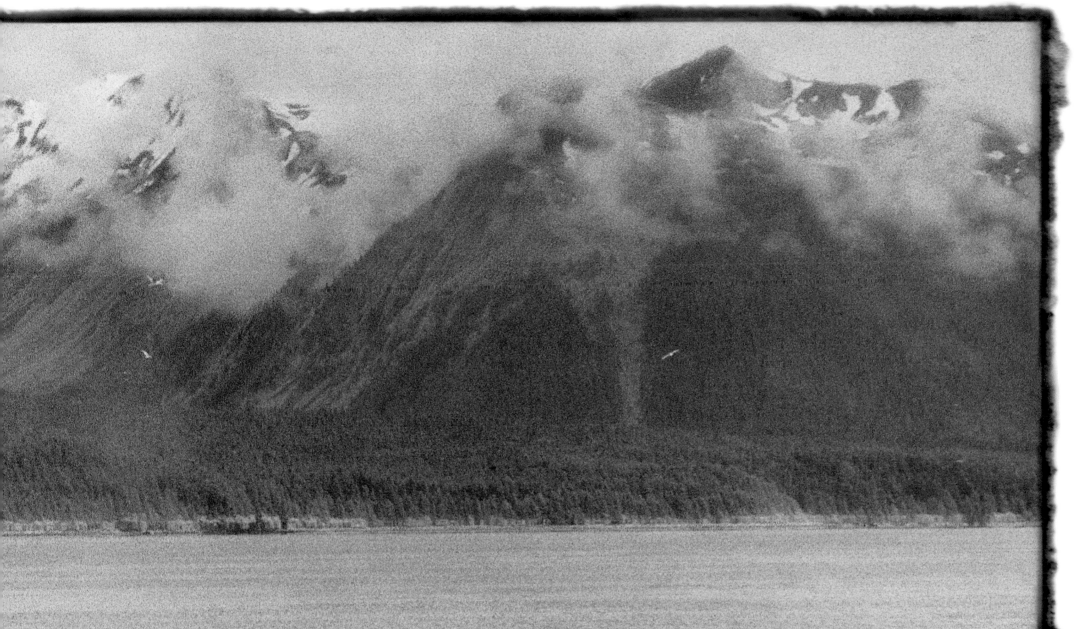

Grasslands

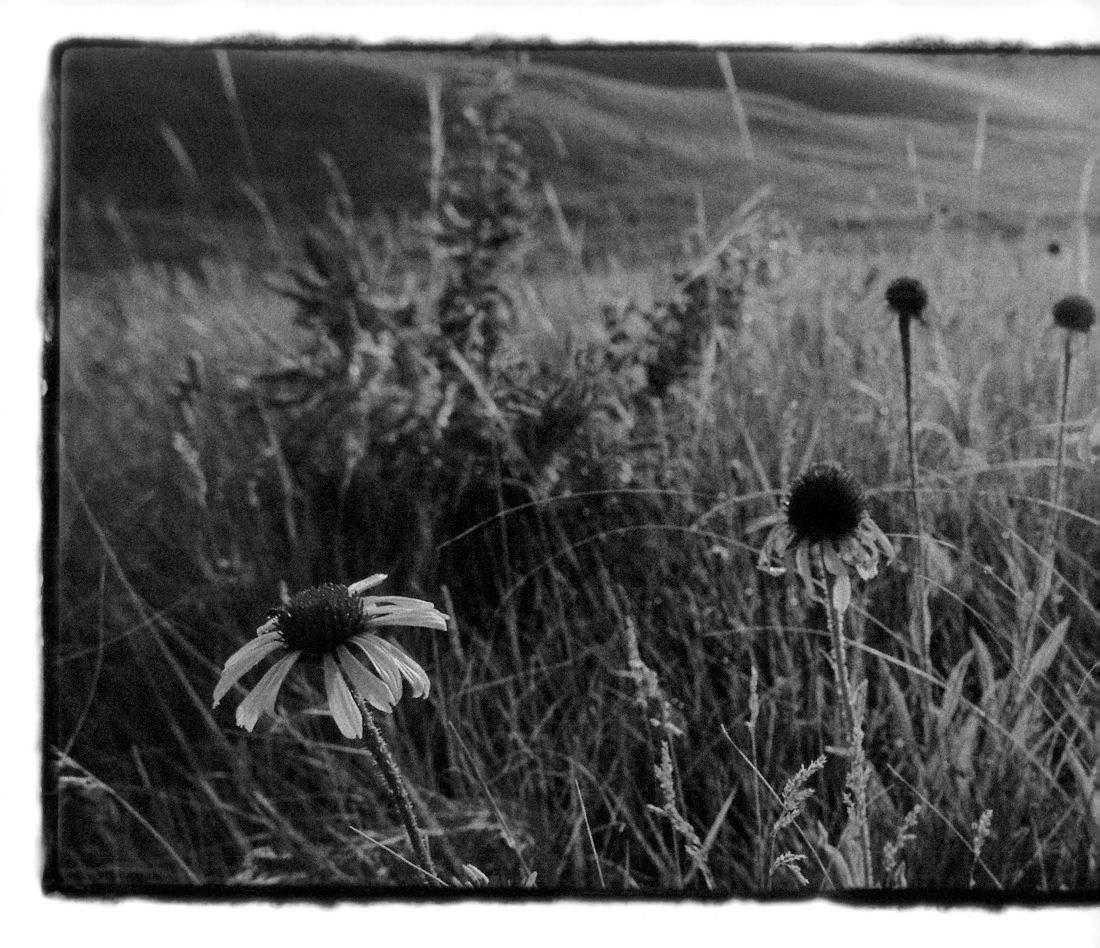

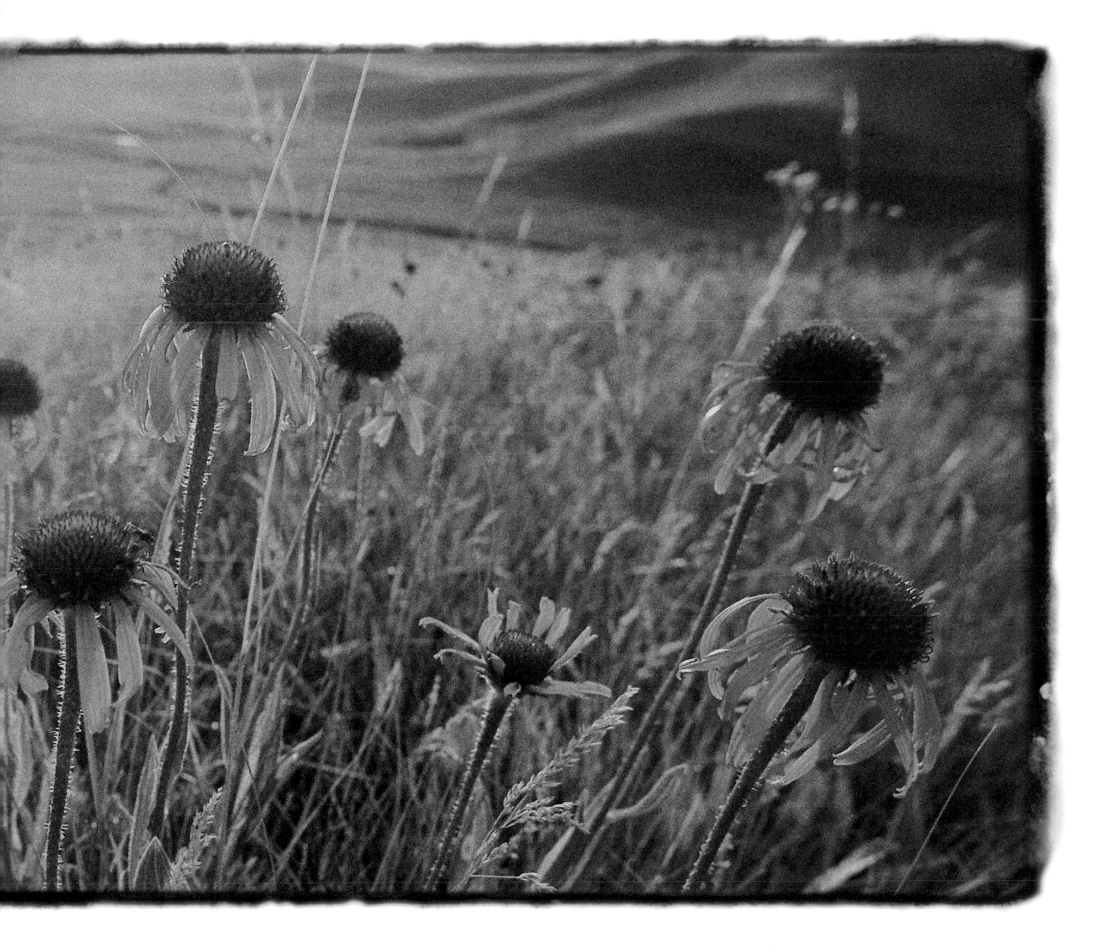

No living man will see again the long-grass prairie, where a sea of prairie flowers lapped at the stirrups of the pioneer.

ALDO LEOPOLD

Sea oats / SOUTH CAROLINA

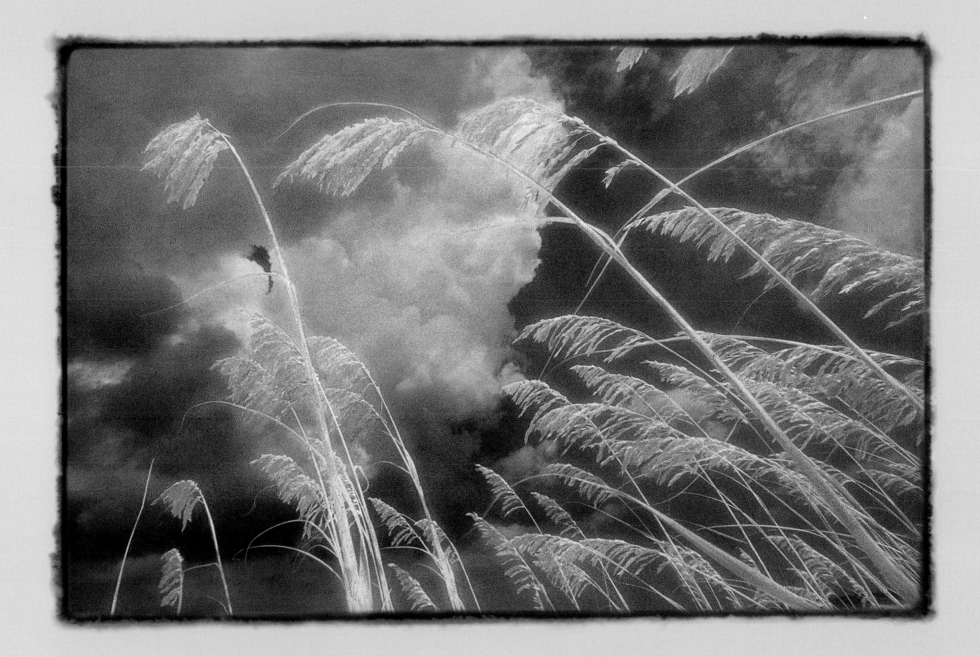

In the late 1940s a professor at the University of Wisconsin had the habit of noticing a certain country graveyard. He always passed it while driving to the washed-out farm on the Wisconsin River his family used as a weekend retreat. The little cemetery had the usual snaggletoothed array of old headstones decorated with fading bouquets. Its only remarkable feature was its shape: triangular, with one acute corner inside its fence that was impossible to mow efficiently. And so, purely by accident, the cemetery harbored a tiny remnant of the native prairie into which the graveyard had been dug a century before. To the pioneers who buried their loved ones in that plot, the grasslands surrounding them must have seemed daunting, as unconquerable as the ocean. Astonishingly, by the time the professor and his family came to spend weekends on their sand farm, that ocean had become droplets. The professor watched the graveyard relic with a poignant care, noting how it changed with the seasons:

"Hertofore unreachable by scythe or mower, this yard-square relic of original Wisconsin gives birth, each July, to a man-high stalk of compass plant or cutleaf Silphium, spangled with saucer-sized yellow blooms resembling sunflowers. It is the sole remnant of this plant along this highway, and perhaps the sole remnant in the western half of our county. What a thousand acres of Silphiums looked like when they tickled the bellies of the buffalo is a question never again to be answered, and perhaps not even asked.

This year I found the Silphium in first bloom on 24 July….

When I passed the graveyard again on 3 August, the fence had been removed by a road crew, and the Silphium cut. It is easy now to predict the future; for a few years my Silphium will

try in vain to rise above the mowing machine, and then it will die. With it will die the prairie epoch....If I were to tell a preacher of the adjoining church that the road crew has been burning history books in his cemetery, under the guise of mowing weeds, he would be amazed and uncomprehending. How could a weed be a book?"

The professor was Aldo Leopold, a man whose knowledge of botany, evolution, and the new science of ecology allowed him to read every leaf and season of the wild world as history book and floral encyclopedia and to translate them into the poetry of *A Sand County Almanac.* He would help change our view of landscape from still life to active drama. In the rings of a felled tree or the light tracings of grouse tracks on a creek bank, he led us to look at a moment and see eternity. Surrounded by the tamed Midwest, he could invoke for us the way it was when the buffalo roamed and silphiums bloomed by the millions.

Most Midwesterners would agree with Aldo Leopold that the interior of the continent is a special place, not for everybody. For the same reasons more people prefer to live in San Francisco or Baltimore than in Iowa, our continent's middle is home to a tough prairie ecosystem that can stand cold winters, hot summers, and drought. The potential evaporation rate here exceeds precipitation; the growing season is limited by freezing springtime temperatures and rainless autumns. Until recently, fires swept across the land with ferocious regularity; occasionally they still do. There is a reason why virtually all the world's large grasslands grew up in the centers of continents. Far from the moderating influence of ocean, life is severe: It's no place for delicate ephemerals or trees. It's a place for grass, plains of it, endless and awesome.

North America's great grassland took root about 25 million years ago, when the Rocky Mountains pushed upward and began to capture all moisture-bearing winds from the Pacific. The dry western plains

became short-grass prairie; farther east, where moisture from the Gulf of Mexico contributes to an annual rainfall of up to 40 inches, the grass grows tall. Throughout eons of advancing and receding glaciation, boreal forests marched down over the tallgrass prairie, then receded from it, during millennia of never-settled skirmishes between these two ecotypes. When the first European settlers walked into this drama they found mostly forests from the coast into present-day Indiana. But from the Wabash River westward, they encountered more grass than they'd ever imagined: bluestem, switchgrass, Indian grass, 240 million acres of it in all. And underneath lurked a root system like the bulk of the iceberg; some 90 percent of a prairie's biomass lies beneath the sod, providing the stems and leaves up above with the means for surviving drought, lasting out long winters under blankets of thatch and snow, and living through fire as well. Prepared to endure temperatures between minus 40°F and 400°F, the eternal life of the prairie lies in its roots.

But it couldn't survive the plow. Waves of incoming settlers battled and ultimately beat the tough prairie sod, reinventing the tool that could cut through it, tapping eagerly into a vein of soil as black as coal and richer than any dirt yet known. North America had taken 25 million years to build topsoil like that. And in less than 80 years, the whole 240 million acres was converted to cropland. It was one of the most massive biological alterations humans have ever affected on our planet in such a short time. Almost before we knew we could do it, we'd reduced the enormity of the prairie to a handful of remnant islands — a graveyard corner here, a tiny state park there, nearly lost in the sea of corn and soybeans.

It's hard to know where to begin, when calling the roll of the lost — countless plant species, from small starry-eyed flowers to undulating grasses that grew 12 feet tall. A massive movement of bison that turned the interior of the continent into one vast, functional ecosystem, with cowbirds and bow hunters and prairie regrowth following in endless, circular migration. The grace of elk, the booming of prairie

chickens, and the human cultures that organized themselves around this lively wild community.

Only lately, it seems, have we come to think twice about what we plowed under on our way to agricultural bounty. I did not learn until adulthood that my own home state, Kentucky, once was covered with large stretches of grasslands. They were called "barrens" by early German settlers, who mistook the absence of trees for an absence of fertility but soon found otherwise as they turned it under their plows.

Now, in what seems like miraculous resurrection, some farmers in those regions have discovered that after burning off fescue and other non-native pasture grasses, or taking tired land out of row-crop agriculture, they may witness the regrowth of native grassland species from seed banks that have lain dormant in the soil for many decades. In a recent summer of hard drought, long after every fescue field had withered to brown, some farmers who had restored their pastures to native grasses found a steady stream of passersby stopping to ask about these mysteriously lush green fields. The resilience of the prairie may yet outlast our resolve to remove it.

Native grasses are a compelling new crop for Kentucky, where farmers are desperate for an alternative to the single crop — tobacco — that anchored the economy for the last century. For use on state lands and highway medians, drought-resistant pasture, and habitat restoration projects, the seed of native prairie grasses is a valuable commodity. In western Kentucky I visited a farm cooperative and walked through the sibilant stillness of a 50-acre field of big bluestem. I thought that day of Professor Leopold. He lived his life for the memory of prairie and died in its embrace, while trying to help his neighbors fight a grass fire. Aldo would have been delighted, I think, to see this new kind of farm, where an old crop was plowed under to make way for an even older one. He would have loved to see how things come around.

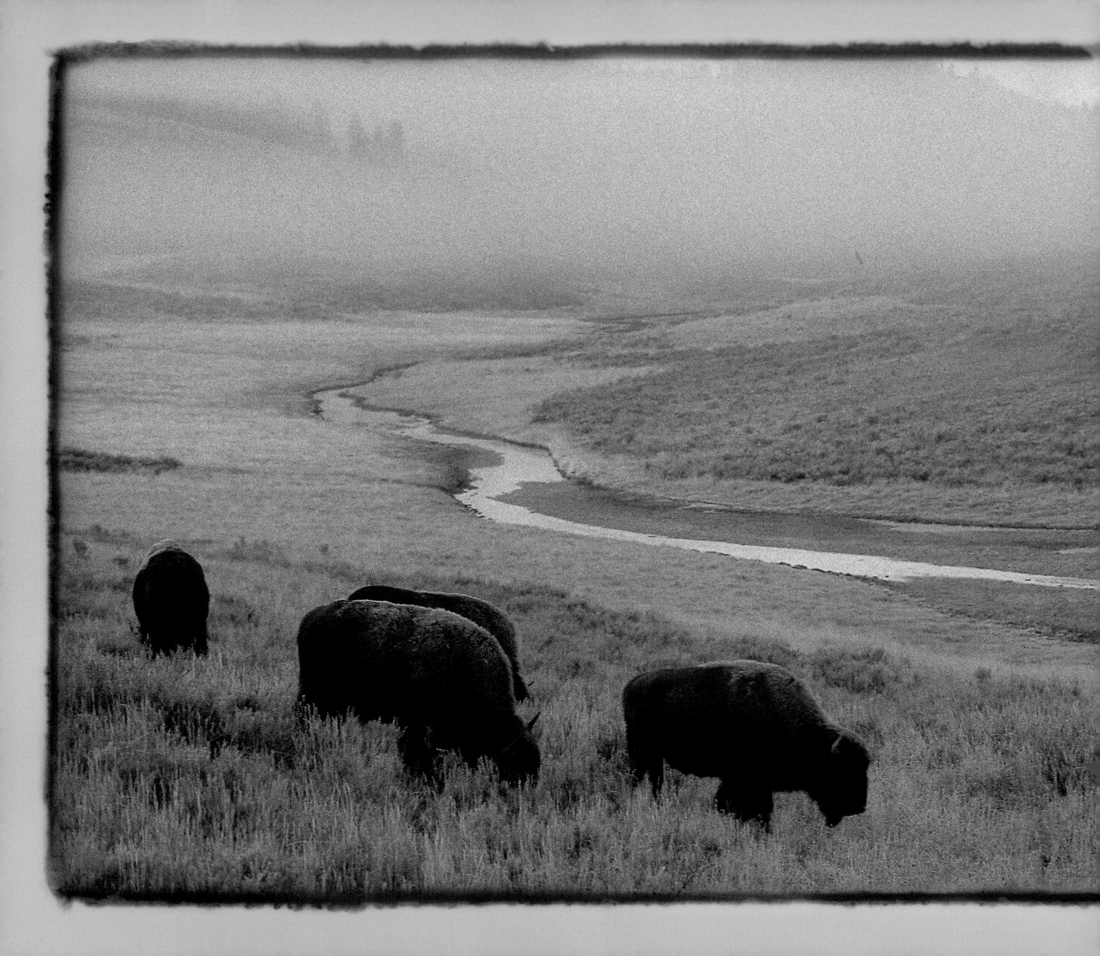

An endless caravan of generations has built of its own bones this bridge into the future....

ALDO LEOPOLD

Grazing bison / NORTHERN WYOMING

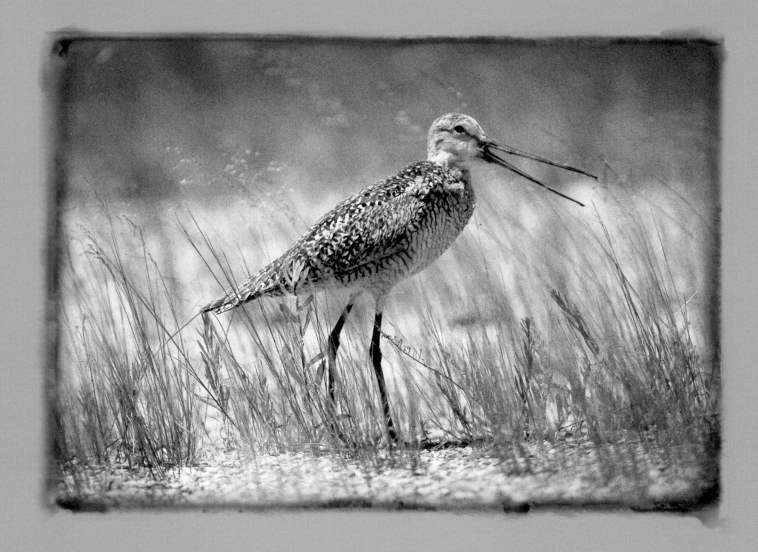

Willet / NORTH DAKOTA

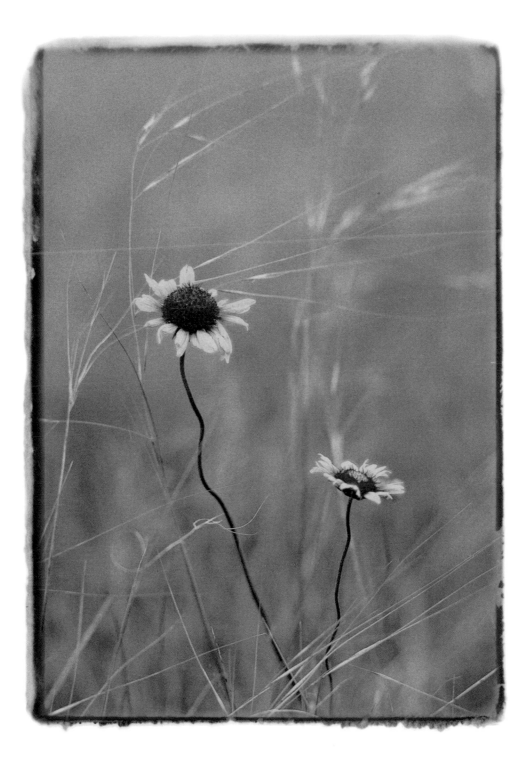

Yellow coneflowers / EASTERN NORTH DAKOTA *(Overleaf) Short-eared owl* / SOUTHERN MINNESOTA

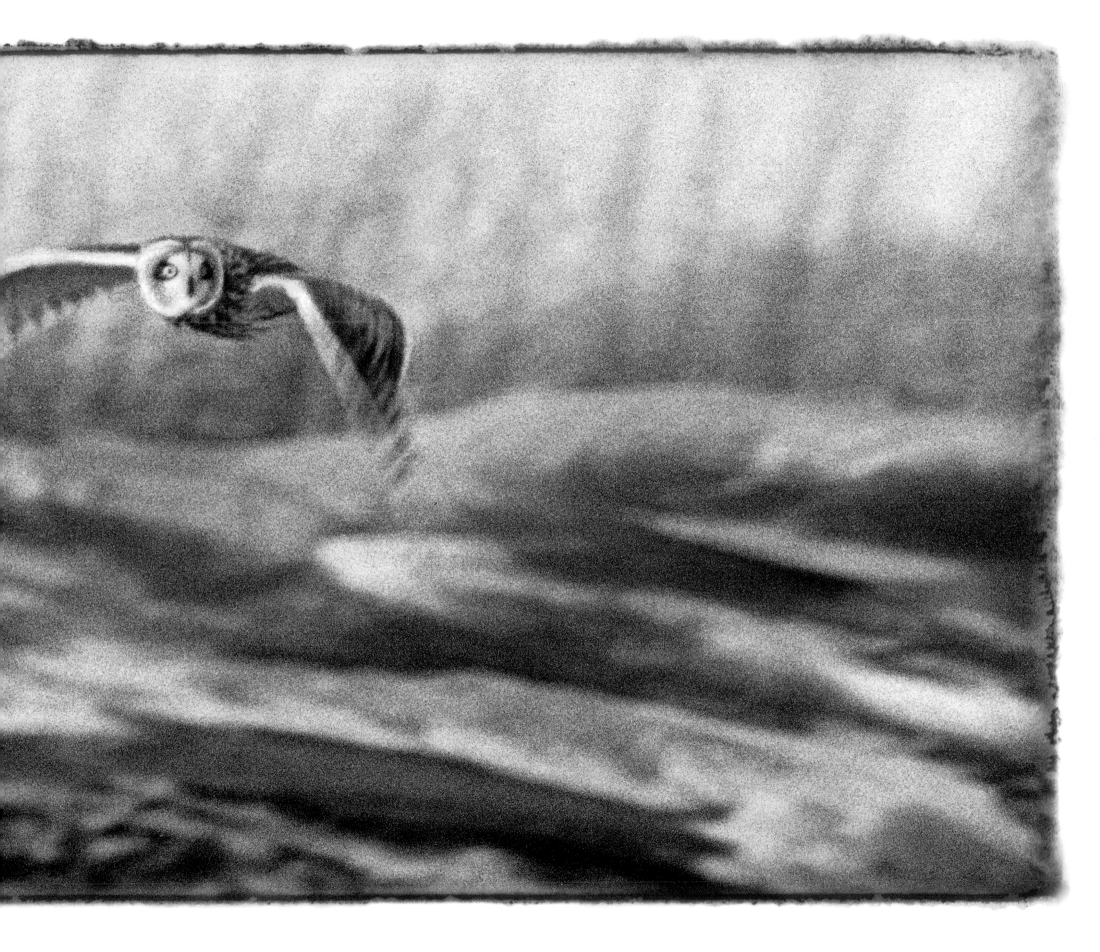

What is life? ...It is the breath of a buffalo in the winter time. It is the little shadow which runs across the grass and loses itself in the sunset.

<div align="right">CHIEF BLACKFOOT</div>

Bison in a blizzard / NORTHERN WYOMING

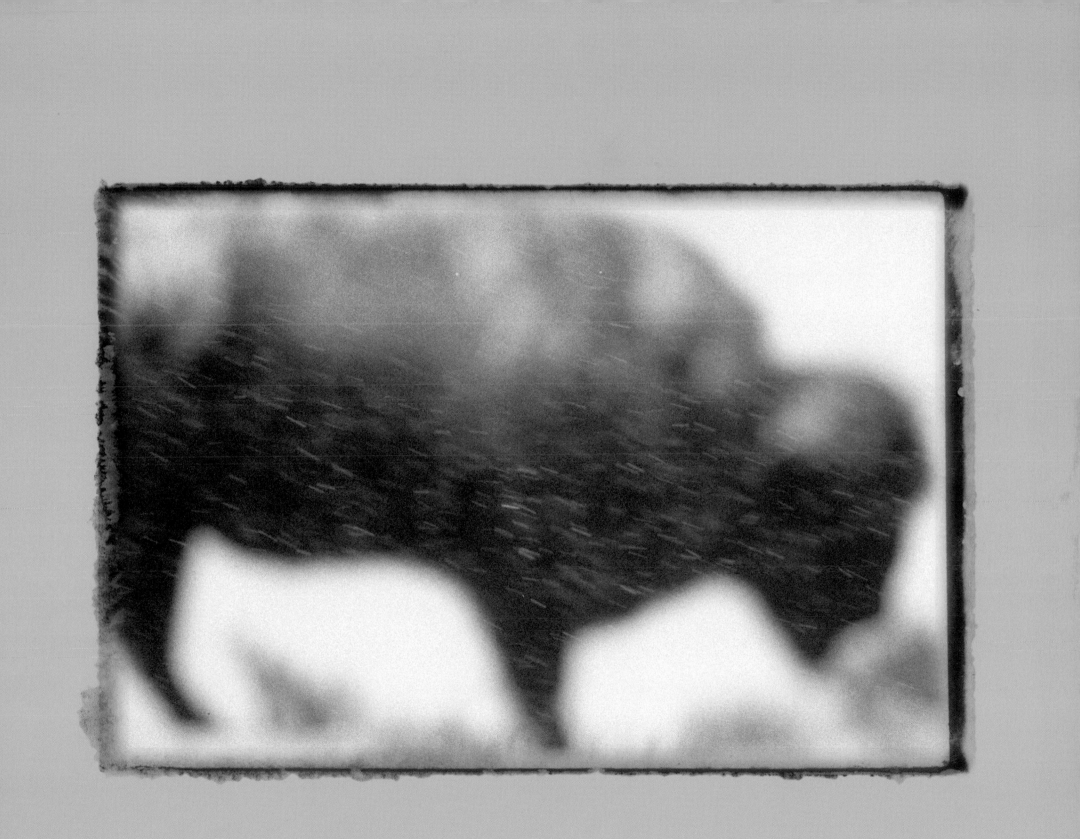

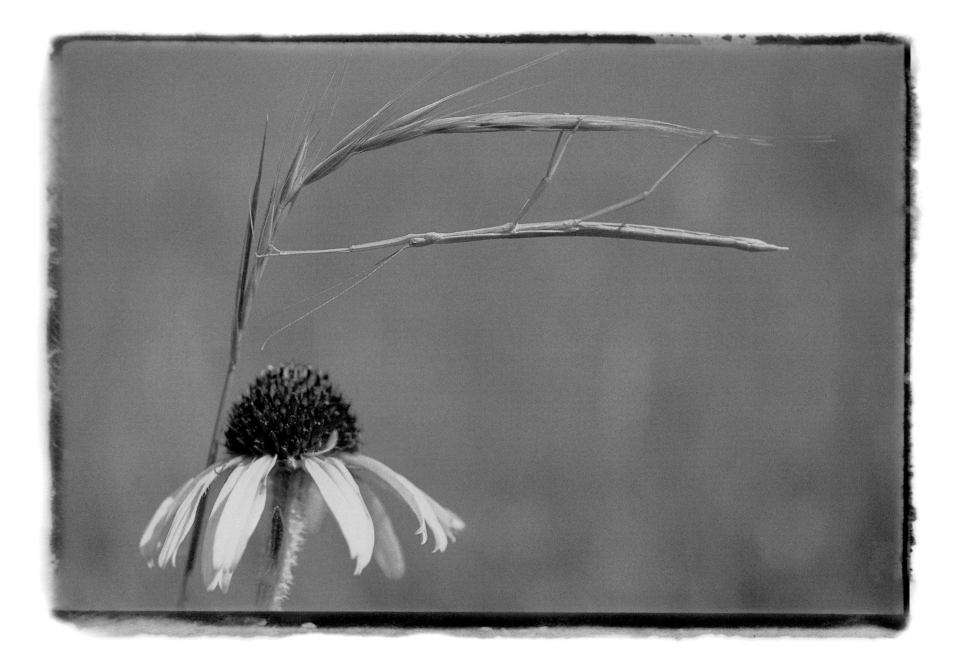

Walking stick perched on a coneflower / WESTERN SOUTH DAKOTA

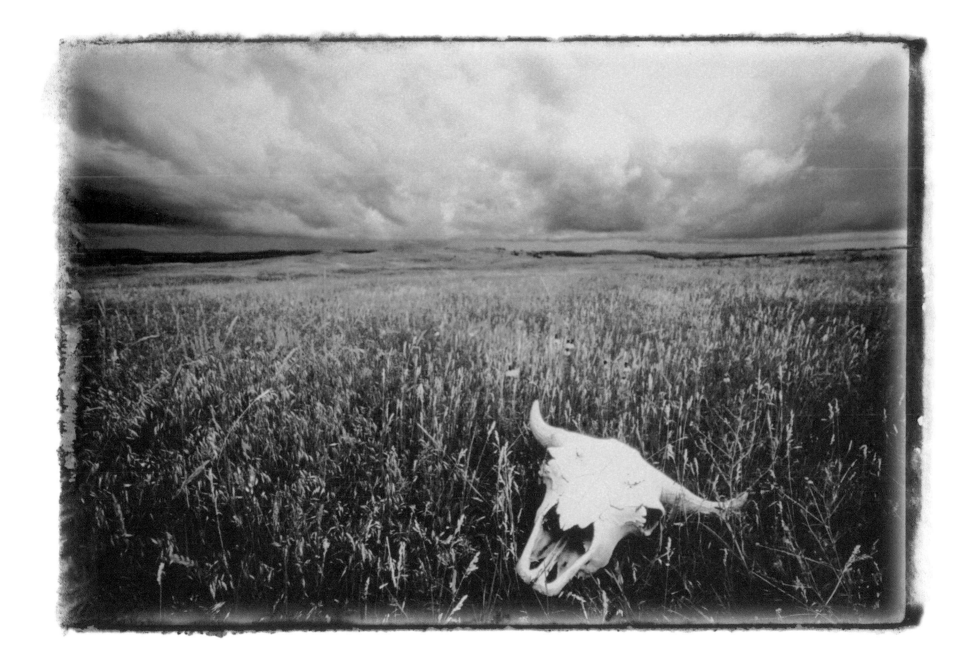

Bison skull / SOUTH DAKOTA *(Overleaf) Salt marsh* / COASTAL SOUTH CAROLINA

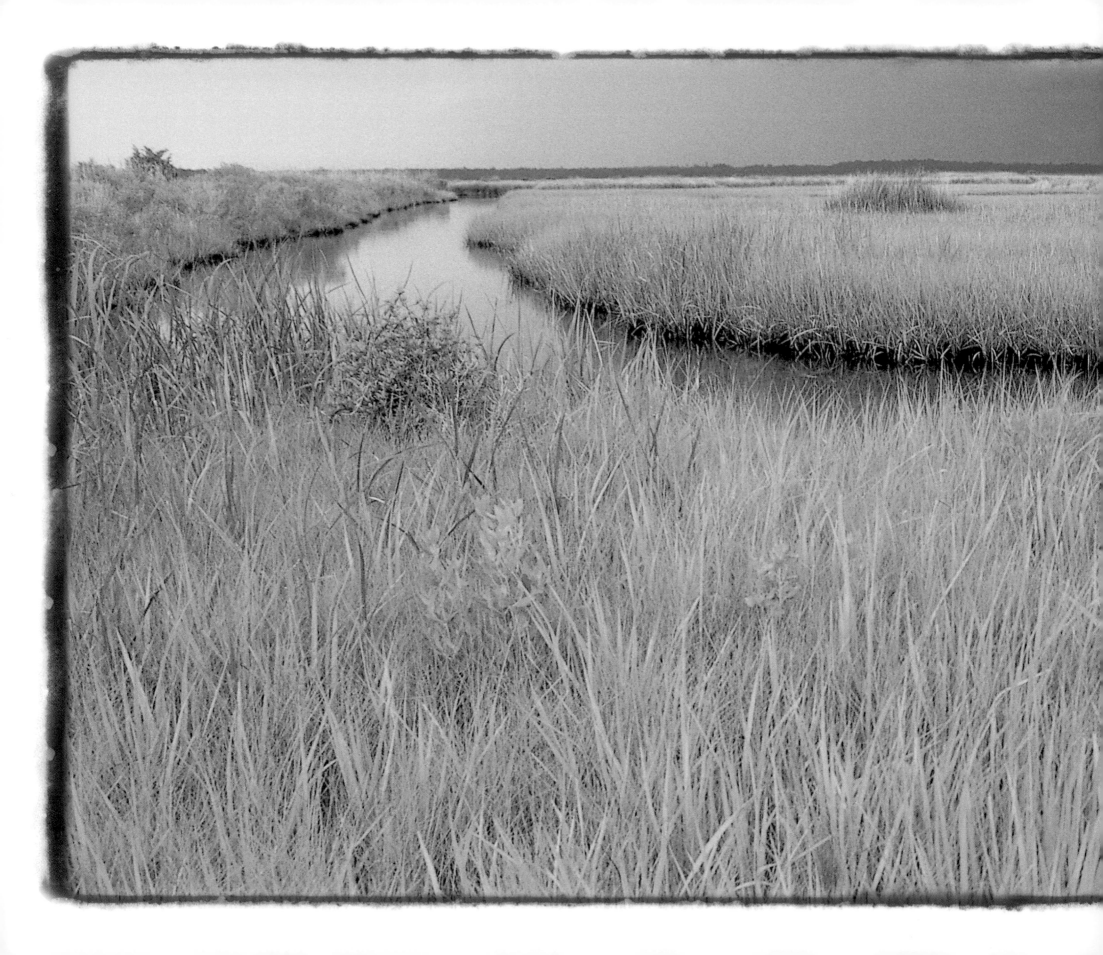

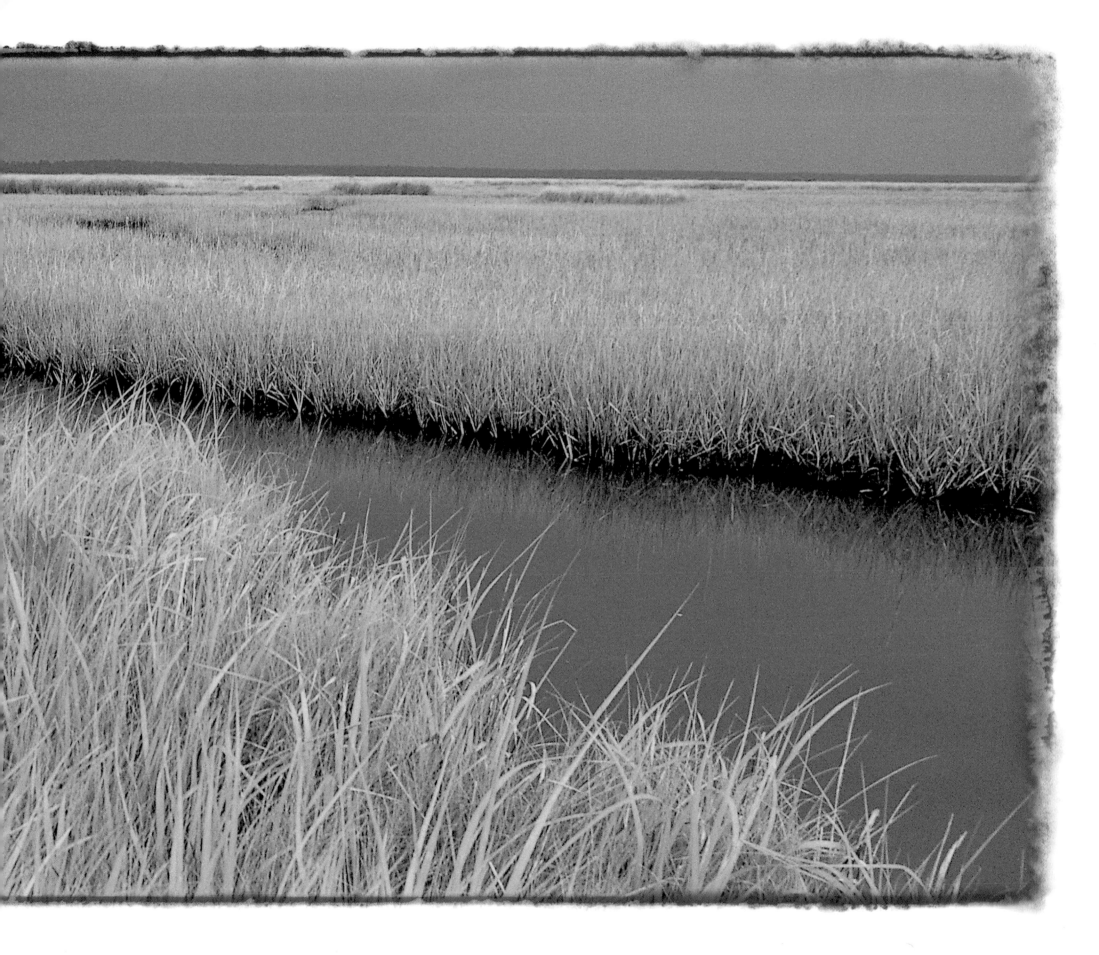

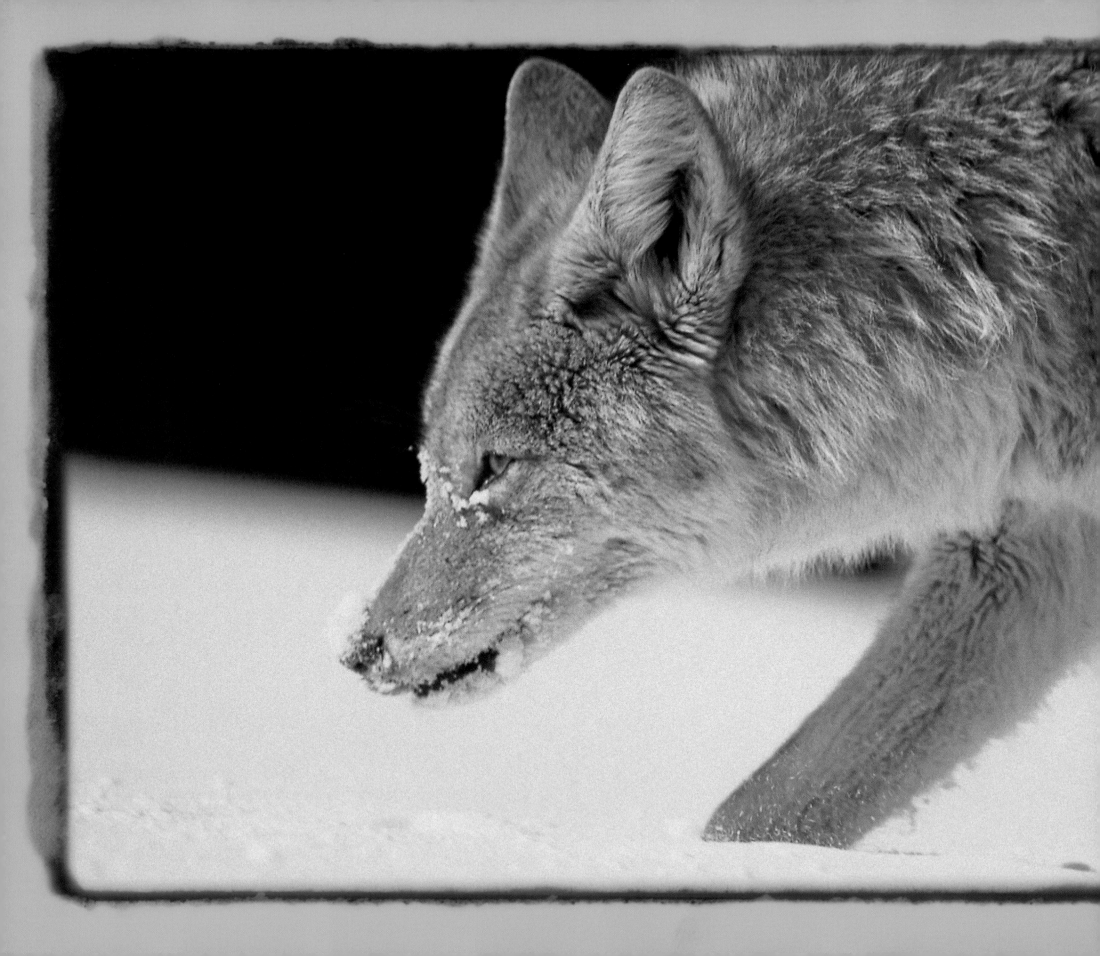

I am glad I shall never
be young without wild country
to be young in.

ALDO LEOPOLD

Coyote in winter / NORTHERN WYOMING

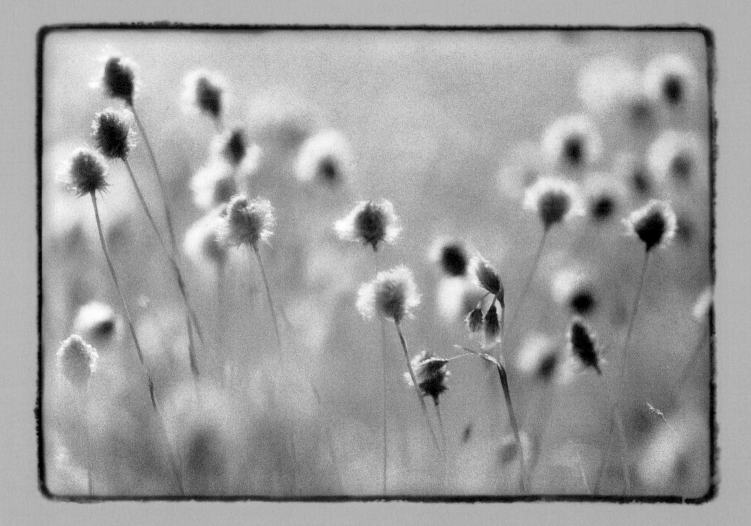

Cotton grass / ARCTIC NATIONAL WILDLIFE REFUGE, ALASKA

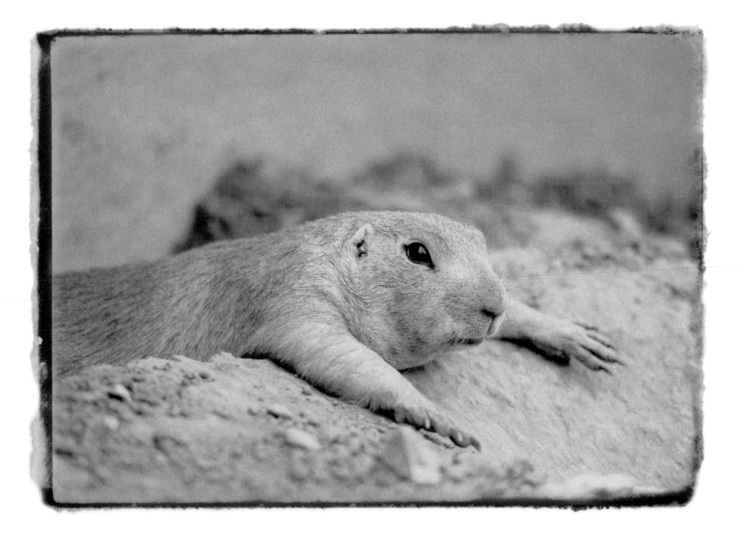

Prairie dog / OKLAHOMA *(Overleaf) Grasslands and buttes* / WESTERN NEBRASKA

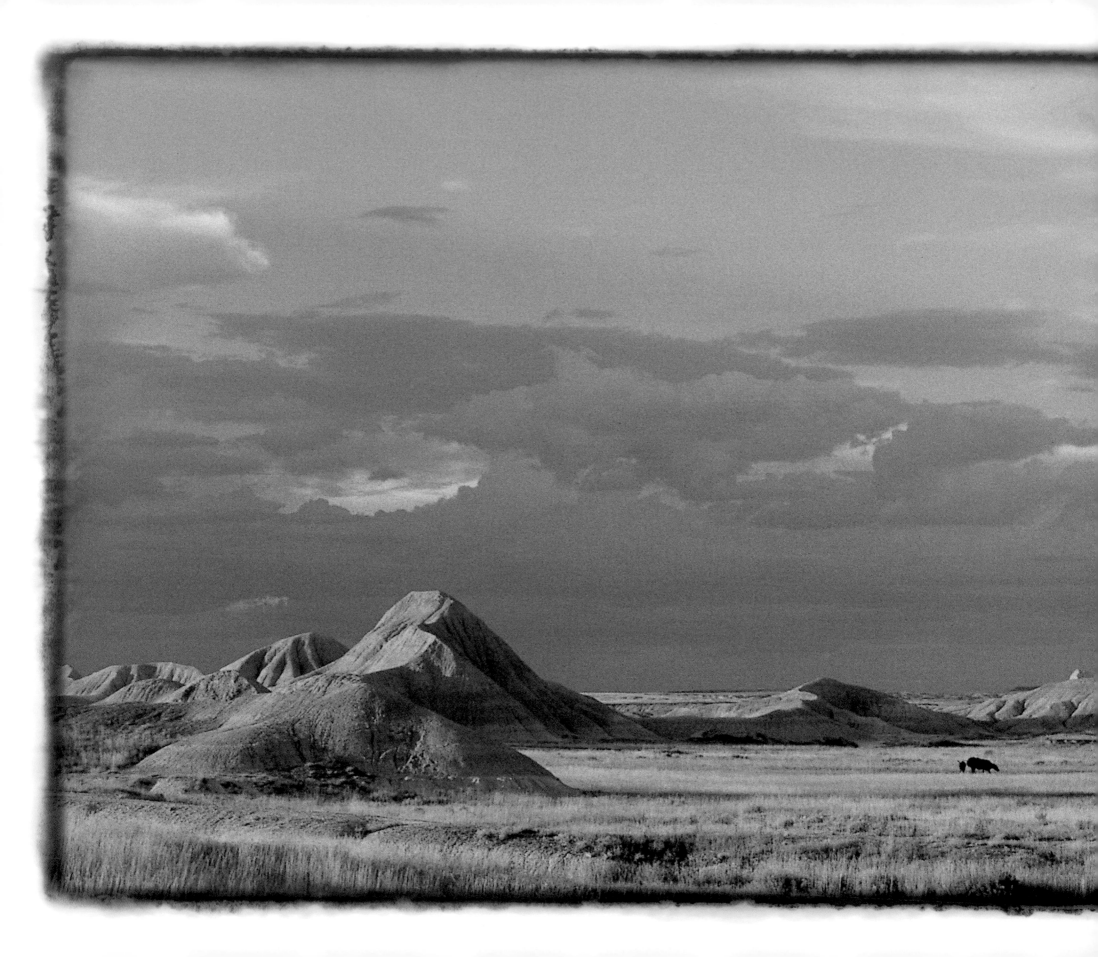

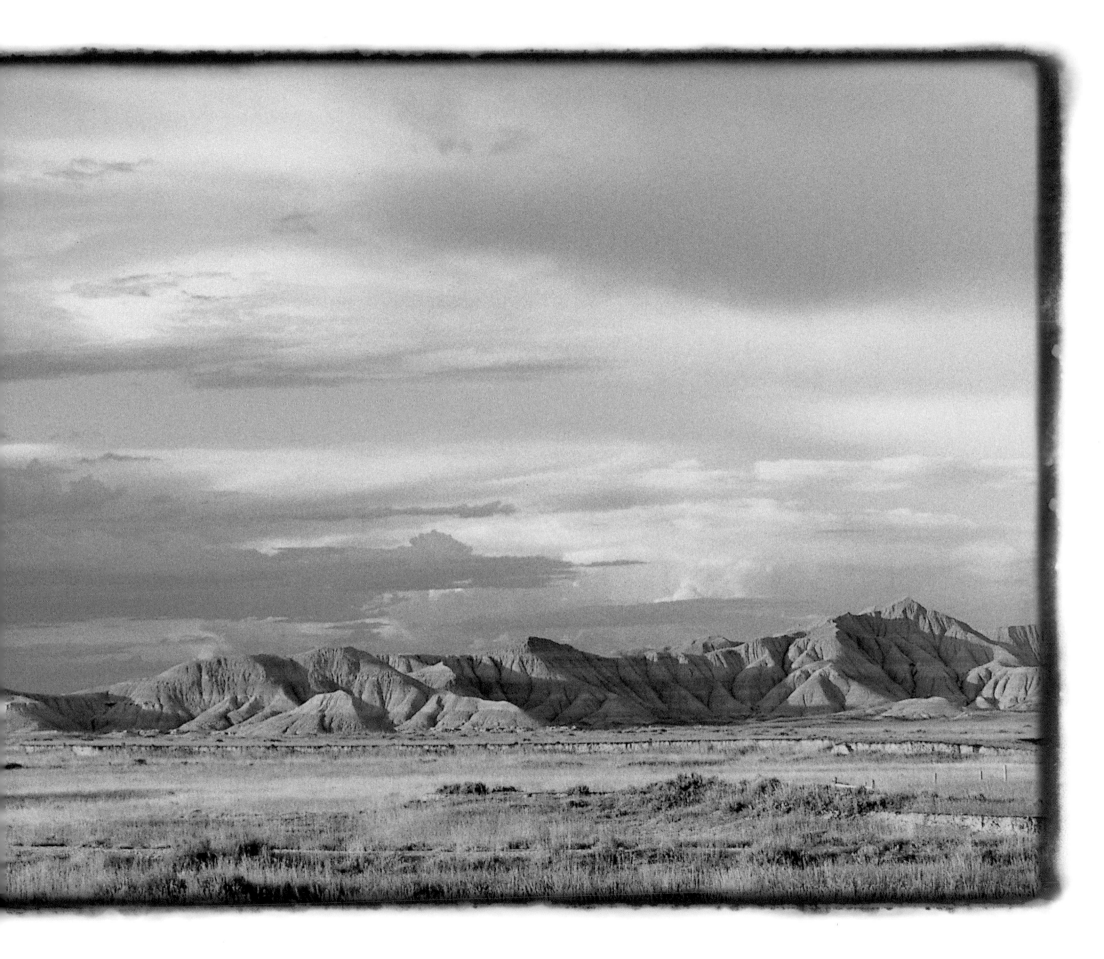

I would be converted to a religion
of grass....grow lush in order to be
devoured or caressed.

LOUISE ERDRICH

Prairie grass / KANSAS

Drylands

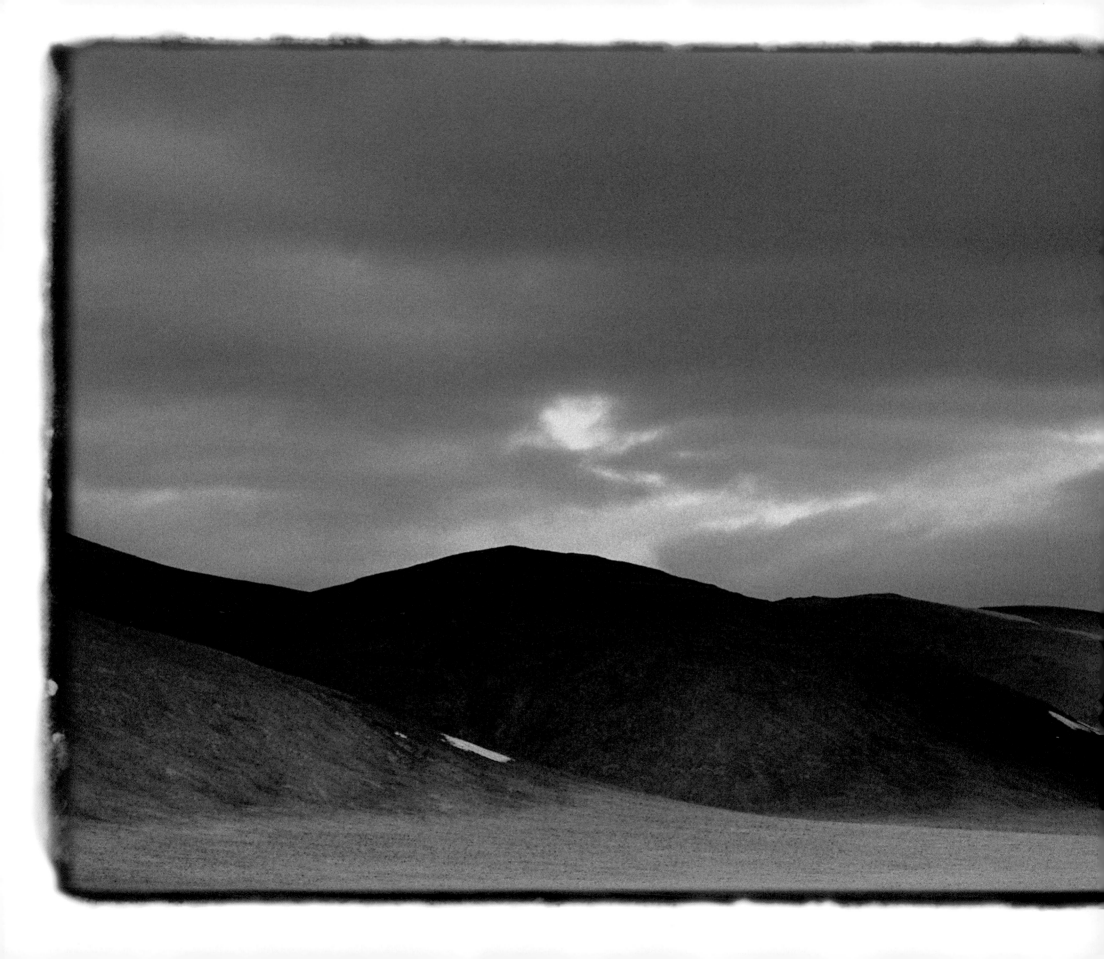

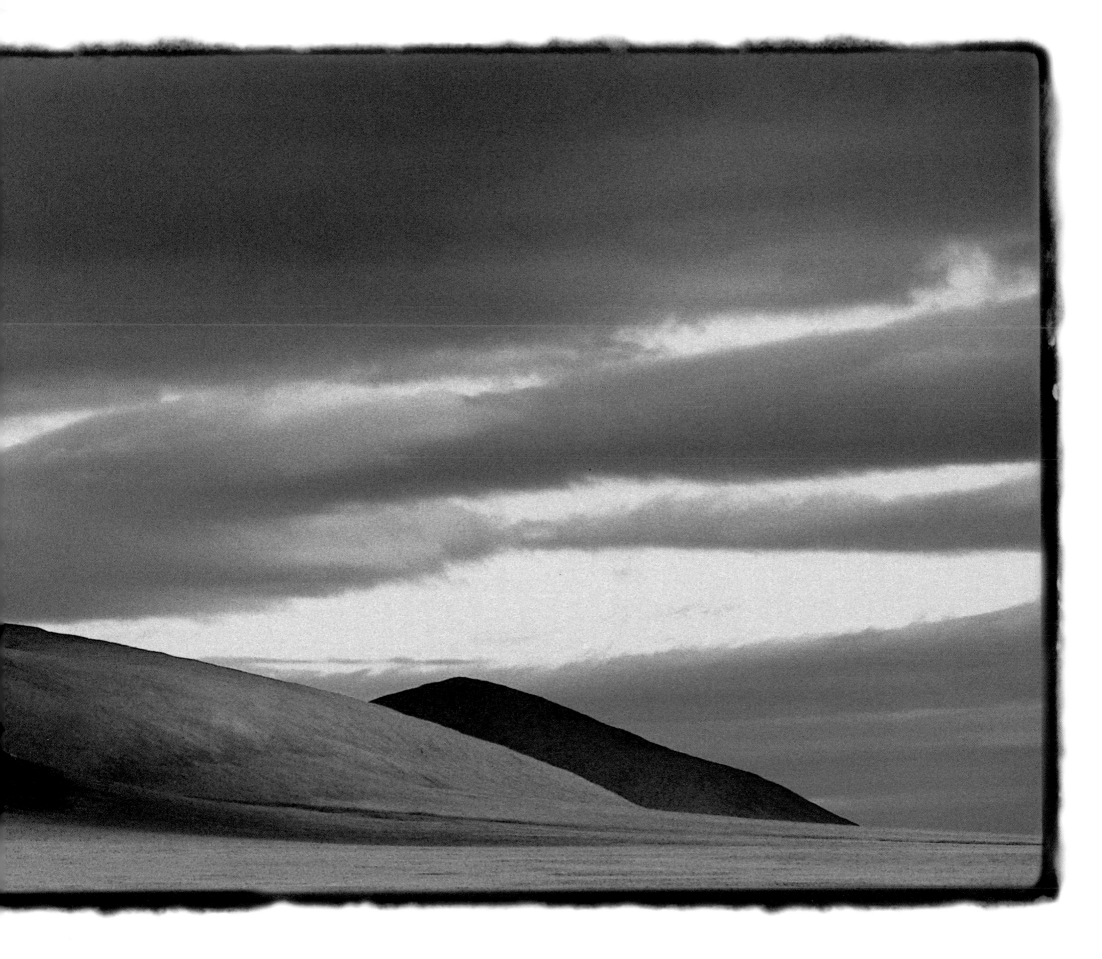

How strange and wonderful is our home, our earth....
We are none of us good enough for the world we have.

<div align="right">EDWARD ABBEY</div>

Cholla and saguaro cactuses / WESTERN ARIZONA

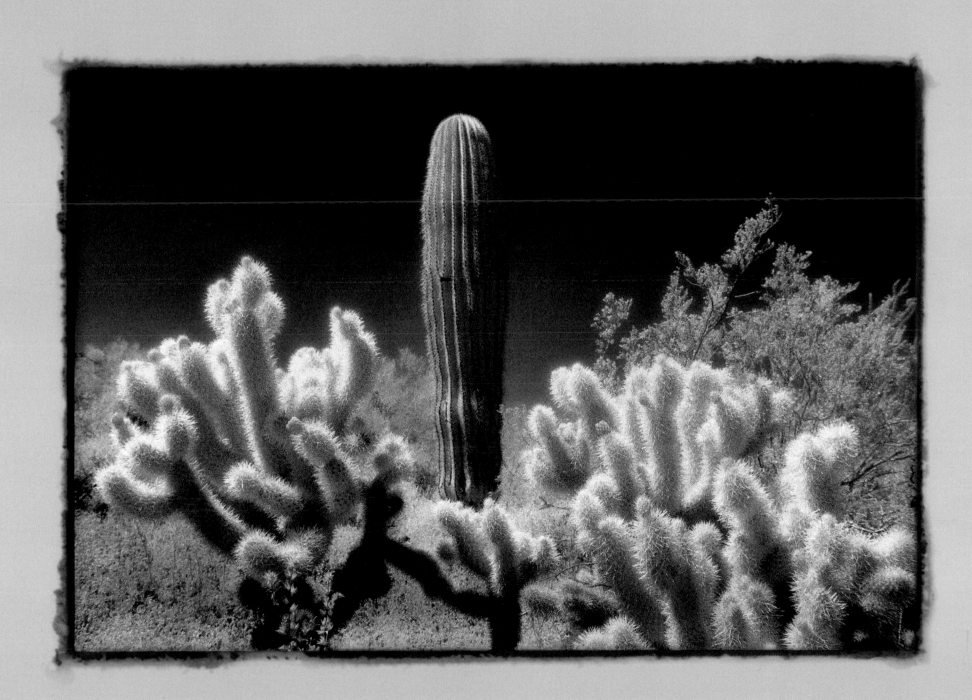

The human imagination seems to reserve its greatest dread and reverence for drylands: We name them badlands, wastelands, *deserted*. From Siberia to Monument Valley, these ends of the Earth have long been considered places of exile and emptiness reserved for populations that needed to be pushed from greener pastures.

And just as surely as we deprecate the hostility of these lands, we also understand somehow that they are God's country. We have designated many thousands of acres of our western deserts as preserves, and the names we give these places — Zion, Thunder Mesa, Desolation Canyon — disclose an uneasy knowledge that they are ruled by forces we can't control. We're awed by these landscapes where Earth and eons will lie down together and reveal themselves to us so completely. We've encountered no other valleys like the western gulches and coulees where the land's mineral bones are bared, revealing the deepest colors of her secret history. No ceremony on Earth can compare with sunset over an Arizona canyon: The yellows deepen to orange, the red cliffs blush scarlet. The peaks of pointed buttes light up like candles, and then, one by one, they are snuffed out by the cool, silent wind of nightfall. Sinuous valleys darken and fill with blue shadow. A haze on the air glows in the slanted light.

Drylands are a permanent consequence of the Earth's immense exhalations. Moist air warmed by the sun at the Equator continually rises, cools, and then descends in great cascades of air falling toward the north and south, sucking up every molecule of water to be had, while tumbling earthward. These strange, reverse waterfalls of atmosphere descend from a high-pressure belt at the horse latitudes into the flow of tropical trade winds and touch down on broad arid belts that circle the planet between 15° and 30° north — the Sahara, Libyan, Arabian, Lut, Thar, Sonoran, Chihuahuan, Mojave, and Great Basin Deserts — and the equivalent latitudes in the Southern Hemisphere, where lie the Namib and Kalahari of Africa,

the Australian outback, and the Atacama of South America. Geographers call these the horse latitude deserts – a name that conjured for me, in childhood, visions of Arabian stallions racing across the sand. (I eventually learned the name derives from the Spanish *golfo de las yeguas,* or "mare's sea.") These familiar xeriscapes give shape to our notion of desert. But far to the north and south of them is a second tier of deserts encircling the poles where a meager precipitation, sometimes less than five inches annually, falls on the perennial ice fields of Antarctica and Greenland and the tundras of North America and Eurasia.

All these drylands encircling the globe are stitched together by the desperate fragilities they share, though they do not look fragile. Their surfaces may be rugged mountains, gravel slopes, or windswept plains of ice; they seldom conform to the cliché of shifting sands. In fact, windblown dunes cover only about 10 percent of the Sahara and less than 2 percent of North American deserts. Far more common are talus slopes and sculpture galleries of eroded bedrock — mineral boneyards, insofar as human utility may be concerned, but infinitely devoted to their own purposes. "The desert is a vast world, an oceanic world, as deep in its way and complex and various as the sea," wrote Edward Abbey, a man who lived and died in the desert, gave himself over to its preservation and spoke for it as no one else ever has. "If a man knew enough he could write a whole book about the juniper tree. Not juniper trees in general but that one particular juniper tree which grows from a ledge of naked sandstone near the old entrance to Arches National Monument."

That gnarled juniper tree, both unlovely and beautiful, is a good representative of the fierce resourcefulness that is the recurring biotic theme of all the world's arid lands. Deserts on nearly every continent have some mammal that looks like a kangaroo rat and a prickly assortment of water-storing plants that resemble a cactus. The Old World's spiny euphorbias and the cactuses of the Americas are

genetically unrelated but have been drawn to convergence by the similar evolutionary pressures of a land with little water and no mercy. Deserts are not deserted; on the contrary, they are filled with life-forms that distinguish themselves through extraordinary strategies of persistence: Tough waterproof integuments, nocturnal habits, predator-discouraging spines, and strange physiologies are the order of the land. Some desert reptiles and rodents excrete their urine in a highly concentrated form so as not to waste water and may live out their entire lives without ever drinking a drop. Dryland trees may shed all leaves and appear dead to the world for months or seasons at a time as they patiently wait out a drought, holding their breath between rains. At the opposite end of time's spectrum, ephemeral desert wildflowers rush through their life cycle from germination through blossoming and seed set in the few short weeks that adequate moisture is allowed them by late winter rains.

Desert-dwelling amphibians like the spadefoot toad follow the same mad dash: After mating noisily in a summer storm, they lay eggs that will hatch and hurry through tadpolehood in just days, in a quickly shrinking puddle. The ocelot prowls through narrow streambank forests to find enough prey to sustain life in the desert. In a longer search, arctic terns and certain sandpipers migrate each year from the Arctic to the subantarctic reaches of Patagonia and back again, following the sun and food across the length of our planet. The great white bear is circumpolar instead, staking its claim on the frozen land at a single high latitude and, heedless of any human timetables, routinely traversing every time zone on Earth. The Arctic National Wildlife Refuge is home to herds of caribou so vast that their movements alter the landscape as they pass through it, just as mile-wide flocks of passenger pigeons shadowed our continent a century ago. But numbers do not always promise safety.

Tundra and desert are notoriously fragile, easily damaged by human encroachment and slow to

repair themselves, when that is even possible. In the arid Southwest, many species are now endangered by habitat loss. Of the 14 fish once native to the San Pedro River, 12 are extinct; many amphibians, reptiles, and birds face a similar fate. Arctic bird and mammal species will bear their losses in turn, if we exploit the tundra for its oil as thirstily as we have drilled the desert for its water.

Or perhaps we will rein in our appetites. We might yet learn to appreciate our whole Earth as more than the sum of parts we can eat or burn. We seem capable of such vision. "A man could be a lover and defender of the wilderness," wrote Edward Abbey, "without ever in his lifetime leaving the boundaries of asphalt, powerlines, and right-angled surfaces. We need wilderness whether or not we ever set foot in it. We need a refuge even though we may never need to go there. I may never in my life get to Alaska, for example, but I am grateful that it's there. We need the possibility of escape as surely as we need hope…."

I don't know whether he ever saw Alaska. On a late winter's day in 1989, a friend called to tell me our longtime colleague and eccentric neighbor, Ed, was dead. His closest friends had carried his body out into the land he'd loved with all his might and buried him there beneath a huge cairn of rocks. Thus ended half a century of fierce advocacy for a landscape that's slipping away from us while we watch: being paved over, ground to dust beneath automobile tires, or littered with the detritus left by the careless species Ed called *Slobivious americanus*.

I believe all of us who knew Ed — and many more who never got to meet him — made promises to ourselves that day, that we wouldn't let it all go to rest under that pile of rocks in the desert. We know what we must do, what small or great measure of carelessness we need to give up, in order to salvage for our progeny and ourselves the greater gift of a land that roars and whispers of its wildness. We can't possibly give up on it now. There is too much here to love.

Man did not weave the web of life; he is merely a strand in it.

CHIEF SEATTLE

Flowering penstemon / CENTRAL ARIZONA

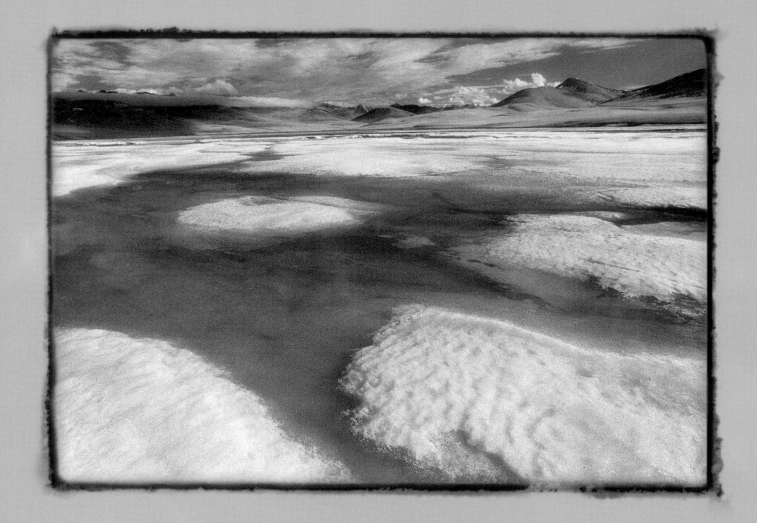

River ice / ARCTIC NATIONAL WILDLIFE REFUGE, ALASKA

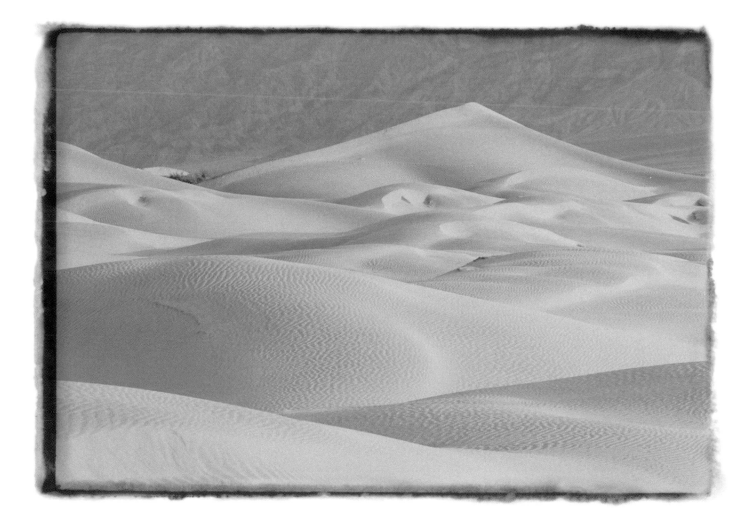

Death Valley dunes / SOUTHEASTERN CALIFORNIA

Endangered Mexican gray wolf / ARIZONA

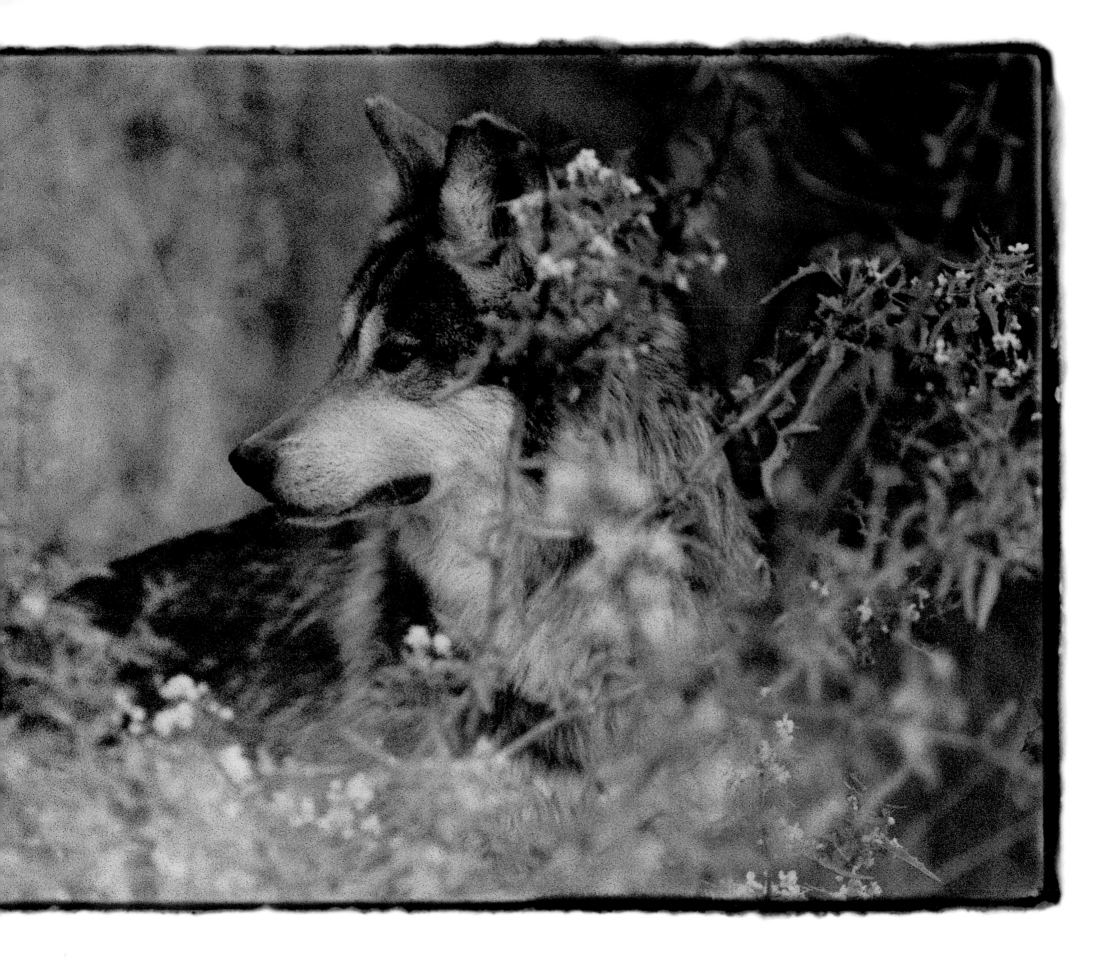

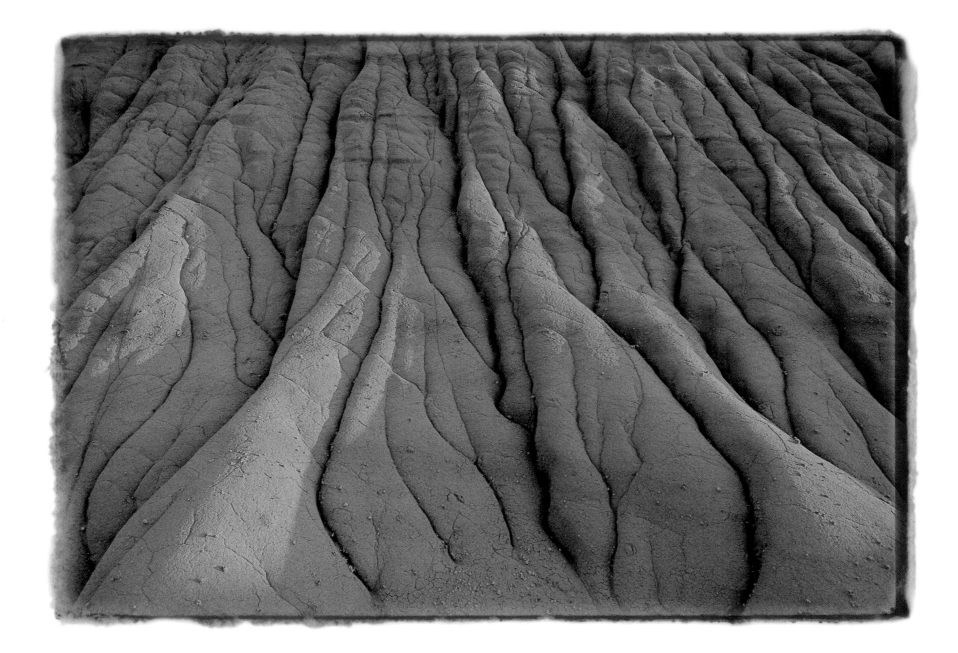

Badlands / EASTERN MONTANA

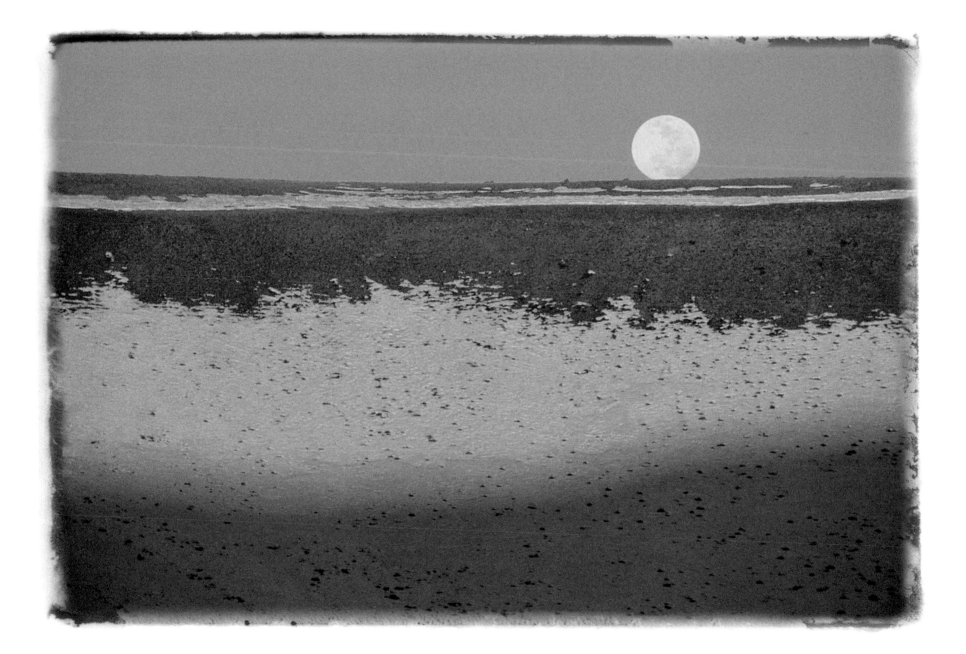

Rocky Mountain moonrise / COLORADO

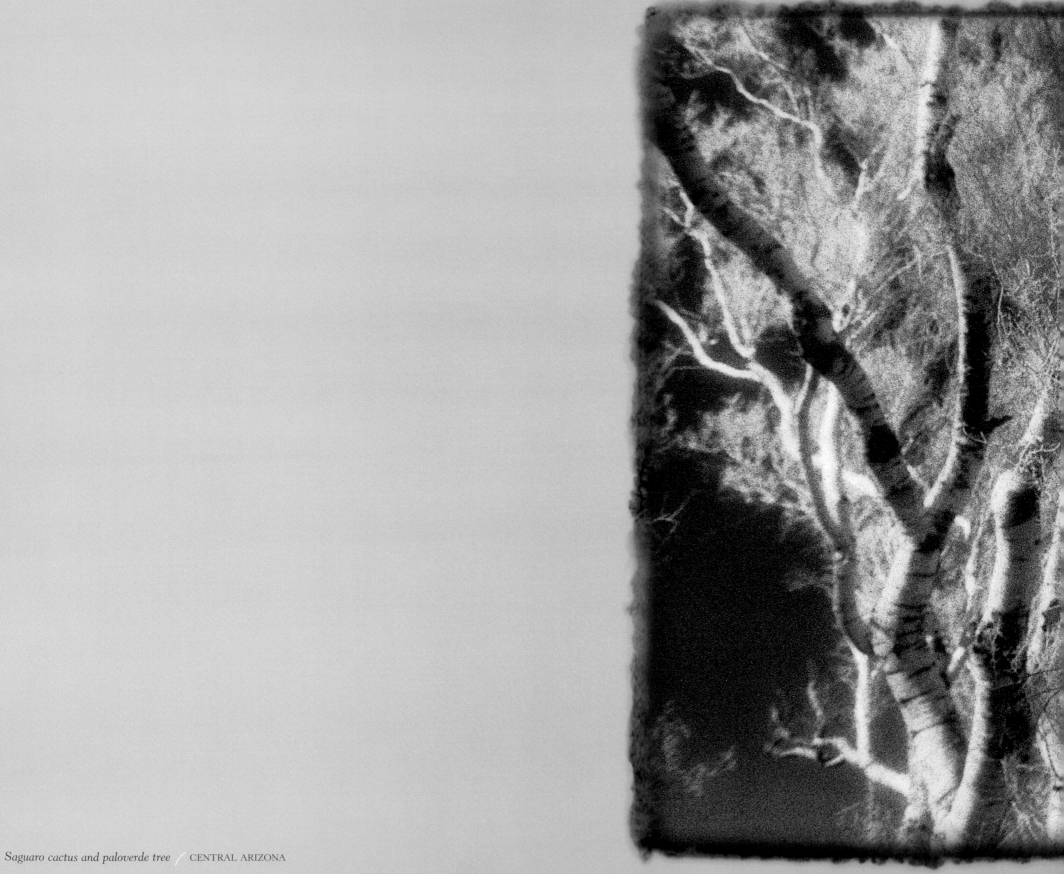

Saguaro cactus and paloverde tree / CENTRAL ARIZONA

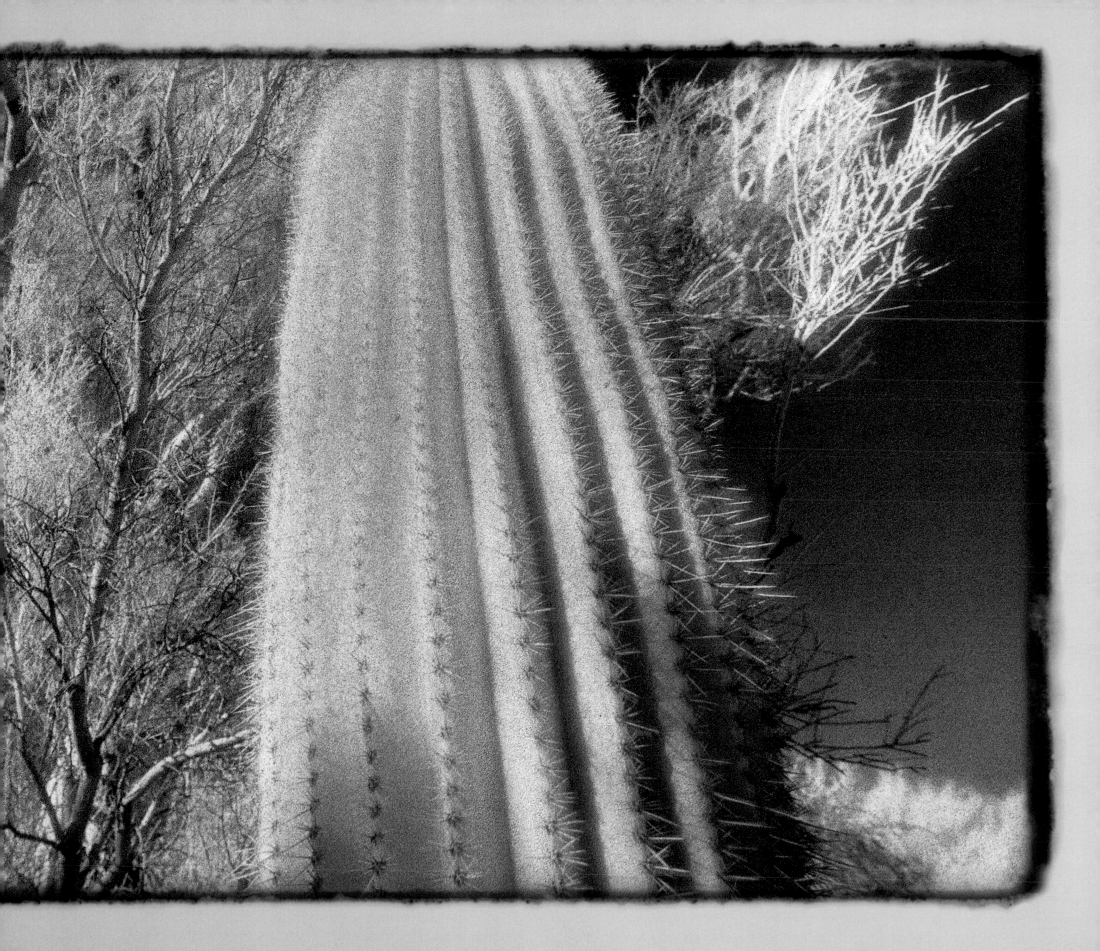

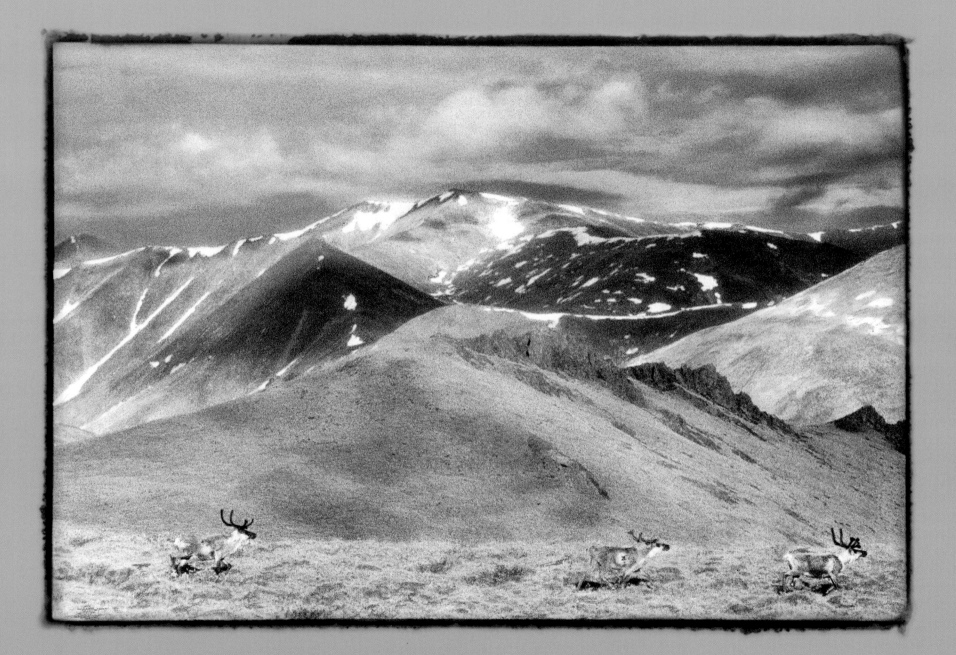

This is a landscape that has to be seen to be believed, and even then... it strains credulity.

<div style="text-align: right">EDWARD ABBEY</div>

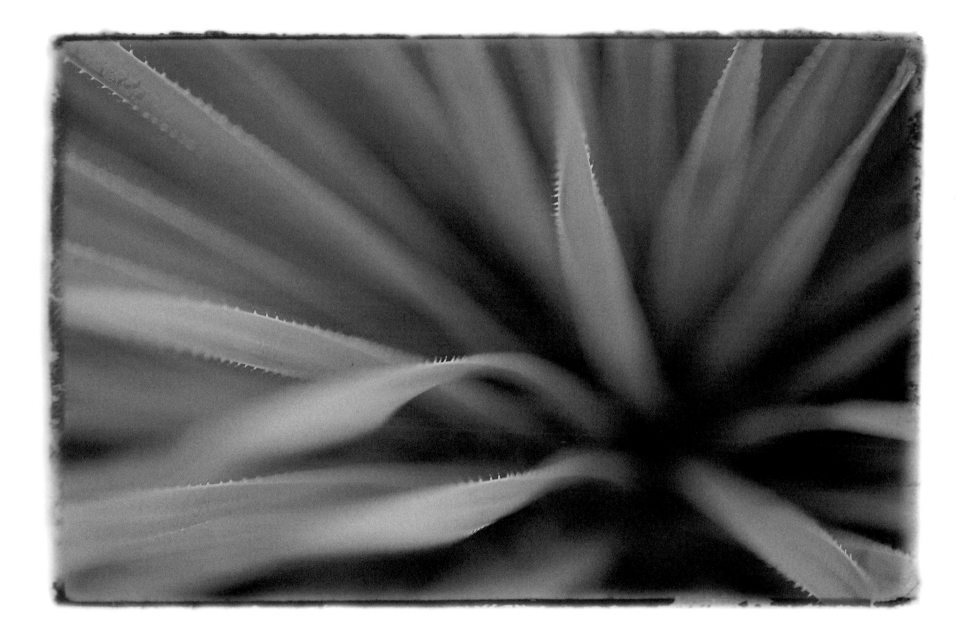

Sotol agave / CENTRAL ARIZONA

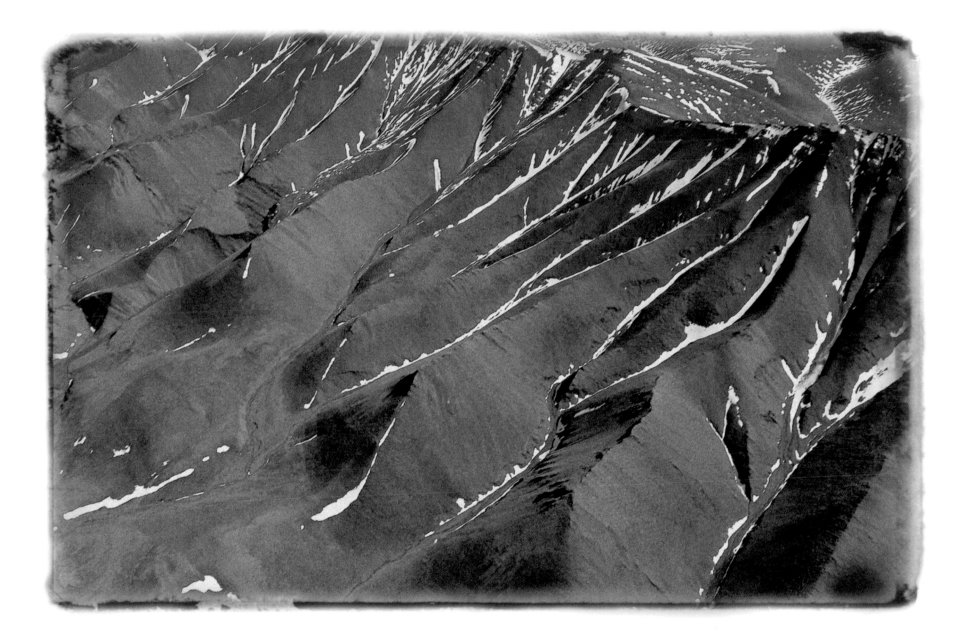

Brooks Range / NORTHERN ALASKA

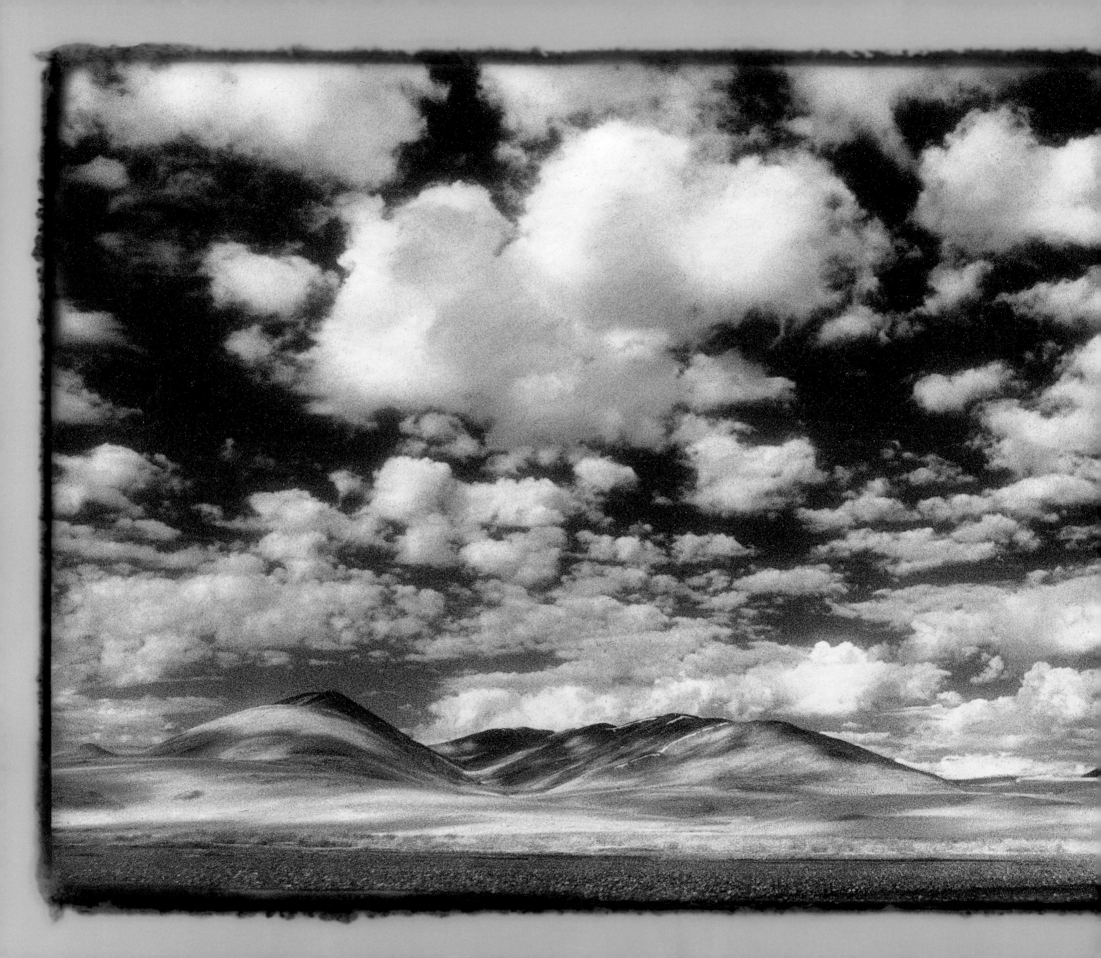

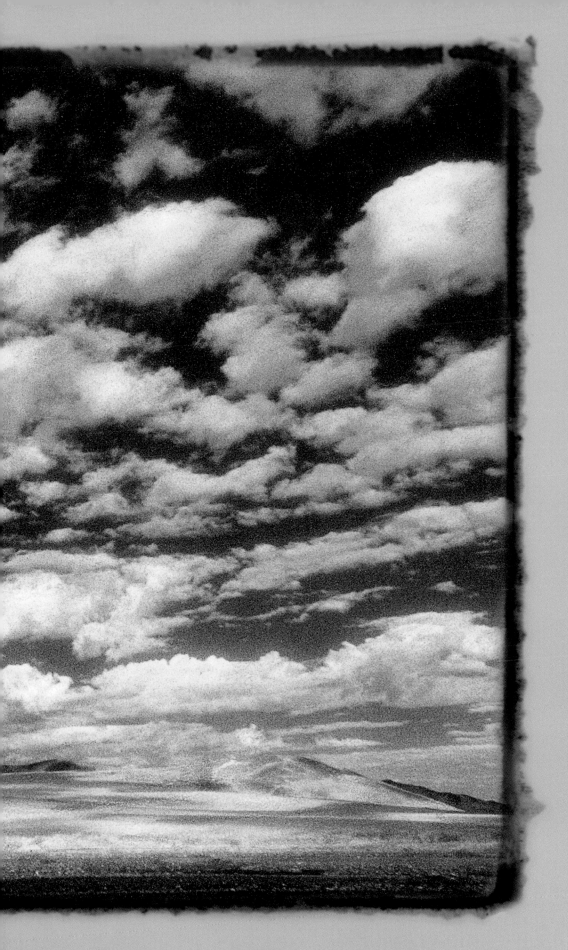

Light and space without time...a country with only the slightest traces of human history.

EDWARD ABBEY

Summer dawn / ARCTIC NATIONAL WILDLIFE REFUGE, ALASKA

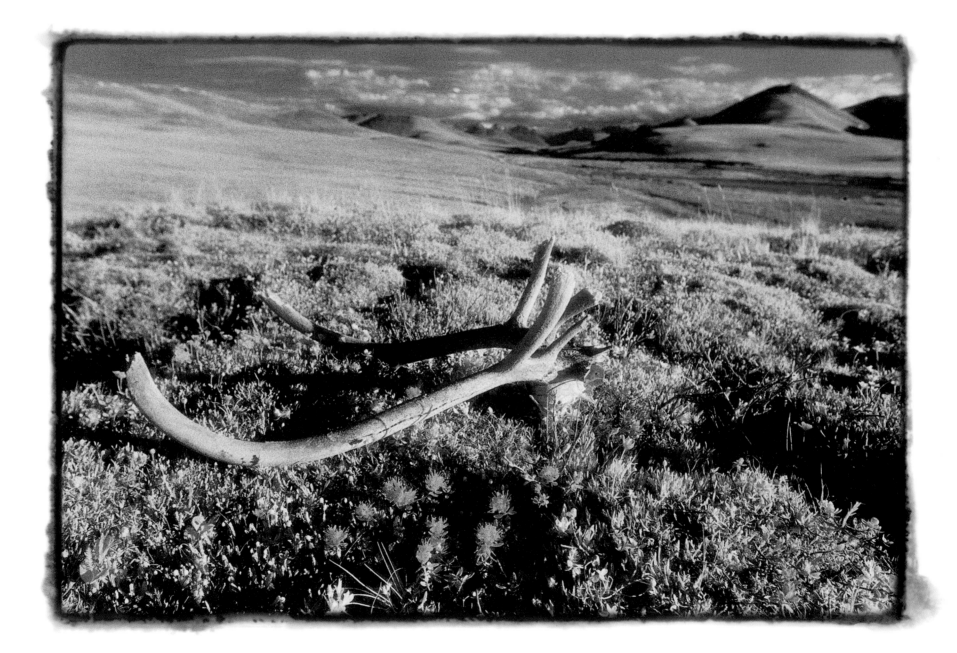

Caribou antlers / ARCTIC NATIONAL WILDLIFE REFUGE, ALASKA

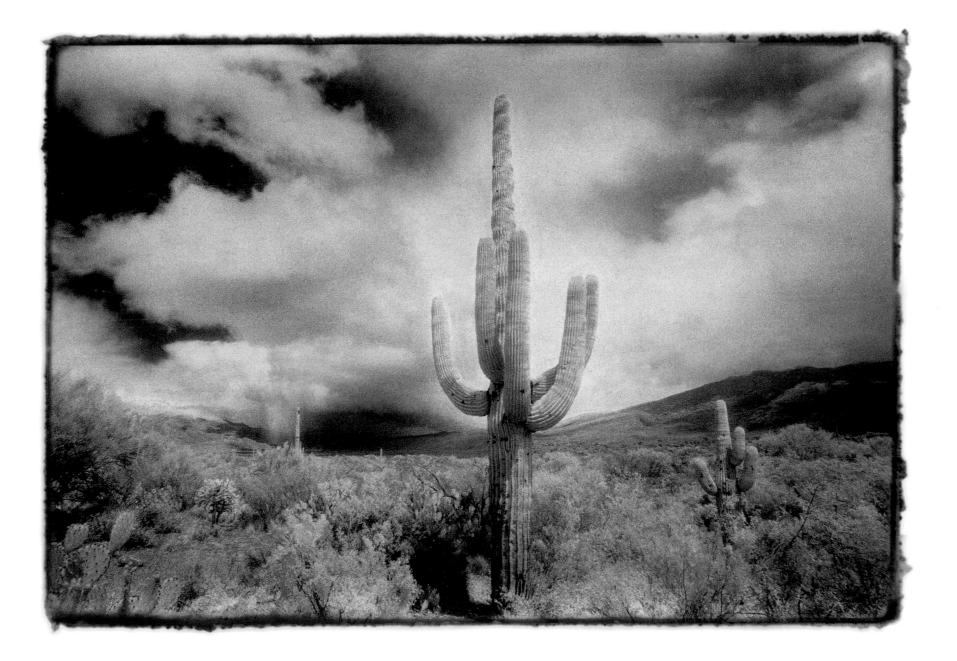

Summer storm / CENTRAL ARIZONA

To walk on this earth is to walk on a living past, on the open pages of history....

LINDA HOGAN

Eastern front of the Rockies / MONTANA

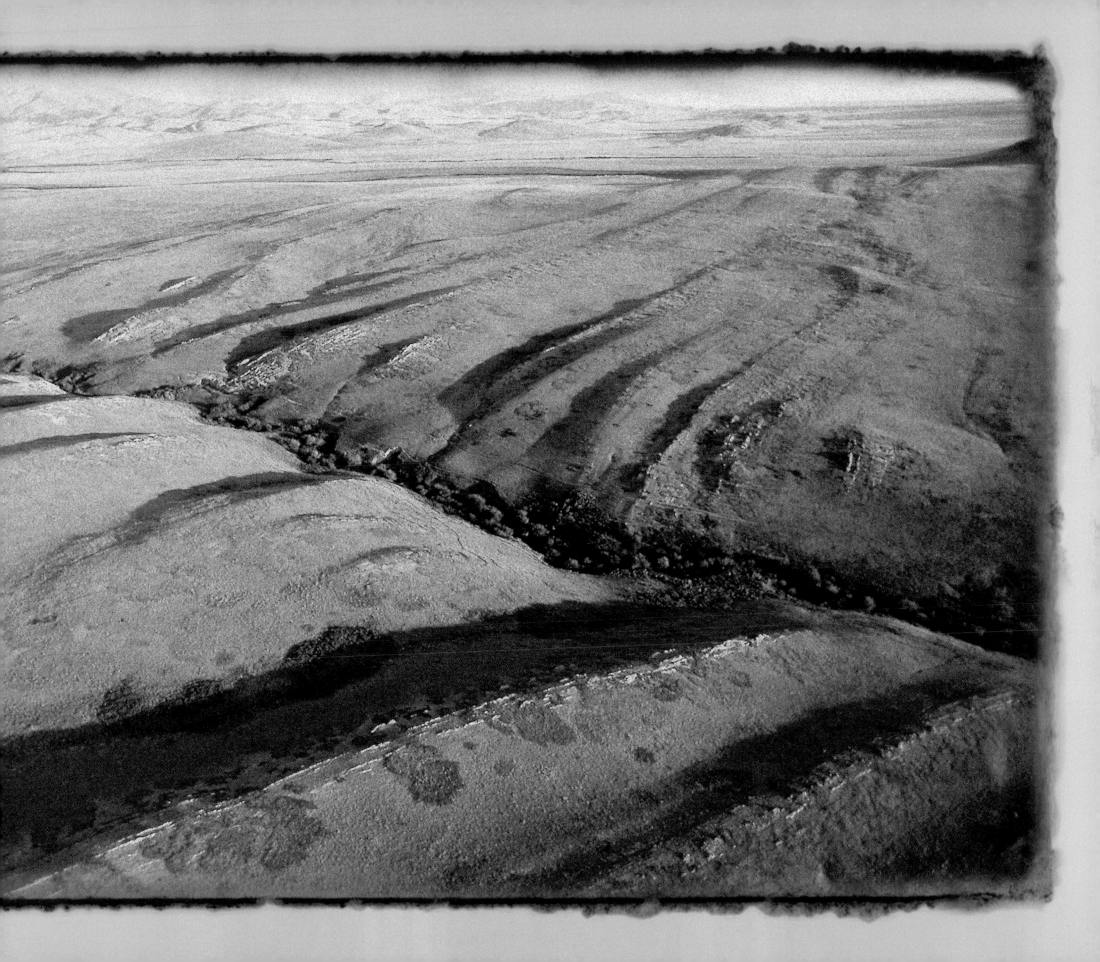

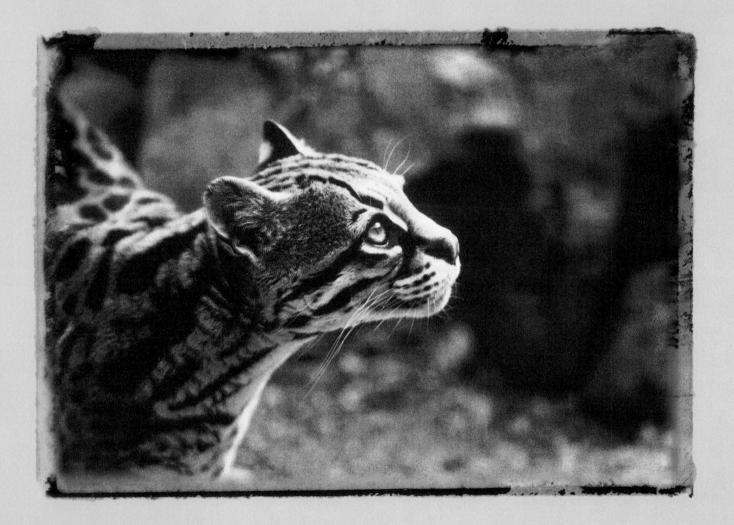

Captive ocelot / ARIZONA

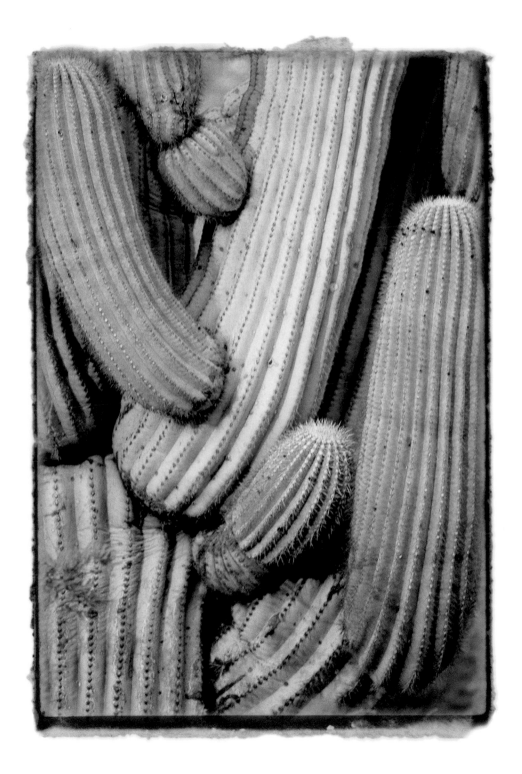

Aging saguaro / ARIZONA *(Overleaf) Desert snowfall* / NEVADA

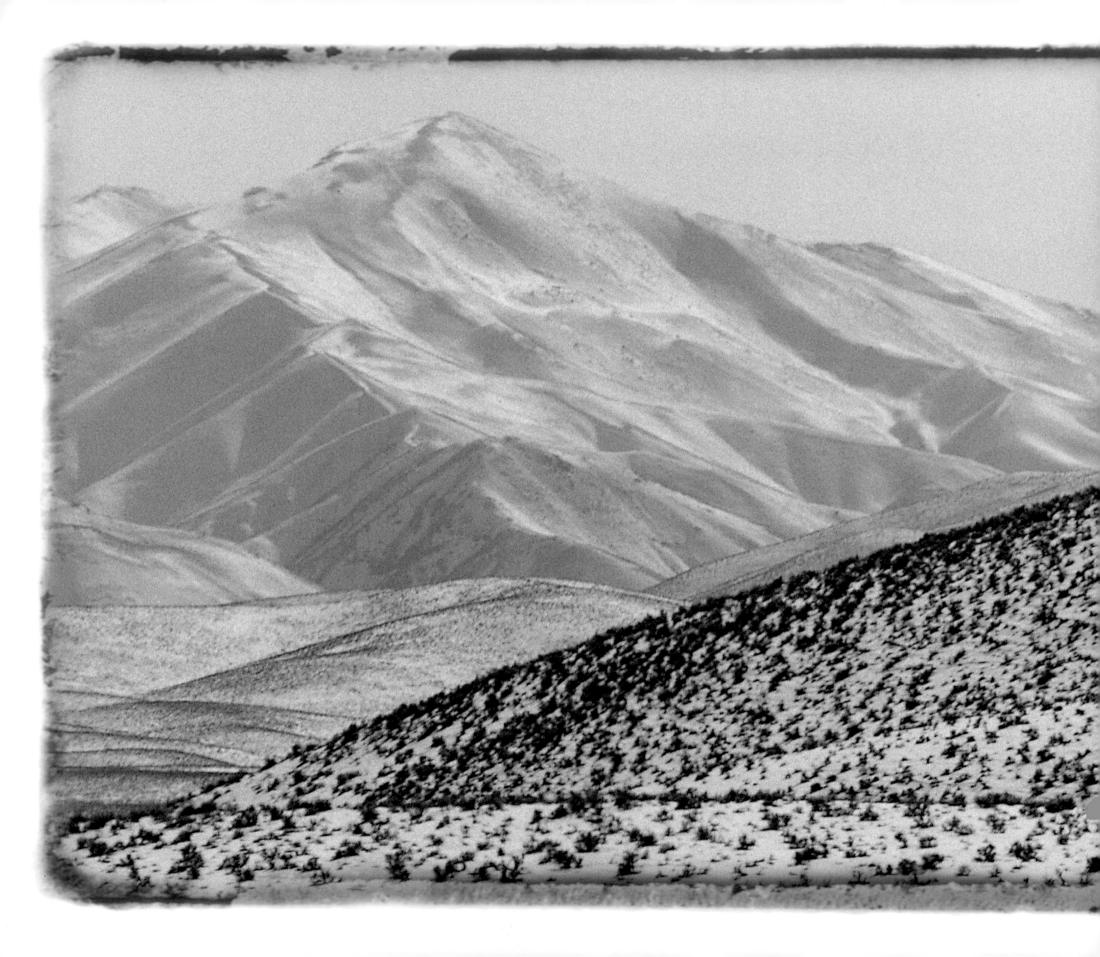

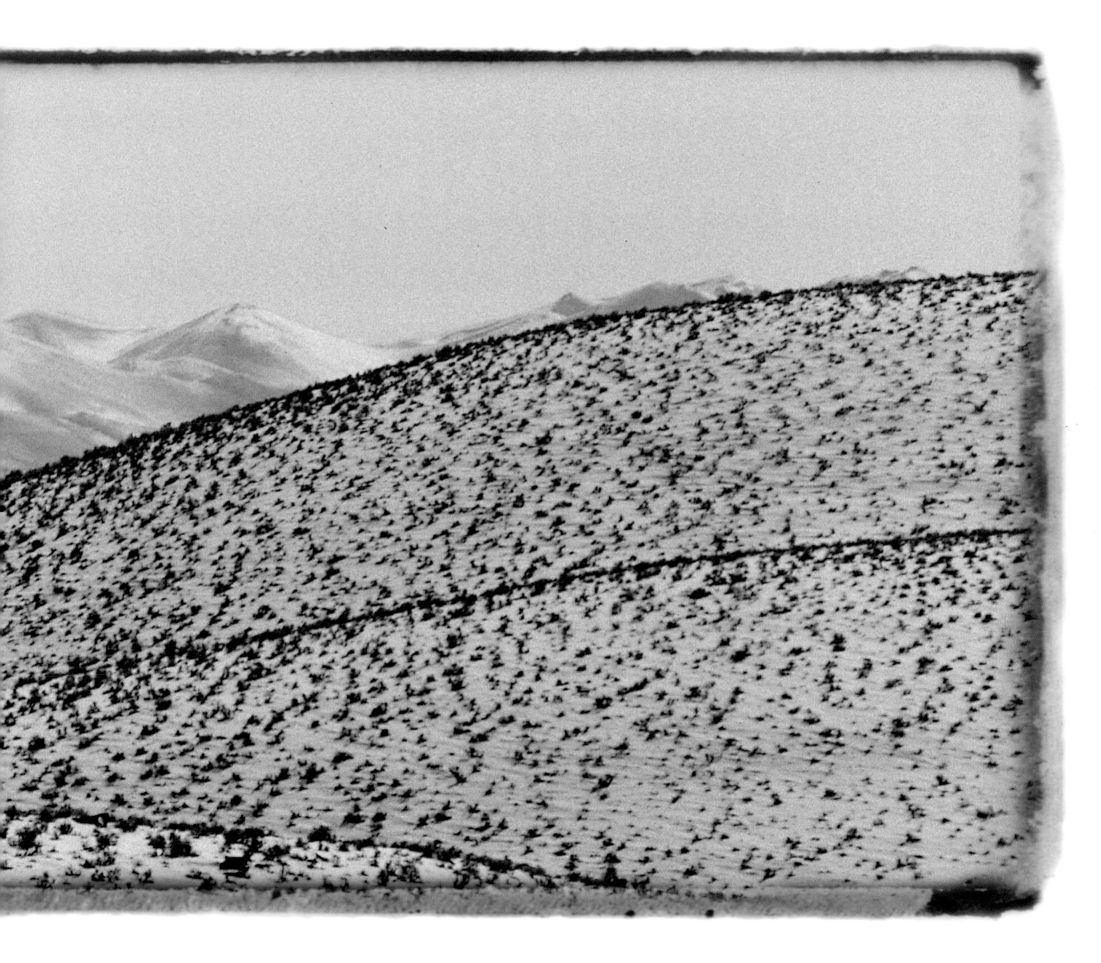

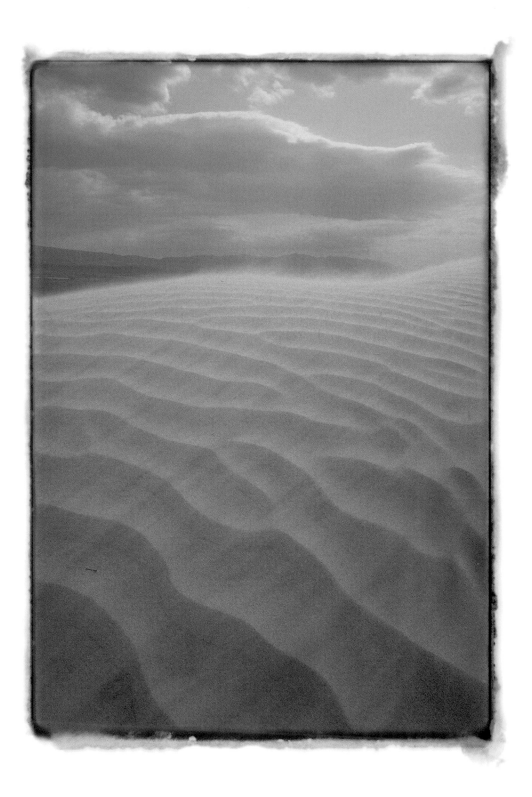

Death Valley sandstorm / CALIFORNIA

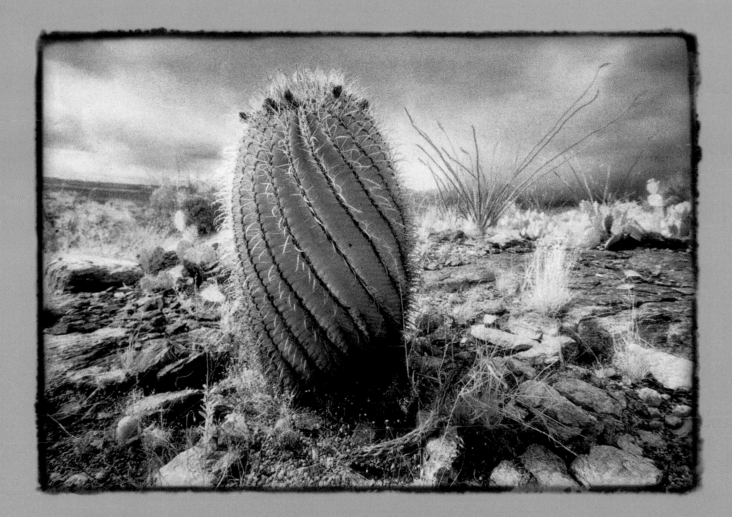

Barrel cactus / CENTRAL ARIZONA

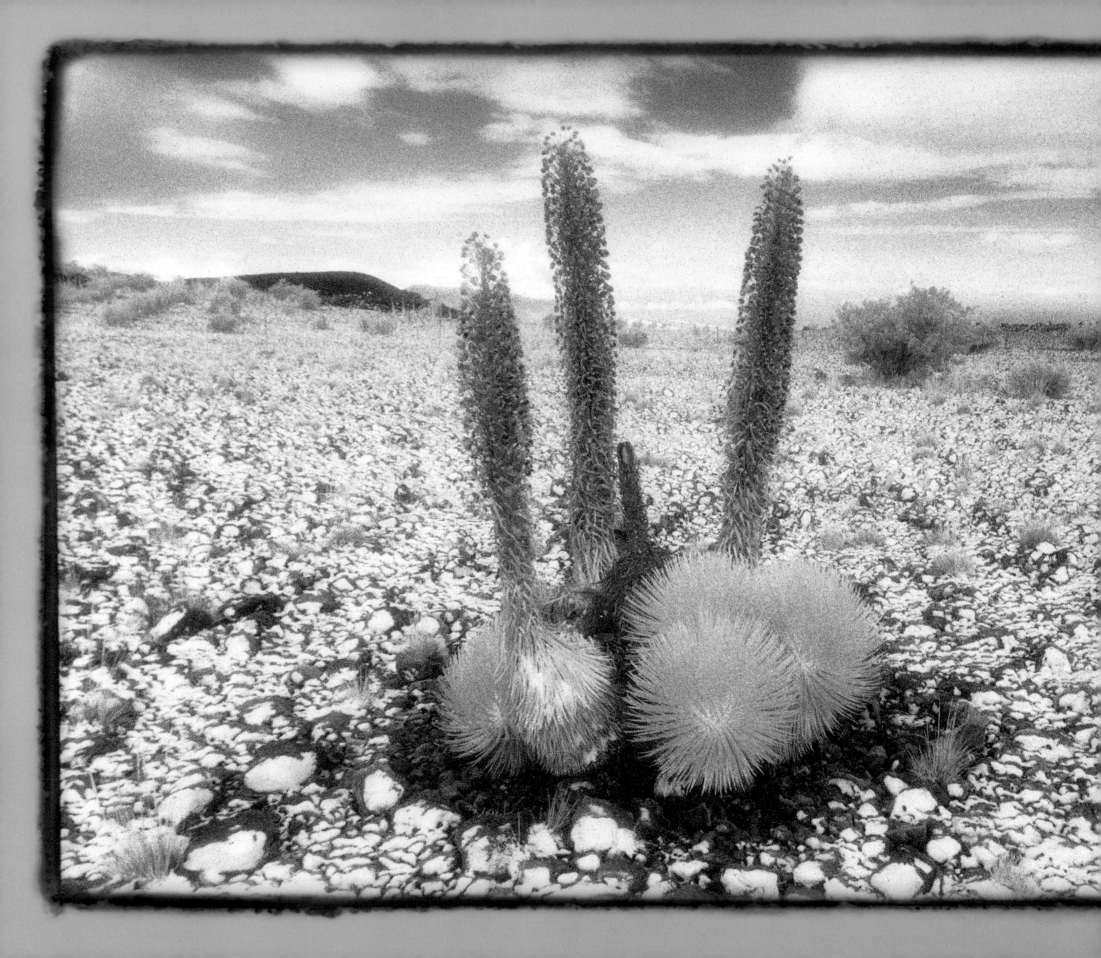

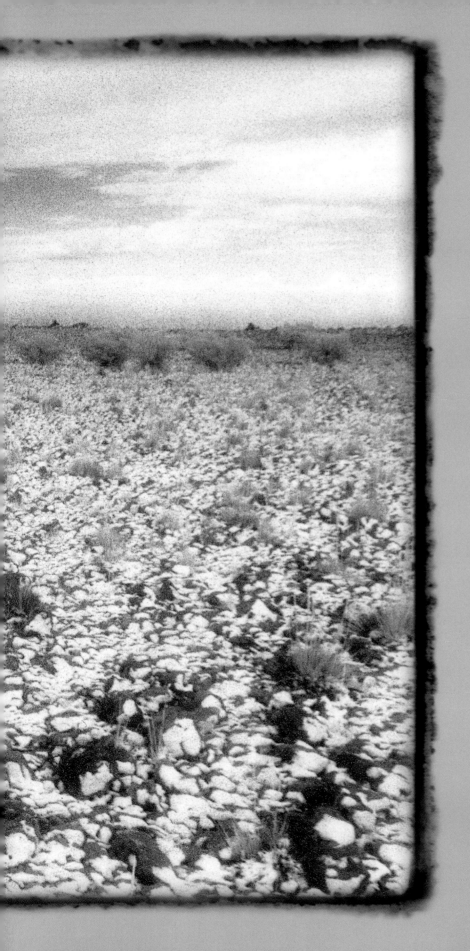

The idea of wilderness needs no defense. It only needs more defenders.

EDWARD ABBEY

Endangered Mauna Kea silversword / BIG ISLAND, HAWAII

Additional Reading

Abbey, Edward. *Desert Solitaire: A Season in the Wilderness* (Ballantine Books, 1971); *The Journey Home: Some Words in Defense of the American West* (E. P. Dutton, 1977).

Barbato, Joseph, and Weinerman, Lisa, ed. *Heart of the Land: Essays on the Last Great Places* (The Nature Conservancy). Vintage Books, 1994.

Bartram, William. *Travels and Other Writings* (Slaughter, Thomas P., ed.). Library of America, 1996.

Carson, Rachel. *The Sea Around Us.* Oxford University Press, 1989.

Emerson, Ralph Waldo (Atkinson, Brooks, ed.). *The Essential Writings of Ralph Waldo Emerson.* Princeton Review, 2000.

Hogan, Linda. *Dwellings: A Spiritual History of the Living World.* Touchstone Books, 1996.

Leopold, Aldo. *A Sand County Almanac.* Sierra Club/Ballantine, 1966.

Lopez, Barry. *Crossing Open Ground* (Vintage Books, 1989); *Desert Notes/River Notes* (Avon Books, 1990).

Mac, M. J., Opler, P. A., Haecker, P .A., Doran, C. E. P. and P. D., eds., *Status and Trends of the Nation's Biological Resources.* Department of the Interior and U.S. Geological Survey, 1998.

Muir, John (Cronin, William, ed.). *Nature Writings.* Library of America, 1997.

Thoreau, Henry David. *The Portable Thoreau* (Bode, Carl, ed.). Penguin Books, 1982.

Acknowledgments

I wish to thank the magnificent women who believed in this project and gave their hearts to it: Nina Hoffman, who trusted me; Barbara Kingsolver, who blessed this book with her words and whose friendship and moral vision guided me; Karen Kostyal, who thoughtfully minded every detail; Marianne Koszorus, whose artistry touched every page; Jen Christiansen, who gently framed each image; Kathy Moran, who has been my second pair of eyes on every project I have done for the past 20 years; Connie Phelps and Jill Enfield, who taught me so much about how to dress these images; and Rebecca Martin and her Expeditions Ladies. Without support from the National Geographic Expeditions Council, this book would not have been possible.

Thanks to the production gurus: Gary Colbert, John Dunn, and Mark Freydler; the crew at the Black and White Lab, who worked with me so closely on the infrared images; and thanks to Janet Dustin, Melissa Farris, Bill O'Donnell, and Barbara Fallon.

In the field I was helped at every turn by a band of believers in land conservation. I would like to thank my dear friends, Kim and Melanie Heacox, tentmates and tireless advocates for the Arctic National Wildlife Refuge; Jack and Gretchen Jeffries, who opened their home and their island to me; Grady Timmons, Connie Gelb, and Ed Misake of the Nature Conservancy; Steven Hopp, Glenn Oeland, Saul Weisberg, Stephen and Donna O'Meara, Rik and Bronwyn Cooke, Dewitt Jones and Lynette Sheppard, Flip Nicklin, Chris Johns, Tim Lengerich, Matt Sclar, and Kirk Sweezer.

Deepest thanks to Bob Gilka, Papa-mentor, who opened so many doors for me, and to Janet Gilka; thanks to Melina and Keith Bellows, to Bill and Lucy Garrett; and to my parents, Bob and Mary Griffiths, who have been on the sidelines cheering since I first picked up a camera.

And most of all, thanks to Don Belt, partner, driver, schlepper, shoulder, heart.

Annie Griffiths Belt

A Note about the Book

The photographs appearing in this book represent two types of work. Roughly half were shot on color transparency film. The rest were shot on black-and-white infrared negative film and the prints then hand-colored by photographer Annie Griffiths Belt. The borders were specially created by designer Jen Christiansen. Captions for photographs were deliberately kept vague as to location to discourage visitation to these fragile natural sights.

This book is printed on recycled paper.

Funding for this project was provided as part of the National Geographic Society's Conservation Initiative.

Footprints in the sand / GULF OF MEXICO BARRIER ISLAND

Published by the National Geographic Society

John M. Fahey, Jr., *President and Chief Executive Officer*

Gilbert M. Grosvenor, *Chairman of the Board*

Nina D. Hoffman, *Executive Vice President*

Prepared by the Book Division

Kevin Mulroy, *Vice President and Editor-in-Chief*

Charles Kogod, *Illustrations Director*

Marianne R. Koszorus, *Design Director*

Staff for this Book

K. M. Kostyal, *Editor*

Marianne R. Koszorus, *Art Director*

Sallie M. Greenwood, *Researcher*

R. Gary Colbert, *Production Director*

Janet Dustin, *Illustrations Assistant*

Melissa Farris, *Design Assistant*

Michele Tussing Callaghan, *Consulting Editor*

Manufacturing and Quality Control

Christopher A. Liedel, *Chief Financial Officer*

Phillip L. Schlosser, *Managing Director*

John T. Dunn, *Technical Director*

Vincent P. Ryan, *Manager*

Clifton M. Brown, *Manager*

Published by the National Geographic Society
1145 17th Street, N.W., Washington, D.C. 20036-4688

Text copyright © 2002 Barbara Kingsolver
Illustrations copyright © 2002 Annie Griffiths Belt

Library of Congress Cataloging-in-Publication Data
Kingsolver, Barbara.
 Last Stand: America's virgin lands / Barbara Kingsolver; photographs by Annie Griffiths Belt.
 p.cm.
 Includes bibliographical references.
 ISBN 0-7922-6909-8 (hc.)
 1. Habitat (Ecology)—United States. 2. Endangered ecosystems—United States. I. Belt, Annie Griffiths, 1953- II. Title.

QH104.K55 2002
333.95'16'0973—dc21

One of the world's largest nonprofit scientific and educational organizations, the National Geographic Society was founded in 1888 "for the increase and diffusion of geographic knowledge." Fulfilling this mission, the Society educates and inspires millions every day through its magazines, books, television programs, videos, maps and atlases, research grants, the National Geographic Bee, teacher workshops, and innovative classroom materials. The Society is supported through membership dues, charitable gifts, and income from the sale of its educational products. This support is vital to National Geographic's mission to increase global understanding and promote conservation of our planet through exploration, research, and education.

For more information, please call 1-800-NGS LINE (647-5463), write to the Society at the above address, or visit the Society's Web site at www.nationalgeographic.com.

Printed in Spain